COMPOSING AND SHA

Studying the techniques of the old masters for working methods and a personal style.

by GASPARE DE FIORE

Translated from Italian
by Joachim Neugroschel

DING YOUR DRAWINGS

The Drawing Course, Volume Two

*WATSON-GUPTILL
PUBLICATIONS
New York*

Copyright © 1983 by Gruppo Editoriale Fabbri, S.p.A., Milano

Published 1983 in Italy by Gruppo Editoriale Fabbri S.p.A., Milano

First published 1985 in the United States and Canada by Watson-Guptill Publications, a division of Billboard Publications, Inc., 1515 Broadway, New York, N.Y. 10036.

Library of Congress Catalog Card Number: 84–040632

ISBN 0-8230-0878-9

Manufactured in Italy

First Printing, 1985

Introduction

I am convinced that while drawing cannot be taught, it *can* be learned because in a way drawing comes naturally to us and only needs to be brought out and refined. In a way, the image of something seen or imagined is a drawing formed in our heads and only needs method and materials to transfer it to paper.

But drawing is more than this, too. Precisely because it can express both reality and fantasy, drawing is an expression of our rapport between the world outside us and our inner selves. And so, if we can understand drawing beyond its value as a pretty picture—that is, see it as a means of recognizing and participating in the world around us—then we will find this world of drawing on the pages of our albums, the sketches on our walls, and in the thousands of images that surround us daily.

We are always drawing. The moment we trace a line to paper, our participation in drawing is direct. But we also draw indirectly when we interpret a series of lines by mentally adding form, light and shadow, and color to it as we look. Thus the white spaces—the blank parts—are as important as the filled ones to the viewer, and we can participate in drawings deeply as a part of life, just as we do in poetry, music, dance, painting, and sculpture, interpreting the images of the real world and creating new ones from our imagination.

Thus the world of drawing belongs not only to the great artists, but also to the rest of us who draw what we see in reality or our minds, or who use it daily to solve practical problems. It belongs to writers like Victor Hugo, who enriched his novels with his own charming images; and to film directors like Federico Fellini, who jotted down ideas for lighting, costumes, and scenery for his films on hundreds of colored sheets of paper and hung them around his studio. The world of drawing is also the world of adventure in the comic strips of our daily newspapers and in animated cartoons on television, and includes everything from blueprints for cars

and motorcycles, furniture and buildings...to designing the colors and shapes of a jigsaw puzzle, a deck of cards, record album, or a film poster.

But how can we find the right kind of drawing to express ourselves? How can we learn how to draw? I think there's no more productive and exciting way to learn than by reading the words, advice, experiences, and teachings of the masters, past and present; seeing what they have written about drawing and problems they've encountered, hear them analyzing their work, revisiting them, and discovering in their drawings the manner, methods, and tools they have used.

This book is an invitation to look at the drawings of the masters as though we were looking over their shoulders as they drew, watching them as they traced a line down the page, looking at their models and how they interpreted them, seeing them first sketch an idea and then develop it. What we really would like to do is try to understand those drawings without relying on theory but by letting the artist speak and explain for himself the history, reasoning, meaning, and development of a project from its birth as an idea to the last stroke of pencil on paper.

Every time we can see a work with the eyes of the artist and understand the creative process behind it, we face the problems he faced and prepare ourselves to resolve them as he has. With this in mind, I have chosen a few drawings from the many in the history of art and I have imagined being able to ask the artists about each drawing and through a sort of imaginary interview—or lesson—to get each one to tell his motivation, his aesthetic and technical problems, his artistic solutions and his inventions.

We will do this by interpreting—each drawing and composition carefully and critically so that we can go beyond our own interpretations of the work to unravel the threads of the artistic process to reach the artist himself.

Gaspare de Fiore

The Drawing Course Series

The drawing course is developed through five volumes on the basic phases of drawing, with a sixth volume on drawing materials. The course provides a rich, as well as practical and enjoyable framework for the teaching of drawing. In each section, the ideas, teachings, experiences, and works of the great masters, analyzed through different stages of their development, are used to illustrate the basic techniques taught in the course.

The lessons are developed through a method that individualizes the diverse procedures of drawing without losing the synthesis of the vision and actual portrayal of the subject. At the same time that the lesson teaches the need for scientific and objective procedures, it also emphasizes each person's personality and interpretation.

The course focuses on the techniques of drawing, from the moment of "seeing" to the interpretation of color. One volume gives specific information about materials, such as the various kinds of pencils and crayons available, and how to use them. Other volumes describe the various types of drawings—from sketches to technical drawings, culminating in an introduction to painting.

This is the second volume in the series. The entire six-volume course is described below:

VOLUME ONE
LEARNING TO SEE AND DRAW

Learning to See

The course begins by stressing the need to learn to see. Observing in order to portray an object, the definition of form and chiaroscuro, the analysis of form and color, images of reality and images of ideas all represent fundamental steps in learning to draw, phases which are picked up and developed throughout the course in their most diverse applications.

Drawing From Life

We learn to know the world around us better through drawing, and present it in a personal way. Drawing from real objects, notes from travels (in a sketch book that we will take with us when we go out to help us see and remember), anatomy studies, and perspective of objects and backgrounds that interest us will all be covered, using the drawings of the masters as a laboratory of experience and technique.

Seeing Shape

The first lesson in the learning process is the analysis and representation of form. As we read about shape, we will discover the geometric structures that are the key to the construction or basis for the drawing, along with the relationship of the various elements and the search for balance and proportion. We'll see that even when a shape is represented by a single line, that line can suggest emotion, sensation, light and shadow.

VOLUME TWO
COMPOSING AND SHADING YOUR DRAWINGS

Chiaroscuro

A line can suggest light and shadow but it is chiaroscuro that interprets and expresses it fully through the wise use of black and white, reflections and tinted shadows, thereby creating a third dimension of volume and depth.

Developing the Drawing

A drawing begins with a sketch of the initial idea or impression; then the search begins for the right arrangement, point of view, develop-

ment of foreground and background and its position on the paper. Chosen with awareness, this series of elements will contribute to the synthesis of the composition.

Composing with Geometry

Composition, which is the basic structure of drawing, finds harmony and balance in the discipline of geometry, even in free sketching. An axial composition is based on one of the axes or on two perpendicular axes. It can also be diagonal, triangular, square, circular or something even more complex such as mixed where geometric figures vary or are superimposed on each other.

VOLUME THREE
DRAWING WITH COLOR AND THE IMAGINATION
Understanding Color

Drawing is seeing and interpreting the world around us, a world in color. Light is color; all colors are created from the basic three, red, blue and yellow. Besides the abstraction and stimulus of a black and white drawing, color theory is developed in order to understand and portray new compositions and spatiality.

Color and Personality

Beyond objective color theory there is the world of color in each of us, full of contrasts, variations, harmonies, and subjective agreement for the portrayal of ideas and impressions. Color thus becomes a means of self-expression.

Sketching Our Observations

Sketching is the first step in a drawing; notes are born from ideas or observations, whether real or from fantasy, made up or actually seen. In the sketchbook, images and impressions multiply that can become drawings themselves or parts of another project.

A few lines on a page sometimes say more than a complicated drawing. More than other drawings they succeed in expressing personality and feeling and developing our fantasy.

Getting Practical Ideas on Paper

Fantasy drawing is inventive drawing that can be applied to daily life, in fashion, decoration, jewelry, household objects, furnishings. In drawing, we can freely express our fantasies clarifying ideas that can then be carried out.

VOLUME FOUR
DRAWING TO COMMUNICATE
Drawing as a Language

Drawing is communication. With lines on paper we can speak even to those whose language we don't know. We can draw to explain

something, to show how something is made, to recall an event, to play and even to dream. One needs only a line to suggest something to enrich and complete the imagination.

Illustrating Stories and Ideas

In mass media, drawing plays a protagonist's role, working hand in hand with texts, even substituting for them at times, and competing with photographs. There are scientific drawings, humorous ones, such as caricature and political satire, illustrations in books and magazines, and the still young field of comics and animated cartoons. But even with this wide range, there are fixed rules on which every drawing is based.

Diagramming Objects in Space

The methods of geometric representation give us rules for drawing three-dimensional objects. The concept behind each method, however, is unique: The drawing, as a projection on a surface (paper) seen from a single point of view.

With perspective, an actual point of view is projected, while orthogonal projects such as maps and diagrams are infinite. In each case the geometric drawing is a fundamental tool for the representation of architecture, objects, machines and land.

VOLUME FIVE
PRACTICAL AND FINE ARTS DRAWING
Designing to Catch the Eye

This section looks at the vast world of graphics as used in designing books, covers, signs, publicity and brochures as well as in the industrial world where it becomes a blueprint for the production of models and products.

Preliminary Sketches

A drawing starts with the preliminary sketch; it is also the basis of paintings, sculpture, architecture, scene paintings and engravings. It is the link between the idea and the finished work, letting us understand the beginnings and history of the process of invention and its realization.

Turning Drawings Into Paintings

In the long process toward the discovery of drawing, color is often brought into play. Now that we know something about drawing, we can turn to the fascinating world of painting where color triumphs, with a greater awareness and consciousness, enriching our images, visions, and ideas with color.

VOLUME SIX
WORKING WITH DRAWING MATERIALS

Drawing materials (crayons, pastels, pencils, etc.) and how to use them.

CONTENTS

CHIAROSCURO

Chiaroscuro, the use of tones ranging from gray to black, utilizes the white of the paper. Chiaroscuro contributes greatly to a drawing's volume and depth, and to suggesting the effects of light and dark, reflections, and shading, adding to a drawing's possibilities. An expressive line can suggest the quiverings of light and the mystery of darkness, but chiaroscuro, which captures tones with hatchwork, spots, and shading, can recreate light and the third dimension on the surface of the paper. The pleasure and fascination of drawing also depend on the viewer's participation and imagination. Transforming himself into the protagonist, the viewer looks at an image rendered with a few pencil strokes on a two-dimensional surface, and mentally adds volume, space, and color to it.

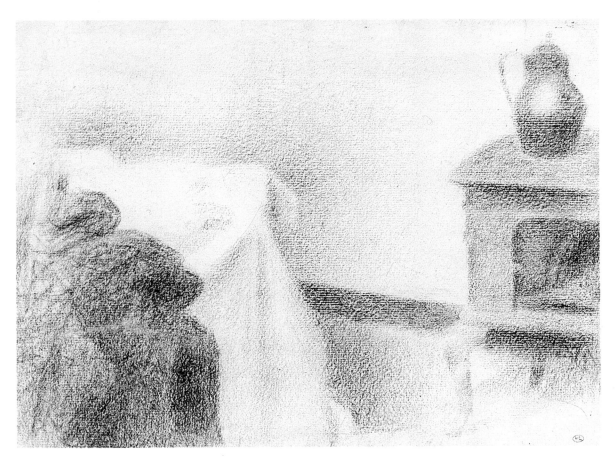

Georges Seurat: Corner of the Artist's Studio, *study for* The Models, *1886-87. Conté crayon, 235 x 305 mm. Louvre, Paris.*

The fascination of Seurat's drawing lies, as always, entirely in the chiaroscuro. Note above all: the expert use of the graininess of the paper on which the artist gently rubs his crayon, producing extraordinary effects of transparency and gray tones around the cloth on the left, which allow the white to "come out."

Drawing Light

Techniques and Development of Chiaroscuro

The term *chiaroscuro* refers to the relationship between light and dark, the distribution of various intensities of luminosity. Chiaroscuro can be divided into five main degrees of intensity: light, color, halftone, shadow, and reflect light and color.

Generally, natural lighting produces diffuse light and reflected shadows, while artificial illumination produces raw light and sharp shadows. We will soon see this in our exercises.

In a drawing, the relationship between light and shade creates the illusion of relief. This is more obvious in a monochrome composition, in which the gradated hue brings out the relief, completing the linear perspective of the composition. In practice, chiaroscuro can be obtained by means of various graphic techniques. We can have a sfumato chiaroscuro, with gradual transitions of tones from light to shade. We can have a halftone chiaroscuro or a chiaroscuro of spots, with sharp distinctions between light and dark. We can also have various combinations of dots and lines, more or less thick, more or less crosshatched, varying in pressure and thickness. We can also use the grain or other features of the paper or whatever material we draw on.

After establishing the structure, composition, and proportions of a drawing—that is, when the outline is completed—we add the light and shade. To do this we begin by working within the more important dark areas, then gradually working around the entire drawing in order of impor-

Titian: Jove and Io. *Charcoal, blue paper, 225 x 265 mm. Fitzwilliam Museum, Cambridge.*

Titian's sketch emerges and develops from the chiaroscuro. In the curling line that seems to envelop the two figures, the artist seeks shape, volume, and shadow, with the latter becoming the main subject. The diagram emphasizes the basic shape and the diagonal composition.

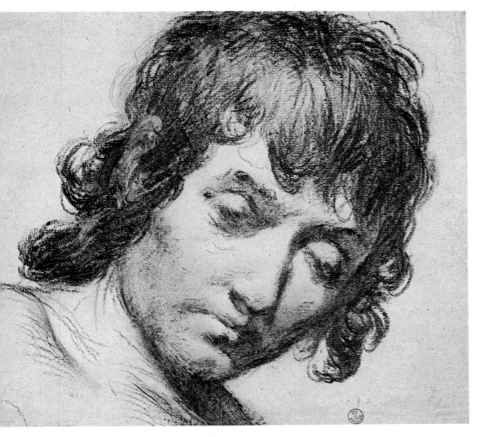

Bernardo Strozzi (1581-1644): Boy's Head. *Black pencil and charcoal, pale blue paper, 240 x 270 mm. Uffizi, Gabinetto dei Disegni e delle Stampe, Florence.*

The boy's beautiful face is given meaning and expression by the chiaroscuro tones, which gently envelop the half-closed eyes, nose, lips, and cheeks. The diagram indicates the areas of light and shade in a quest for synthesis.

tance, while deepening the first areas until they are dark enough. The chiaroscuro relationships thus remain constant from the very beginning of the drawing to the final phase. In other words, the drawing is not done in sections but everything moves ahead simultaneously, so that no part is definite while another remains untouched or incomplete. When you have fixed the outline of the drawing, you then "veil" it with the lightest tone of chiaroscuro, starting with the darkest and most important shaded area. During the successive stages of the draft of chiaroscuro, you have to keep the subject's light-and-shadow ratios unchanged. While dealing with the technical problems of developing the chiaroscuro, you will be depicting the volumes, the light, and even the atmosphere. If you correctly analyze the values in the light and shade, and if you accurately relate the deeper tones of the foreground figure to the lighter background tones, you will succeed in transmitting the feeling of air between buildings or between a tree and a hill, and you will virtually immerse your subject in the atmosphere.

The first artists to experiment with chiaroscuro were probably the ancient Greeks. According to tradition, the inventors of this technique were Apollodorus and Zeuxis (fifth century B.C.). Examples of chiaroscuro have also been found in several monochrome paintings in Pompeii. This technique was then abandoned and eventually taken up again, finding its highest expression in the Italian Renaissance, when drawing was considered the basis of all the figurative arts. Typical chiaroscuro paintings were done by Leonardo da Vinci, who emphasized the dark areas, and by Michelangelo, who preferred the light. Indeed, every artist has his own treatment of chiaroscuro, his own technique.

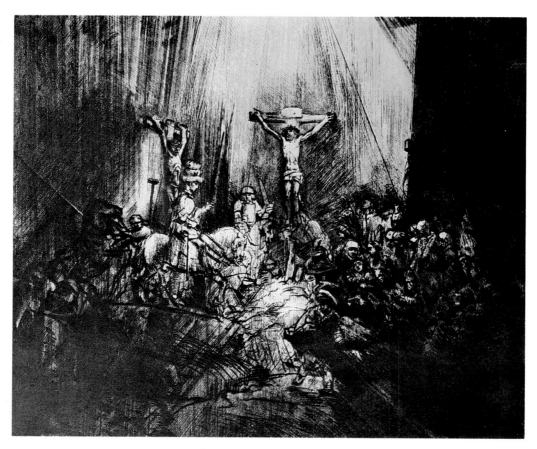

Rembrandt: The Three Crosses, *1653. Etching, fourth state, 385 x 450 mm. Petit Palais, Paris.*

In this etching, Christ appears wrapped in a ray of spiritual and divine fire. The light beam enveloping the crosses seems to come thundering down. I do not know of any other etching in which the sense of drama and the sense of the divine are so vividly present. The dazzle of supernatural light is achieved purely through the artist's incisions on the plate.

Light in Rembrandt's Drawings

Rembrandt explored the relationship between light and shadow more than he did the relationship between bright and dark areas, particularly in engravings. This made him develop his visions and ideas all the more profoundly. The contrast with the reality is even sharper when we discover that details of significance are hidden in the shadow and revealed in the light.

Without color, night and day form a ghostly opposition. Black and white, the limits of human eyesight, constitute not only the invisible and the visible, but also the two antagonistic forces that preside united over the rhythm of the universal order. These absolute contrasts, which are both simple and mysterious, contain a profound philosophy; but light remains the true protagonist of every painting and every scene.

In Rembrandt's etchings, the light achieves a new splendor and the shadows envelop the rest of the scene, which teems with distant and disquieting shapes.

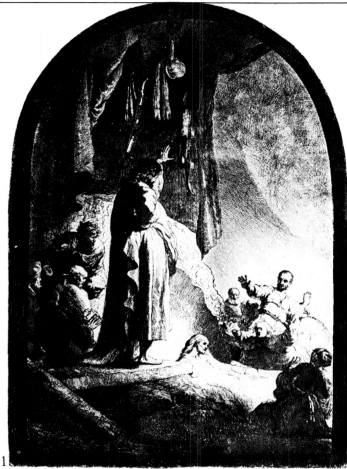

1. Rembrandt: The Great Resurrection of Lazarus, *1632. Etching, 367 x 257 mm. Rijksmuseum, Amsterdam. Lazarus rises from the tomb in the living gust of a spiritual flame. Such a light is also the vehicle of mystical knowledge. This etching is marked by the triumph of light. Never has light been more alive than it is here. Just as, here, life overcomes death, we see the light triumph over shadow.*

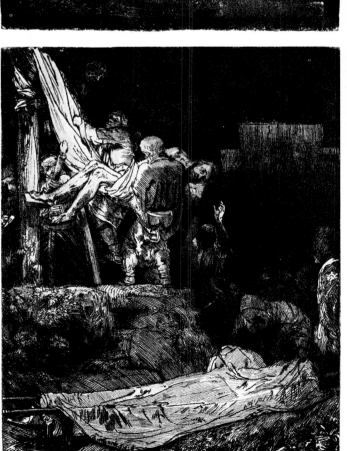

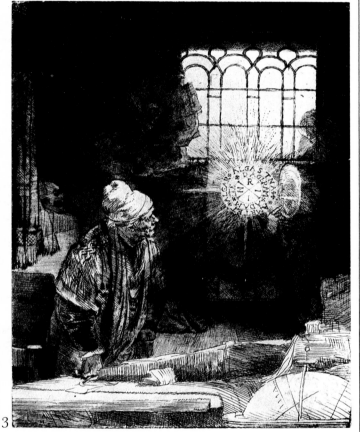

2. Rembrandt: The Deposition of Jesus, *1654. Etching, 210 x 161 mm. Rijksmuseum, Amsterdam. In the various stages of this etching, the darkness becomes more and more intense. What we have here is the silence of death and the terrifying darkness of the tomb. Once again, shadow envelops the mystery of death, exquisitely expressed by Rembrandt's technique, composition, and draftsmanship.*

3. Rembrandt: Faust in His Study, *1652. Etching, 209 x 161 mm. Rijksmuseum, Amsterdam. Faust is in the darkness, seeking, and waiting for, wisdom and truth. The light that suddenly appears is stronger, more splendid, than the light coming from the window overhead, yet the philosopher is not dazzled.*

 This is the frontispiece for the Dutch book The Light of Knowledge in the Centuries of Ignorance and Darkness, *illustrated by Rembrandt with his figure (a philosopher meditating in the mournful glow of a lamp). The etching bore a Latin sentence (In medio noctis vim suam lux exerit): It is in the middle of the night, that light appears in all its strength.*

Light and Shadow

In black-and-white drawings, the lightest area is provided by the whiteness of the paper, and this whiteness is intensified by the gray and the black of the shadows. Thus, light and shadow interweave in terms of laws and their relationships.

When light illuminates an object, that part of the object that remains in darkness is called the *shade*; and the shadow created by the object on an independent surface is called the *cast shadow*.

"You painters," writes Leonardo da Vinci, "in order to be universal and please diverse judgments, combine objects of great darkness and great mildness of shadow, while bringing out the causes of the shadows and their mildness."

Indeed, da Vinci was fascinated by shadow, which envelops his figures and visions in the thick, dark air of twilight and night. He discusses shadow several times in his *Treatise on Painting*. And elsewhere he writes: "The shadow of the white seen in sunlight and air has bluish shadows." Then, generalizing on the basis of a specific instant: "The shadows of plants are never black, for in a place penetrated by air there is no darkness." And then: "There are four principal parts to be considered in a painting: quality, quantity, site, and figure. *Quality* refers to shadow and the more or less secure part of the shadow. *Quantity* refers to the size of the shadow in relation to the other, nearby shadows. *Site* refers to its location and to the portion of the body part on which it lies. *Figure* refers to the shape of the shadow, i.e., triangular, round, square, etc."

These observations on shadows and their qualities are echoed in Delacroix's *Journal* when he

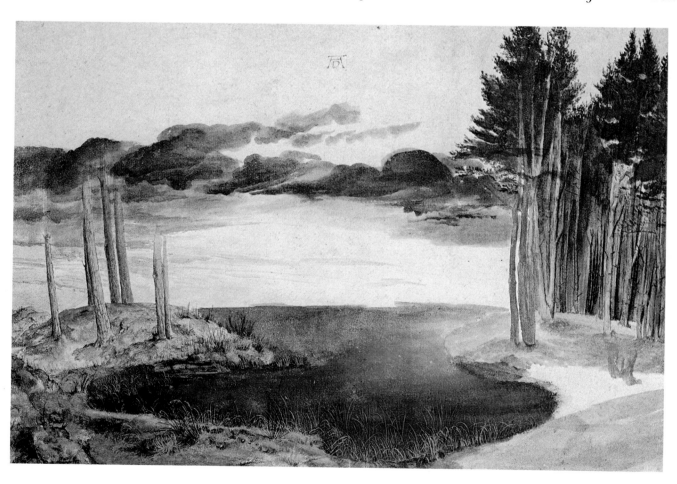

Albrecht Dürer: Lake in Forest, *1495-97. Watercolor and gouache in several colors, 262 x 374 mm. British Musuem, London.*

Dürer was dazzled by his experiences in Italy. This watercolor is an excellent illustration of how "light" can be rendered in a drawing. It is not just the white of the paper, nor the short brushstrokes of yellow, but everything—the dark clouds, standing out distinctly against the sky, the tree trunks, minutely drawn, the deep tone of the lake—that creates an extraordinary luminosity.

writes about drawing trees:

"Even though the vegetation has not advanced here, I have acquired a better understanding of the pictorial principle of trees. I have to model them with a colored reflection, as I do flesh; the same principle seems even more useful here. This reflection does not have to be completely a reflection. When it's done, I can feel even more where it is necessary, and when it comes to lights and grays, the passage is less brusque. I have observed that an artist must always model the leafy areas in terms of round masses, as if they were not composed of an endless number of small parts. Also, they are so transparent the tone of the reflection is very important in the leaves. In short, the flatter the diverse tones, the airier the tree. The more I think about color, the more I realize that the reflected halftone is the principle that should dominate, because that which produces the true tone constitutes the value, which counts in the object and makes it exist."

Delacroix made the following general statements: "Reflections: all the reflections contain something green. The edges of the shadow have a quality of violet. Avoid black. Instead, make the dark tones with pure, transparent tones of lacquer, mixing or cobalt blue or yellow lacquer, or natural burned sienna." By recording his experiences in his journal, Delacroix could clarify and establish for himself several rules to guide him in his paintings. Try to understand how color operates. You will see that reflection is a basic problem in Delacroix's paintings, which are made up of reflected (and hence, colored) shadows.

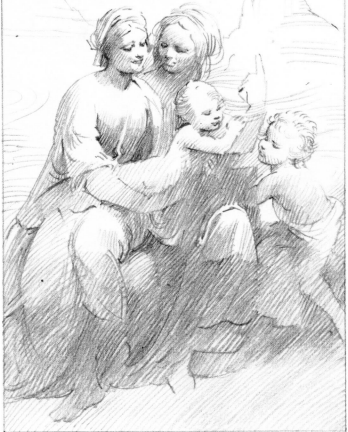

Leonardo da Vinci: The Madonna, Saint Anne, Jesus, and Saint John. *Charcoal and white lead on pieces of reddish paper joined together on canvas, 141 x 104 cm. National Gallery, London.*

For da Vinci, shadow is a "material" to paint with. It is not something one depicts, but something one depicts with. Thus,

when we study da Vinci's drawings, we almost feel as if he saw his figures in the light and then gradually kept observing them when the darkness began to envelop them in its mysterious veils. Just recall the eyes of the Mona Lisa: *da Vinci seemed to be pursuing the secret of light, hoping to ferret out the secret of life in darkness. The diagram emphasizes the significance of darkness as a material to draw with.*

The Development of Chiaroscuro

These diagrams illustrate three of the successive stages in developing a chiaroscuro drawing. Virtually standing behind the artist, I have selected three fundamental stages to show you how to proceed from the outline to the definition of the shadows and to the draft of the chiaroscuro.

1. *The first diagram shows the geometric layout of the drawing contained within a triangle and held together by arcs. The figure fills almost the entire surface with the weight of an extraordinary bulkiness.*

2. *The second diagram presents only the outlines, to be further developed by the artist, with a sensitive line expressing light, color, and atmosphere. Since the drawing follows a logical development, this intermediate phase pinpoints the contours, which define the volumes within the light.*

3. *The third diagram depicts the first draft of the chiaroscuro, proportioned and balanced throughout the composition as it is gradually deepened. The outlines are barely indicated. Shaded areas are slowly hatched in with parallel strokes; the artist will return to them later and reinforce them.*

4. *In the final drawing, shape and chiaroscuro, suggested by various tonalities of the black pencil, are effectively rendered. The figure is brought out in relief by the meticulous use of chiaroscuro. The illuminated left-hand side of the figure is barely drawn. The shadowy right-hand side, on the other hand, is shaded with precise strokes, a hatchwork of parallel and crisscrossing lines that make the figure stand out against the background. This is the logical conclusion of an orderly procedure.*

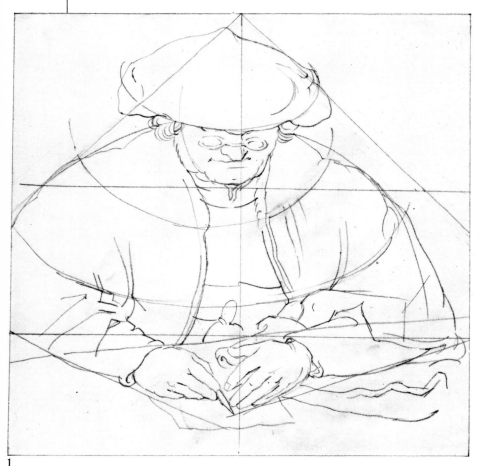

1

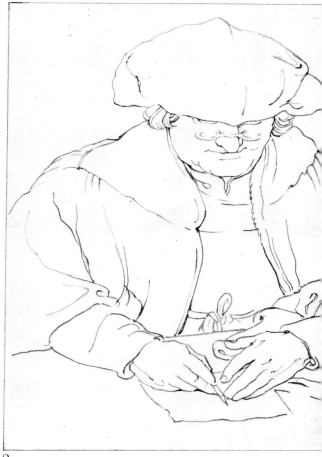

2

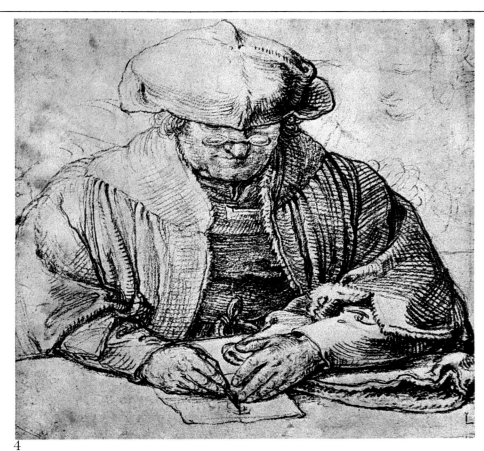

4

Lucas van Leyden:
Old Man Drawing.
Black pencil, 272 x
272 mm. British
Museum, London.

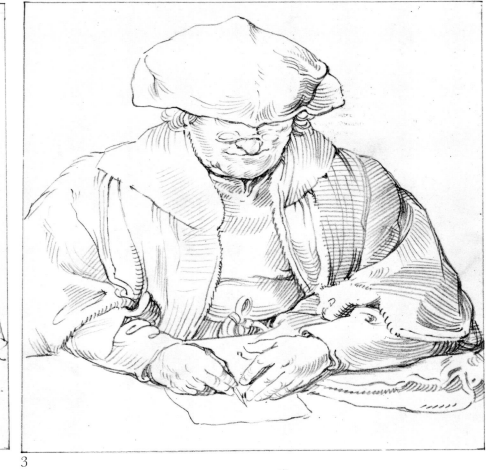

3

A Drawing a Day

These two drawings suggest an exercise you can try with everyday objects like a cup, eggs, or cloth. Place these objects in any arrangement you like, but keep them on a tray or small table you can move around. In this way, you can draw your composition with the light from the left and then from the right. The subjects—eggs, cloth, and cup—are chosen precisely because they offer possibilities for finding and drawing shadows in various tone modulations: shade, reflected shadow, cast shadow, etc. In a subject like an egg, you have to study the tonal variations of the shadow to

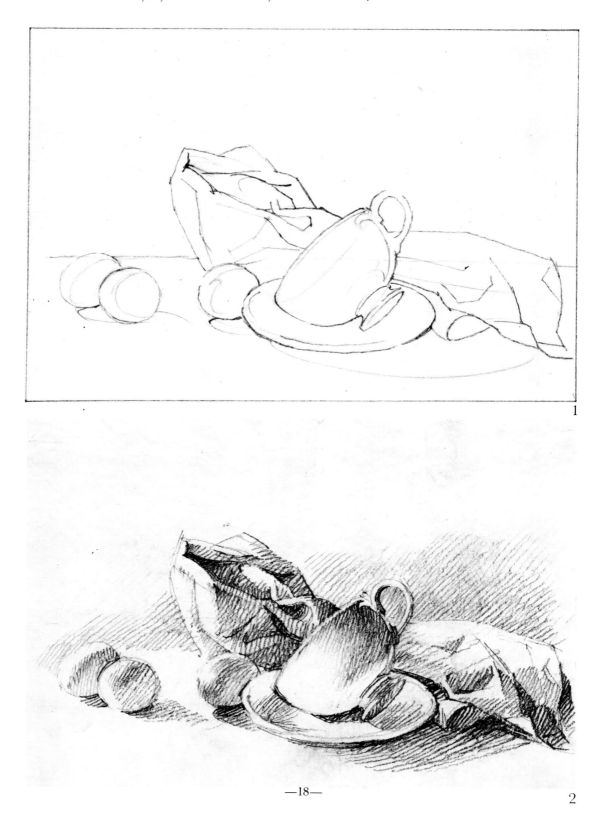

1

2

capture its roundness.
- The first diagram defines the composition, which is handled with an expressive line that is sensitive to light and shade.
- In the first drawing, the light coming from the left illuminates the objects, creating shade and cast shadows, with a wealth of reflections.

- The next diagram illustrates the drawing solely by means of an expressive outline of the composition. The illumination comes from the right.
- The chiaroscuro emphasizes the differences between this drawing and the preceding one through variations in the direction of the light source.

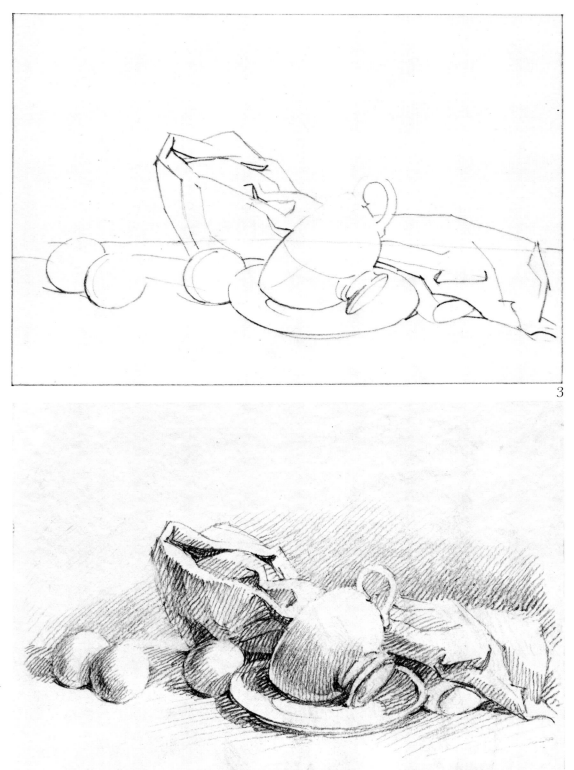

3

4

"No sooner do you realize that you are sufficiently in possession of the pen as an instrument for shading, than you feel capable of spreading a light or dark hue at will. You can gradate the hue, gradually passing from a dark tone to the lightest tone. Almost *all* the expression of form in drawing depends on the ability to gradate tones delicately; and the more perfect the gradation, the less perceptible the transition between a stronger tone and a weaker one. To practice this, draw the boundary lines of the shadow area and try to shade it gradually and evenly from white to black, so that the transition is imperceptible, although every single part of the strip can have a visible change of value. Unroll your strip gradually in the best way you can, so as to offer the gradation a wider space. At the same time accustom yourself to observing the blurrings of spaces that are found in nature."

(John Ruskin: *Elements of Drawing and Painting*, 1898

The Laws of Shade and Shadow

At the point where the shadow begins—that is, at the line separating illuminated and non-illuminated areas—the shadow always seems darkest. This is an optical effect, one based on comparison and contrast, which means a dark value that is close to a light area seems even darker. The section in the light is vivid and precise in its details, which are sharply delineated by the light and shade, while the details in the shaded or dark parts are obscured or at least softened and blurred.

In a drawing, the values are gradated against the principal dark area. However, all shadows have to be studied in terms of their qualities and characteristics:

• The cast shadow is darker than the shade side of objects, which always benefit from reflections from adjacent parts in light.
• The edges of cast shadows seem darker than their inner parts, particularly in contrast to lighted areas nearby.
• The details in shadows are blurry and scarcely visible, but they still maintain their color characteristics.

Austrian art historian Ernst Gombrich tells us that "the Chinese think that a drawing done in proper perspective is wrong, just as we feel that their flat drawings are wrong or marvel at their strange buildings, which are capped by a point. And all primitive works—i.e., those created by untrained people—demonstrate with their lack of shadow how little one can rely on the untrained eye in discovering truth."

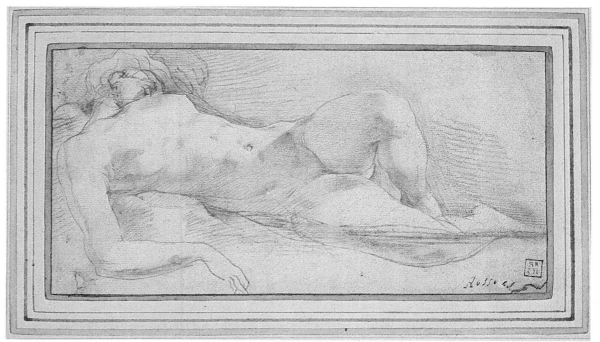

Rosso Fiorentino (Giovanni Battista di Jacopo; 1495-1540): Study for a Reclining Nude. *Red crayon on preliminary sketch made with stump, 126 x 244 mm. British Museum, London.*

In this drawing by Rosso Fiorentino, we can see his highly personal interest in luminous effects, which are obtained by sketching the shadow with all its nuances. Note the reflection on the right arm, the shadow reflected by the sheet on the right part of the reclining body, the darker shadow cast by the left leg upon the belly, the reflections on the left leg in shade, and the accentuation of the shadow of the knee.

Black and White

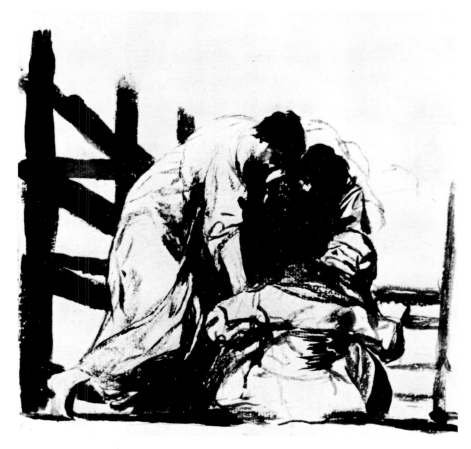

Francisco Goya (1746-1828): Help, *1812-23. Brush and brown wash, 206 x 145 mm. Museo del Prado, Madrid.*

Goya used the pen, brush, and ink more than any other medium. This technique particularly lends itself to rendering the contrast between shadow and light and to simplifying the figures, which are distorted into an essential expressivity. The pyramidal block of the group here is made up of two figures in light and one in shadow, with a strong contrast of white and black, which contributes to the sense of drama.

A black-and-white drawing is generally done with a pencil or a pen. However, the term "black-and-white" refers more specifically to a special way of drawing, one that only uses the white of the paper and the black of the line or spots, with no intermediate tones, shadings, or grays. Such a drawing finds its shapes, outlines, and values by arranging and contrasting the lightest light and the darkest dark. At first glance, this sounds extremely simple, yet it covers both the technique and the meaning of a black-and-white drawing.

• *The Technique.* In a drawing with spots, the effects result from a careful distribution of white and black parts. The latter not only indicate the shadowy areas, but they suggest volume and color, or at least the darker tones.

In such a technique, the outline and the spot (*macchia*) are of fundamental importance. The spot is a white or black area defined by an outline. Hence, the line is sharp, precise, and almost always definite, delineating the profiles of objects and people and the parts that are to be

left in white or that have to be blacked in. We often find a "negative"—that is, a white line in the black areas. Such white lines pinpoint details, decorations, folds, brightness, etc., in the dark tone.

Black-and-white drawings derive from the use of pen and ink. They are particularly suited to the need to show precision and definition in lines, outlines, and filled areas, which makes them useful in the genres of reproduction, particularly lithography. The latter is a system for reproducing multiple copies of a drawing, enabling the artist to preserve a sharp line and a uniform spot. In this way, the characteristics of a black-and-white drawing are not only respected, but they're heightened by the precise reproduction of the continuous line and by the uniformity of the black areas.

• *The Meaning.* It is obviously simplistic to assume you can render a subject with just any technique. Even if this were possible, every subject actually requires a specific technique, or at least one that can express it better than any other. Thus, black-and-white ink is especially suited to interpreting real or invented subjects in which the contrast

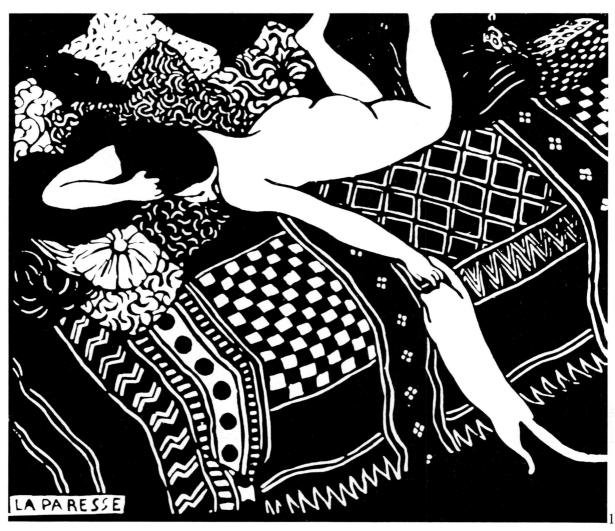

LA PARESSE

1

between light and shadow and the balance between light and dark areas can contribute to rendering shape, volume, and meaning more effectively. It is no coincidence that this type of drawing is used for illustration since an "original" in black and white, one with sharp outlines and shadows, ensures a simpler and more faithful reproduction. For this reason, we find this technique in the graphics and drawings of the Symbolists, who make the luminous images of their imaginations emerge from the mysterious darkness.

1. *Félix Vallotton (1865-1925):* Laziness, *1896. Woodcut, 178 x 208 mm. The Museum of Modern Art, New York.*

2. *Odilon Redon:* "And man appeared, asking the ground from which he comes and which attracts him, life opened toward dark lights," *1883. Lithograph from the series* Origins, VIII, *204 x 280 mm. Bibliothèque Nationale, Paris.*

3. *René Magritte (1898-1967):* The Thought that Sees, *1965. Graphite, 395 x 295 mm. The Museum of Modern Art, New York. (Gift of Mr. and Mrs. Charles Benenson).*

2

3

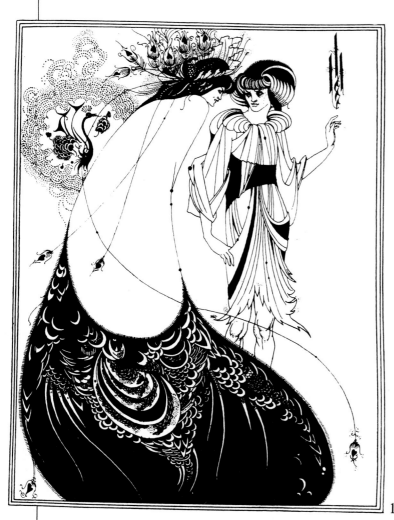

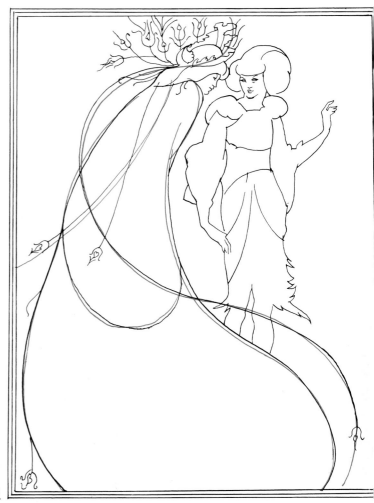

The Inventor of Black and White: Aubrey Beardsley

Aubrey Vincent Beardsley was born in Brighton, England, in 1872 and died in Mentone in 1898. An artist who focused almost exclusively on graphics and drawings, Beardsley employed black-and-white as a personal medium for expressing himself, for relating the brief, burning parable of his life in images that contrast light and dark. He succumbed to tuberculosis at the age of twenty-six. "Whatever he did exhaled the odor of death," notes Jacques Emile Blance in his preface to Beardsley's *Under the Hill*. And he goes on to describe Beardsley's method of working—a fascinating, extraordinary lesson not only in drawing, but also in commitment, dedication, passion, and technique:

"I surprised him bent over a drawing. His work was meticulous and, without corrections, he labored like a monk decorating a page in a missal. Bowed over some Bristol board (a smooth cardboard particularly suitable for drawing in pen and India ink), with his small gold nibs and his aligned scrapers, he labored under the gaze of a crucifix hanging on the wall.

"The sheet of cardboard seemed to stimulate him and the heraldic engraver and medieval imagist contributed their exacting devices to the decadent boy. Beardsley is not a painter but a

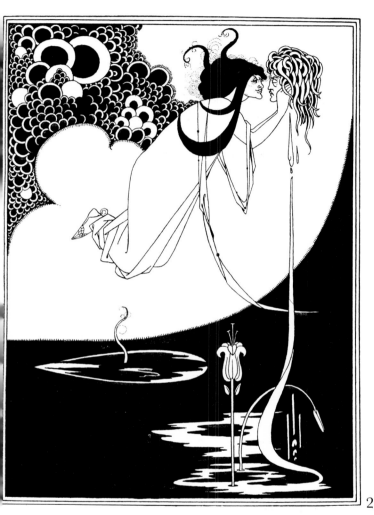

2

master of black and white, and he produces work for the printing press."

Beardsley may be considered the true inventor of black and white—not only as a method of drawing, but as an interpretation of the fashion of the pre-World War I era—its clothes, furnishings, and theater. Oscar Wilde's play *Salomé* was staged by Sarah Bernhardt and designed by Beardsley. It was a flop in New York, but a wild success in Berlin.

Like all artists, Beardsley both interpreted and was conditioned by his time. Yet he also conditioned it, influencing its art and life with his drawings, illustrations, silhouettes, costumes, and hairstyles.

1. Aubrey Beardsley (1872-1898): The Peacock Coat. *Illustration for the second edition of Oscar Wilde's* Salomé, *1895. India ink. Museo Teatrale alla Scala, Milan.*
2. Aubrey Beardsley: The Culminating Moment. *Illustration for Oscar Wilde's* Salomé. *India ink. Giuseppe Sprovieri Collection, Rome.*

In their interplays of curves and contrasting white and black, Beardsley's drawings express the artist's refined, sensual, and tragic world. Beardsley was a singular champion of Symbolism. The first diagram brings out the shape of the peacock's tail of the coat, enriched with the undulating lines of the hair. In the second drawing, in a composition neatly divided in two parts, balanced by the ample curve, we see an interweaving of the intricate lines of the virtually suspended figure and the stream of blood, from which the lines of the flowers emerge.

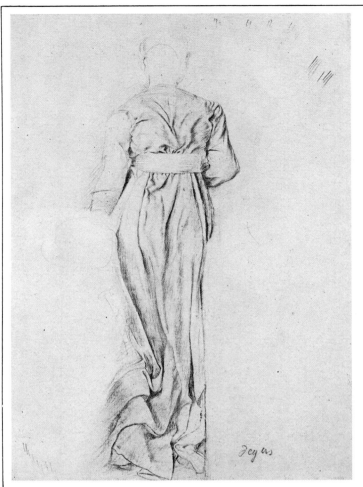

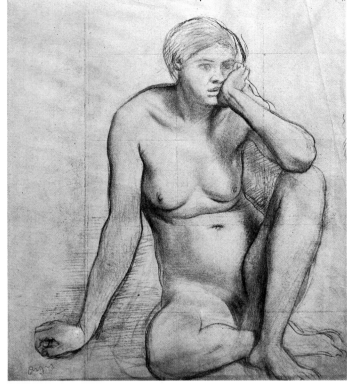

Edgar Degas: Woman Standing, Draped, Seen from Behind. *Graphite on white ruled paper, 206 x 232 mm. Louvre, Cabinet des Dessins, Paris.*

Edgar Degas: Female Nude, Sitting on the Ground. *Black pencil and stump on beige paper, 311 x 276 mm. Louvre, Cabinet des Dessins, Paris (Cliché des Musées Nationaux).*

Black-and-White and Color

Why do so many painters opt for black-and-white or seem to prefer it to color? What moves a painter to express the image of his vision or his idea in the lines, the strokes, and shading of the black and white of a drawing or painting (e.g., a watercolor)? Why does he wish to limit himself to the (admittedly wide) range of a single tone?

Artists are probably drawn to black and white because of its range of immediate and personal depiction, through a medium more open to interpretation than any other. Such an approach is remote from realistic representation—the lack of color alone makes it abstract—hence it is filled with expressive potential.

There are painters—colorists—who are masters of rich palettes of splendid tones. Yet in their studies, sketches, and even final works, they prefer to draw in black and white. They both enjoy themselves and prove themselves by expressing their thoughts and feelings purely with a pencil, in line or, even better, in chiaroscuro.

Seurat was not only a painter but a color theorist, and in the mystery of the shadows of his drawings we can discern the varied tones of color. In the grain of his black and white, we can read the pigments of colored light and shadow.

When we look at Degas's black-and-white drawings, we find the hatchwork of tints made of superimposed lines of different pastels. Degas fixes shape with his pencil. Using colored pastels, he envelops his figures in the splendor of light within frameworks that seem to "block" them, freezing them in their movements at a dressing table or in the wings of a theater. Thus, by using the colors of light and shadow, Degas succeeds in rendering not only space, but also time, arrested in an instant captured by a vision that has much in common with photography and is frequently influenced by it.

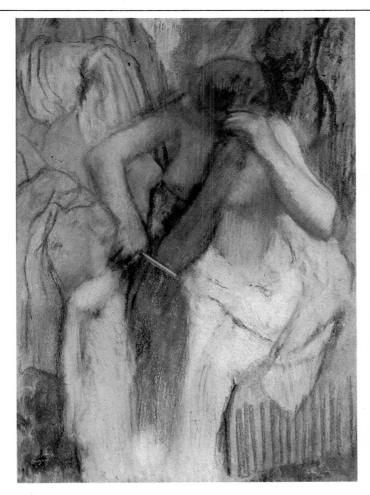

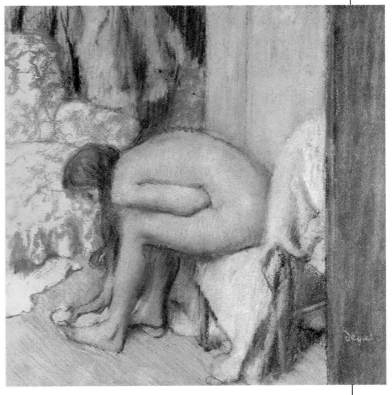

Edgar Degas: Woman Combing Her Hair, *1887–90. Pastel, 820 x 570 mm. Louvre, Paris. (Photo Josse)*

Edgar Degas: After the Bath, Woman Drying Her Feet, *1886. Pastel, 543 x 524 mm. Louvre, Paris*

When we look at Rembrandt's etchings, for example his self-portraits, we see refined passages between light and shadow, darkness made up of velvety blacks, all revealing the rich color sense of the Dutch artist. Few painters have had this sense of color, which lives in light. Rembrandt, who had mastered Titian's lesson, kept making his palette more and more basic. He brought out the colors of the shadows by preparing his paintings on a ground of burnt sienna and by then depicting light and its color rather than by painting colors per se.

It is therefore not surprising that the shadows created by the lines and hatchings on his plates produced the self-portraits that mark out the road of his life, the development of his art, the personal drama, in a kind of gallery of direct testimonies, which are perhaps even more effective than painted self-portraits.

Nevertheless, the question as to whether chia-roscuro in black and white contains color, and when we should draw in black and white and when in color, is still open.

From a strictly technical point of view, the use of black and white obviously excludes color. If a drawing is to render the play of color tones, we have to use a "colored medium" like pastel, chalk pencil, or watercolor. But if the quality of a subject depends on the adjacency and contrast of tones, then we obviously have to use a black-and-white medium.

However, from a theoretical viewpoint, the problem is quite different. Given the possibilities and ramifications of black-and-white drawing, it is hard to say whether the chiaroscuro of a pen or pencil is more suggestive of color than a colored drawing. We have to understand to what extent white can express the colors of light and black the colors of shadow in order to get the maximum effect and meaning from a medium.

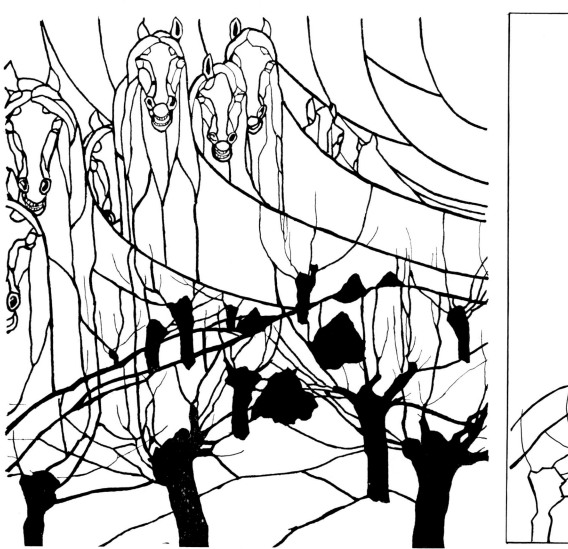

Development of a Drawing

Duilio Cambellotti (1876-1960) was the first Italian designer to work in all areas of design: furniture, windows, illustrations, posters, books for adults or children, monuments, decorations, majolica wares, tapestries, mosaics, medallions, crèche dolls, toys. In the vastness of his experience, Cambellotti always mastered the various techniques in order "to capture a shape within a thought," according

to a style. In his *Autobiographical Notes*, he wrote: "Among artists, I have always been an anomaly. I never went to school, I never had a teacher. I am self-taught.

"I was familiar with materials and instruments at an early age. As a boy I watched people near me working with these instruments and materials. Most frequently, I watched my father, by necessity a quasi-artistic artisan, as he designed ornamental decorations for ceilings, walls, and furniture.

Duilio Cambellotti (1876-1960): Winter Cloud.
Lithograph. Private collection.
 *The diagrams illustrate the method of drawing and bring
out the two themes: the earth and the sky; the snow and the
clouds.*
 *The first diagram emphasizes the lines of the earth, the
outlines of the sheaves and the trees with branches that,
elongated into the sky, seem to become the clouds and the
horses in the clouds.*
 *The second diagram underscores the drawing of the clouds
and the horse images (how often have we enjoyed discovering
fantastic shapes of animals, monsters, castles in the clouds),
which pursue and complete the lines of the branches in a
suggestive synthesis of sky and earth.*

 "Along with other techniques, I also acquired
graphics; not as copies of shapes and lights—as
graphics per se, but put to an immediate use, say,
to capture a form around a thought, whether one
that is elementary or sublime. This practice of
virtually intellectual (i.e. evocative) graphics got
me into the habit of using graphics to capture on
paper not things that were in front of my eyes, but,
rather, things and images that emerged from
within me."

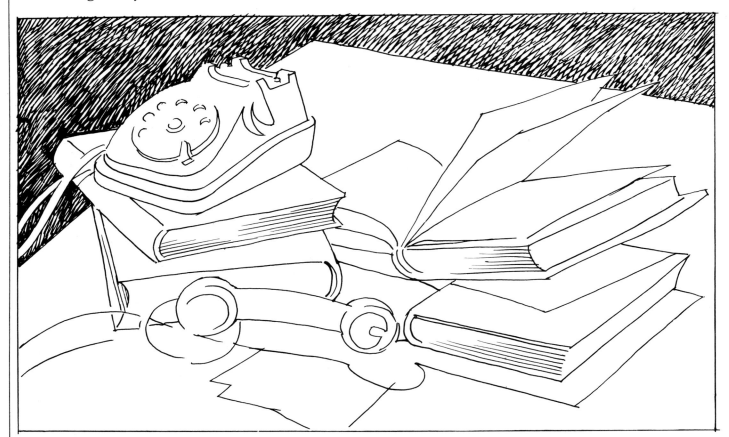

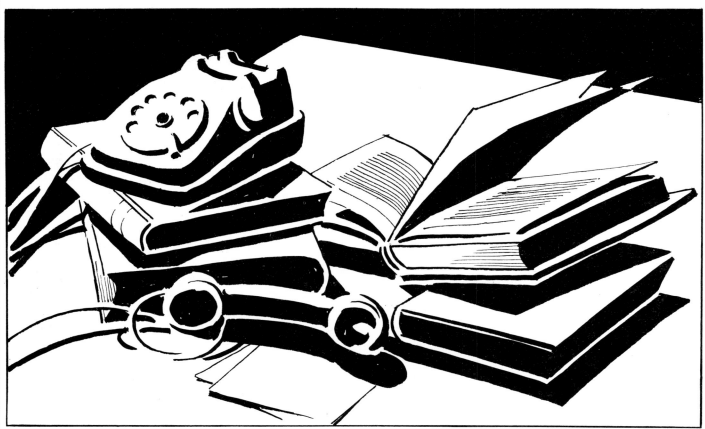

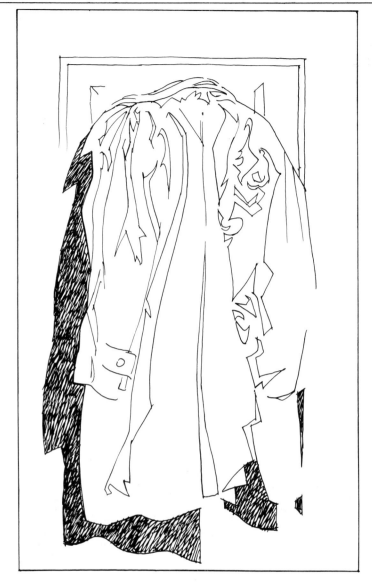

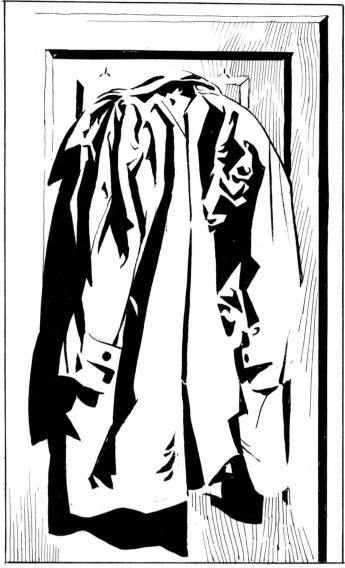

The drawings proposed here deal with two subjects that you can easily find and compose. The first consists of a few books and a telephone. The second is simply a raincoat. The exercise is essentially as follows:

- In drawing the subject and working out the shape of the composition, arrange everything so that some parts are in light and some in shadow, all defined as sharply as possible.
- Define and draw the shaded areas, ignoring the chiaroscuro and the reflected parts.
- Fill in the shaded areas with black, trying to balance them with the illuminated areas.
- Bring out the shapes of the objects, not by using outlines, but rather by emphasizing the contrast between the whites and the blacks, working toward a synthesis or balance of both.

In the first drawing, the books are placed in a corner of the table, which is defined by a plane of light; on it, we see the black spaces of the shadow areas and the telephone. The synthesis of the white and the black must be sought in the vision itself. Either half close your eyes or use your mind to eliminate the halftones, transparent areas, and reflections.

In the second drawing, the shapes of the hard-edged shadows surrounding the illuminated subject bring out only the main shadows, the strongest and most important ones. Ignore the grays and the details. In this drawing, as in the preceding one, the shade and the cast shadow melt together into a synthetic effect that both conceals and suggests, enhancing the viewer's pleasure in reading and interpreting the drawing.

The Choice of Light

The choice of light is important in a drawing: I mean the direction of the light source, the quality of the light, and above all, the illumination of the foreground with respect to the background in shadow, or vice versa. But, you don't always have to seek a contrast between light and shadow. Sometimes, it is better to have the same light illuminating both the subject and the background, both the foreground and the middleground, or else to have the same light enveloping the entire scene.

Normally, however, the artist seeks a contrast or at least a difference in illumination, in order to bring out the subject and make us participate in the space. The ability to create sculptural effects, based on the choice of light, reaffirms the impor-

tance of the light, for it is the interplay of illuminated and shadowy planes that creates the illusion of space and depth.

From a practical viewpoint, it is better to first use a design that brings out the contrast or at least shows the difference in light between planes. However, this should not make us forget that usually it is not the obvious appearance of the subject or its plastic values that claim the artist's attention or forces him to examine a subject in order to draw it. Rather, he is attracted to a subject by the design or composition—by the chiaroscuro of a discrete penumbra that envelops the whole, or by the splendor of a light that illuminates everything. So it is actually the impalpable substance of the light which gives life to the lines and the overall drawing.

1

2

1. Rembrandt: Study for *The Large Jewish Wife, c. 1635. Pen, India ink, and brown wash, 241 x 193 mm. Nationalmuseum, Stockholm.*

2. Rembrandt: The Large Jewish Wife, *1635. Etching, second proof. Musée du Petit Palais, Dutuit Collection, Paris.*

The preparatory drawing and the etching illustrate the importance of choosing light in an image. In the sketch, the luminosity is indicated not only by large shadowy areas corresponding to the

sepia brush strokes (repeated in the hatchwork of swift pen strokes), but, above all, by the differences in tone between the line delineating the face and the hair, and the line used to draw the rest of the picture. The idea of using the diffused light from the window in contrast with the splendid light projected on the figures is already apparent in the drawing. In the etching, the relationships are partly modified. Rembrandt engraves only the top part of the plate, sharply concentrating our attention on the woman's face, while indicating the gray tones of the background, leaving it up to our imagination to "draw" the rest.

Depth and Atmosphere

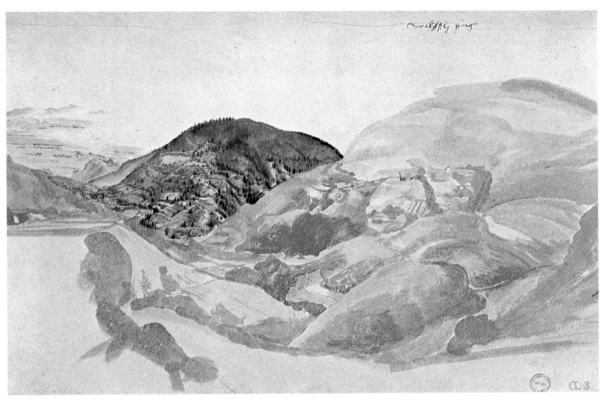

Albrecht Dürer: Alpine Landscape in South Tirol, *c. 1495. Watercolor and gouache. 210 x 312 mm.*
Ashmolean Museum, Oxford.

This is one of the watercolors in which Dürer makes utmost use of the tones of azure for rendering depth and atmosphere, filtering his rich palette through a blue veil. However, there is another element that claims our attention: the hill on the right. Although in the foreground, the hill is treated with wide brushstrokes, it is almost dim. Dürer did this to focus attention on the background hill on the left, with its details—its houses and fir trees—making the entire hill stand out against the bright sky. Nevertheless, the view does not lose its aerial perspective, which confirms the fact that an artist's freedom can go way beyond the rules.

In order to depict a figure, we need only lines—just drawing the height and width of the image on the flat surface of the paper. However, if we want to render depth, then we have to use an expressive line or, even better, chiaroscuro. We also have to use certain media—charcoal, wash, watercolor—to obtain "the concept and formation of natural things," as Leonardo da Vinci wrote it, "the visual and tactile effect of relief."

The diversity of gray tones, the various shadings from white to black do not only help to depict the volume and roundness of an object or figure, they also break through the surface of the material in order to create depth. A drawing never comes as close to a painting as when the artist achieves painterly effects with tones produced by charcoal or pencil.

The fascination of such an approach is obvious. It is wonderful to create the space of a "linear perspective" with lines and planes converging in the respective vanishing points. And it is even more wonderful to "deepen" an aerial perspective

simply by aligning and distributing light and dark as well as grays in black-and-white drawing, and bluish and hazy tones in a colored drawing.

What is the secret of such perspective? The artist has to suggest air, suggest the presence of the atmosphere, treating more distant objects with filtered tones that make them blue, concealing and dissolving the details.

An exercise and demonstration of skill that has interested artists throughout history, first instinctively and then theoretically (especially after Leonardo da Vinci's studies), revolves around the

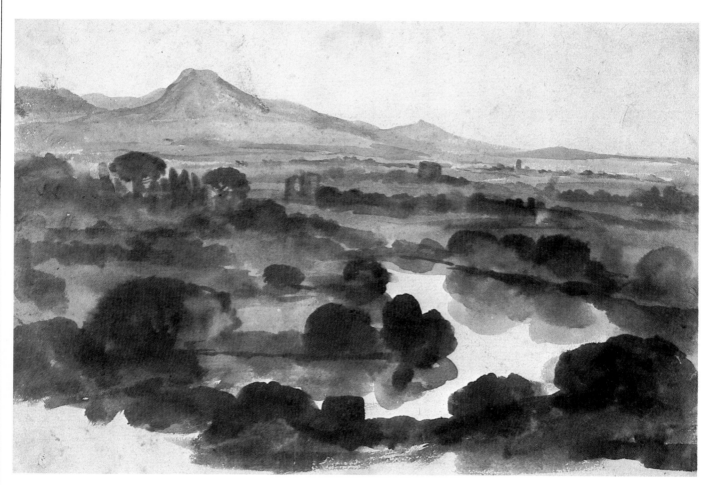

Claude Lorrain: View of a Lake Near Rome, *c. 1640. Bistre watercolor, 185 x 268 mm. British Museum, London.*

Lorrain's watercolor suggests the luminosity of the air and the depth of the landscape purely through the sepia color, which he has applied to the paper with rapid brushstrokes. Through the softness of these strokes, the artist has rendered the volume of the tree foliage and through the transparency of the watercolor he has rendered the reflections of the river.

The diagram emphasizes the foreground of the trees, the horizontal surface of the landscape (with the wide loop of the river brought out by the diagonal), and the profile of the hills in the background.

problem of rendering depth. This problem was felt, above all, by landscape painters and was developed by the English artists who wanted to depict vast meadows, the skyline of the hills, and the depth of skies animated by clouds. These elements of spatial depiction have recurred century after century, from artist to artist, often reducing the elements of a scene to their essentials. Ultimately, artists learned to rely solely on stage perspective—the horizontal plane—rendered with a few elements and suggesting the immensity of the sky purely with the white paper.

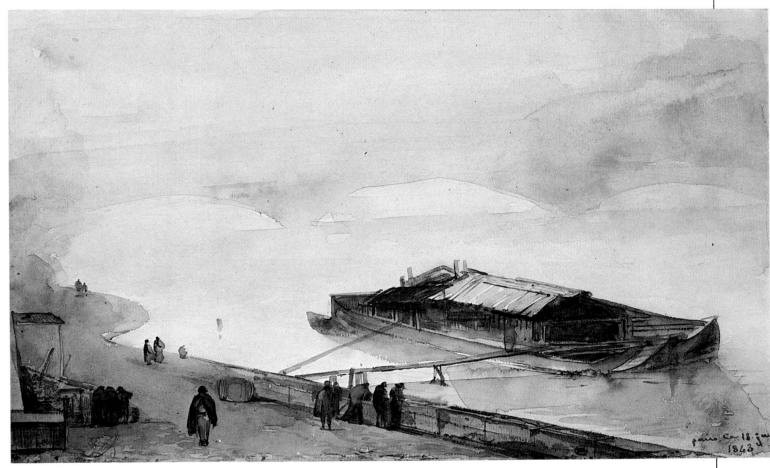

François-Marius Granet: Lungosenna in the Fog, *1843.*
Watercolor on graphite lines, 180 x 295 mm. Louvre,
Cabinet des Dessins, Paris.

Granet's landscape offers a particularly imaginative framework, especially in the fog tones, which, in the transparency of the watercolor melt the blue of the river into the blue of the sky. The artist shows only the bank of the river, with a few figures and the volume of the barge moored at the bank. However, the real "protagonist" is the bridge with its three arches barely indicated by brushstrokes against the background tone, rendered in large spots without corrections. The effect of depth and transparency here is extraordinary.

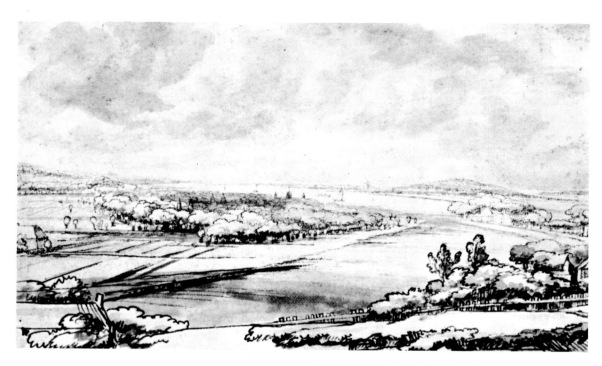

Linear and Aerial Perspective

If I wish to depict an object, I select a plane as a "frame" (remember Leonardo da Vinci's "window" and Leon Battista Alberti's "veil"?). Next I fix the viewpoint. The projection of the object from the viewpoint on to the framework constitutes the *perspective*.

Usually, the frame of perspective can be any plane. But it can also be a surface formed by several parallel planes as in set designs, or a curved surface such as a cylinder, sphere, dome, or vault.

If you render only the geometric construction of the scene to be reproduced in perspective, with or without shade or cast shadows, you have *linear perspective*. The perspective of an object or scene varies according to the viewpoint selected. The height of the viewpoint is fundamental to the point of view. The normal height is on a level with a man's eyes, roughly five-and-one-half feet above the ground. A bird's-eye view, on the other hand, allows an overall vista from above.

A *bird's-eye perspective* presumes that the spec-

Philips de Koninck (1619-1688): River Landscape, *c. 1650-53. Pen, brown wash, and India ink, 194 x 310 mm. Institut Néérlandais, Custodial Foundation, Paris.*

In Koninck's drawing, the horizon divides the space in half. Above the horizon, the sky opens outward; while below it, the river curves in a wide loop. The view encompasses the foreground of the riverbank, with the trees and constructions at the right. It moves outward to the perspective of the fields and the forest at the center of the scene, then runs along the course of the river and into the skyline in the background.

The various elements are fused in a perfect geometric balance along the angles of the "directions" and the gray tones that vary in intensity are also well-balanced.

Vincent van Gogh: La Crau, View of Montmajour, *1888. Reed pen and fine pen, India ink, and black pencil, 490 x 620 mm. National Vincent van Gogh Museum, Amsterdam.*

Van Gogh's landscape is exemplary for many reasons, including the perfect perspective construction from a bird's-eye view: The high horizon reveals the vista of the fields that, with their perfect geometry, help to evoke depth (almost like the perspective drawing of a Renaissance floor). Van Gogh's knowledgeable distribution of tones, done by using different elements (dots, strokes, shading) of pen strokes, succeeds in rendering the character of the various subjects and an overall sense of depth.

tator's eye is situated far above the object or scene depicted, so that it can be observed as a whole. The perspective of a city with its streets, its monuments, and its buildings is all done from a bird's-eye view.

On the other hand, *aerial perspective* is based on the fact that the colors of objects vary in intensity and grade in value according to their distance from the eye. This effect is caused by the density of the air, the depth of the atmospheric stratum, and the position of an object with respect to the light source. Applied aerial perspective is the art of combining the color gradations on a surface in such a way that an object is depicted in its apparent tones.

To understand the effect of atmosphere on eyesight, we have to experience the "construction" of air thickness in theatrical or cinematic sets. For example, an atmospheric layer of "thick air" (as da Vinci calls it) was created by the Italian filmmaker Luchino Visconti in order to suggest distance and depth. For his movie *White Nights,* Visconti had to create the illusion of utmost depth within the space of a movie studio. The director put up large curtains of transparent gauze. This was virtually a materialization of the atmosphere, making distant objects look blue and hazy. In this way, the appearance of more distant houses along the river were "fogged" by a filter. By simulating the thickness of the atmosphere, which is always heavier near a river, this filter made the houses seem further away.

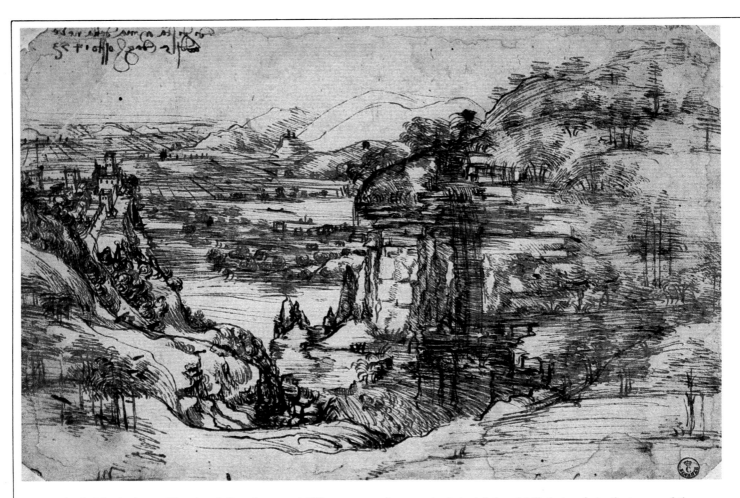

Leonardo da Vinci: Arno Riverbank Landscape, *1473.*
Pen and ink on metal-point lines, redone in darker ink, 195
x 281 mm. Uffizi, Florence.

Da Vinci's landscapes offer a complete lesson in seeing and
depicting space. In this drawing, in addition to the

framework of the left-hand hill that ends in the towers of the
boundary wall and the foreground of the right-hand rocks, we
see something highly significant—the free, masterly use of the
pen. The lines, orderly arranged within the vista of the
background fields, become more and more free in depicting
the trees and the flow of curves at the center of the scene.

Leonardo da Vinci's Aerial Perspective

Once you start drawing, you cannot sidestep the
problem of aerial perspective. On the other hand,
you will be fascinated by the possibility of breaking
through the pictorial plane solely with the tones of
black and white or color. Hence, it is natural for
anyone who writes and theorizes about drawing to
deal with this problem and to suggest methods
and approaches.

Thus, in his treatise, Cennino Cennini advises
us to "make distant mountains" with dark tones
and nearby mountains with light tones. And Leon
Battista Alberti concludes his lengthy dissertation
on rendering depth: "The greater the distance,
the hazier the viewed surface." Leonardo da Vinci
was the theorist par excellence on aerial perspec-
tive, and in his *Treatise on Painting* he devotes
several chapters to the problem of rendering

depth. The sense of depth, he says, is caused by
"thick air" between the viewer and distant objects.
There is, however, a more important factor: light.
The tones of distant mountains vary according to
the distance and hence according to the at-
mosphere that envelops them and that lies be-
tween the viewer and the mountains. However, the
tones also vary with the light—daylight or twi-
light—which makes the atmosphere more or less
dark, and therefore makes the mountains more or
less dark.

In his introduction, da Vinci immediately de-
fines perspective, which he divides into three
types: (1) the "lineaments of body," i.e., linear
perspective; (2) the "diminution of bodies"; and
(3) the loss of the "cognition of bodies." Together,
all three types make up aerial perspective. And we
can instantly perceive the features of a similar
perspective: the variation of color tones (lighter

and bluer) and the fusion of details of distant objects, in a more synthetic vision.

The human eye is the organ that can capture all this, and the hand, guided by the mind, can depict it. In fact, says da Vinci, the human eye has ten "jobs," ten important tasks and possibilities: it differentiates the subjects we observe— "shadow, light, body, color, figure, site, distance, nearness, motion, and motionlessness." And our hands depict and interpret all these things through our draftsmanship and, above all, perspective. Perspective is the new science, one that is still being defined, one that offers the artist the most important tool—to render the third dimension.

Basically, Leonardo da Vinci seems to prefer aerial to linear perspective. Linear perspective offers the possibility of using the rules of geometry (central projection) to depict an object or scene in its depth and volume. However, this is an objective scientific system, it can be used by anyone, and it is therefore impersonal. On the other hand, aerial perspective, no matter how much it is theorized about, is ultimately not reducible to geometric rules. It is not an objective method, but one that is linked to an individual's personality. It is truly a "filter" between us and reality, which is perhaps why da Vinci preferred it.

The study of nature direct, experience, the dawn seen day after day, the attentive and passionate observations by a scientist who cannot forget that he is an artist, and the persistence of an artist who seeks a "reason" behind his intuitions and feelings—all this helped to enrich da Vinci's work. In regard to the manner of depicting remote things in a painting, da Vinci's experiences suggested that distant objects are not only those seen before us, but also those that are above us. And the air above is thinner so that "you, painter, when you do a mountain, always make the heights lighter than the lower parts from hill to hill."

When reading these words, we cannot help thinking of the transitions in da Vinci's art, a problem that acquires a meaning of its own in his interpretations, an autonomous significance that goes beyond the depiction of nature. Just think of the backgrounds in *The Virgin of the Rocks* and the *Mona Lisa*. In the *Mona Lisa*, for instance, the horizon is staggered, at the left and the right; that is, it is a bit higher on one side. This seems to create a mysterious vibration of life that is concealed in the shadow of the woman's eyes and smile, as she is enveloped in the fog and atmosphere.

Leonardo da Vinci: Tempest over an Alpine Valley, *c. 1506. Sanguine crayon, 220 x 150 mm. Windsor Castle, Royal Library, England. In this drawing, the main subject is the tempest in the sky: the landscape is drawn with the hills in the foreground, the clumps of trees, and the houses, with a scant shading. In the background, the mountains are charged with the shadow of the clouds that slice across the scene. And beyond, we see the light-colored peaks of the mountains. Altogether an extraordinary interplay of planes, light, shadows, and depth, organized in four groups and centering on the tempest that brews over the valley.*

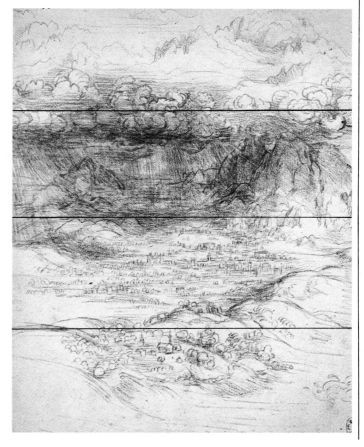

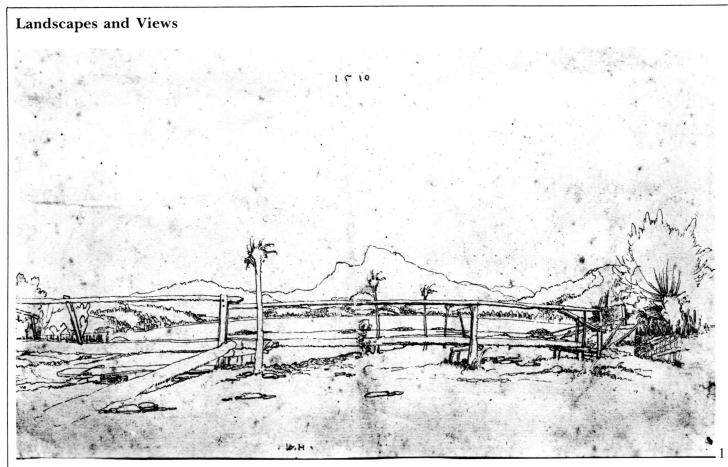

1

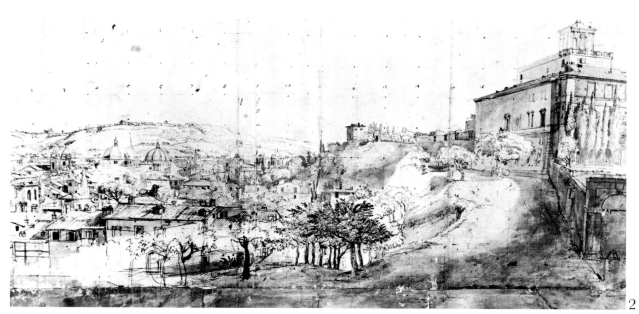

2

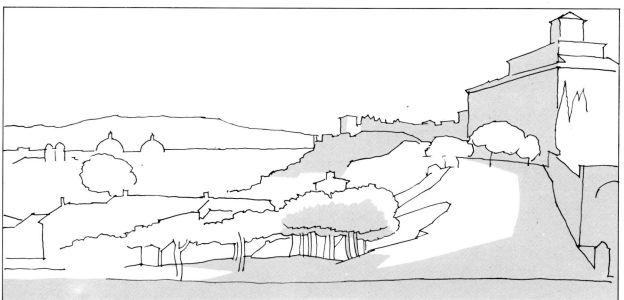

1. *Wolf Huber (c. 1480/1490-1553):* Landscape with
Pruned Trees. *Brown ink, 127 x 206 mm. Germanisches
Nationalmuseum, Nuremburg.*

*Huber's drawing is a significant example of the possibility of
breaking through the surface of the paper with an almost
insignificant subject: a hurdle, five pruned trees, and the
profile of a mountain against the background of the sky. And
yet Huber manages to render depth and atmosphere. The
secret obviously lies in the composition: the skill with which
the various elements are arranged, seen, and depicted; the
essentiality of the means; the correctness of the perspective
construction; and the accuracy of the tonal variations. The
space of the sky occupies more than half the sheet, making the
image very airy. The hurdle is seen and drawn parallel to the
frame, that is, frontally, to form a kind of backdrop, with the
ground plane stretching out on both sides of it.*

2. *Gaspar van Wittel (Gaspare Vanvitelli, 1653/55-1736):*
View of Rome with the Villa Medici and Mount Mario.
*Charcoal, pen and ink, watercolor, 490 x 920 mm. Museo
Nazionale di San Martino, Naples.*

*This drawing takes up the classical themes of the view: the
encompassing of a vast angle of the horizon; the position of
the horizon halfway down the paper or lower, to suggest the
amplitude and airiness of space; the framework composed in
terms of a backdrop, in this case the right-hand complex of the
Villa Medici, which opens up to the left side of the landscape;
the interest in synthesizing architectural details into the
landscape by means of a careful distribution of lines and
tones; and finally, the technique, which is limited to lines for
the more distant profiles, and which is enriched by spots in the
foreground and the backdrop.*

1

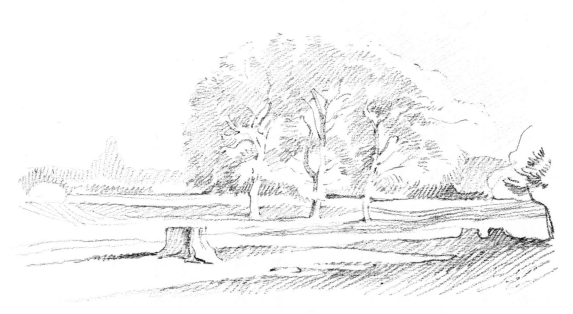

2

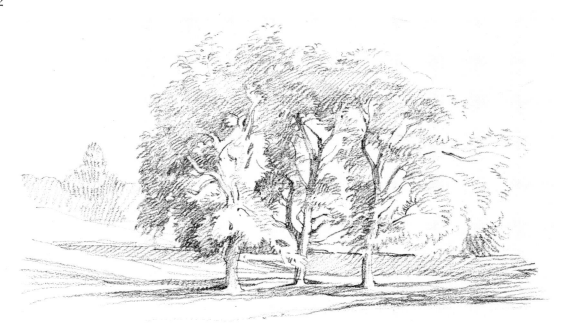

1. These illustrated examples show four successive stages in the quest for depth. In the first sketch, the little girl is drawing a dome (Saint Peter's basilica). In the second sketch, the subject is seen at a shorter distance, but still far enough to be vague in the details and affected by the filter of the atmosphere. In the third sketch, there are three planes in the depth, indicated by the outlines of the domes. Finally, in the fourth sketch, only the profile of the dome of Saint Peter's fills out the space of the sky. The sketches were done with a pen nib and tonal variations were obtained through repeated lines, superimpositions, shading, and hatchwork.

2. The two drawings were done from different viewpoints looking in the same direction. In the first drawing, the more distant viewpoint, the artist tried to render the depth of the scene, synthesizing the mass of the tree crowns with a uniform gray tone. In the second drawing, the closer viewpoint, the artist investigates the shapes and the tonal variations more closely, in order to maintain the overall atmospheric effect and also to bring out the trunks and foliage more precisely. The two drawings were both done with the same soft pencil on grainy paper. The tonal variations were obtained solely by varying the pressure on the pencil and with a more or less dense shading and hatchwork.

The Blue of the Air

Why do mountains and distant objects look blue? Because the atmosphere transforms their colors, filtering them, and turning them blue more or less according to the light and the transparency of the air. Therefore, if you want to make the viewer feel the depth of a background, and if you want to depict remote objects, you have to make your colors "blue," and you have to express the feeling of atmosphere and distance in this blue.

Thus, in writing about nature, Cézanne says that in order to make the viewer feel the air, the artist has to introduce a sufficient amount of blue into the vibrations of light, the reds and yellows. (Cézanne's watercolors testify eloquently to this approach.)

Actually, many painters have felt the synthesis, transparency, and reflections of the atmosphere, and have tried to render them with blue tones.

For this reason, take the following approach when drawing a landscape: Choose a simple subject, for instance a countryside with the profile of a hill against the background. Depict this profile with the blue of the air (seeing it "blue" with your mind even before you see it with your eyes). Next, do the following exercises purely with color:

- On watercolor paper, draw five or six rectangles and divide each into four equal parts along the axes.
- Take a brush and put four spots of color—red, yellow, green, brown, or any color you prefer—in each of the four parts of each rectangle.
- After the colors have dried, take a very wet brush and paint a very thin wash of blue over the second, third, and fourth spot of each color.
- When the blue is dry, repeat with a further coat of blue over the third and fourth spot.
- Finally, after this second coat has dried, put a third coat of blue on the fourth spot.

You now have three different tones of each color, with different amounts of blue. In the red rectangle, you will have pure red, then red with just a little blue (one coat), a violet red (two coats), and a purple-bluish red (three coats), and so on for each color. You can modify the color tones, just as they are modified to the eye when observing atmospheric depth, by adding blue—the color of air—to your other colors.

Volume

Chiaroscuro (the amount of light and shade in one or several colors) emerges from a more or less gradual passage from light to shade on the surface of a drawing or a painting—or even sculpture or architecture. In a drawing or painting, the chiaroscuro effect is part of the overall structure of the work. It is an integral component of a colored or black-and-white drawing in its variations of light. In sculpture and architecture, on the other hand, the chiaroscuro is determined by outside factors, by the number of luminous sections on the forms and the reliefs.

Painters use chiaroscuro in their work in order to render volume, the third dimension, or rather, to depict the illusion of three-dimensions. For now, however, we will limit ourselves to chiaroscuro in black-and-white drawings containing variations of gray tones from the white of the paper to the black of the deepest shade and to chiaroscuro in colored drawings done with chalk pencils or watercolors, with transparent shadow tones enlivened by color.

In the various methods of drawing, chiaroscuro is an essential operation, particularly in the two basic and perhaps most fascinating aspects of depiction, the rendering of *depth* and volume.

It is hard to depict the third dimension solely with an outline, to break through the surface

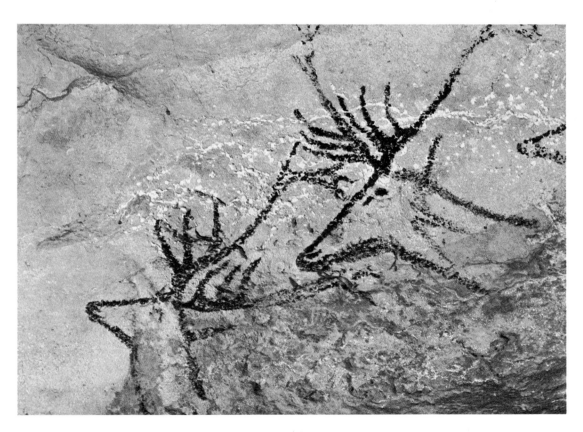

Cave painting from Lascaux.

Ancient hunters painted the profiles of animals on cave walls in order to bring good luck in the hunt. Depicting them was a way of possessing them. In order to make the image more true to life, they drew it on protruberances in the rock, which contributed to the sense of volume.

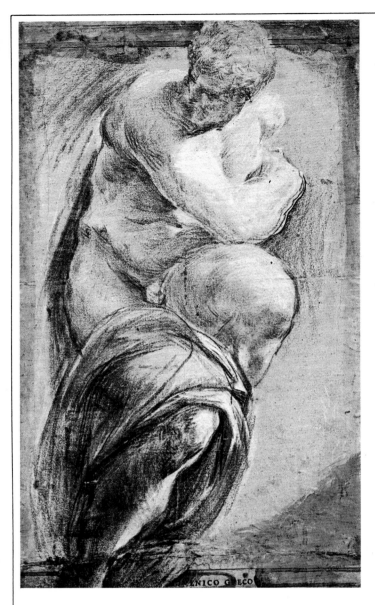

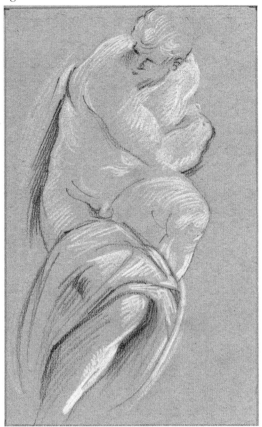

The model is one of Michelangelo's statues in the Medici Tombs. Above all, it is the volumetric interest, the depiction of fullness that strikes us, with its extreme sparseness of technical means: just black pencil and white lead on colored paper. The light, the volume, the weight of the statue are rendered with rare efficacy in the composition of the drawing; in the touches of black pencil, which emphasize the shadows; and in the strokes of white lead, which emphasize the details in the light, heightening the mass. The diagram emphasizes the synthesis of light.

El Greco (1541-1641): Day. Black pencil and touches of white lead on blue-tinted paper, 595 x 345 mm. Staatliche Graphische Sammlung, Munich.

plane or move around the figures and objects drawn. However, should we succeed in expressing a third dimension, then the outline is no longer merely a profile of what we want to depict; but, in its expressive line, the outline then begins to suggest the quality of light and hence depth and volume. But line is rarely used for such a function. Instead, in order to express depth and volume, we usually resort to tones of chiaroscuro, which instantly fascinates anyone who draws.

At the dawn of civilization, in the very first artistic renderings, the interest in volume predominates. We need only recall that in the earliest cave drawings of animals on walls, the outlines are drawn with respect to the bumps and reliefs on the rocks, so that the volume of a figure is rendered physically as well as linearly. Even when artists rendered volume on a completely smooth surface, they used the illusion of chiaroscuro to recreate the play of light and shadow, which brought them closer to objective reality than a simple outline.

Soon, artists began to deal with the problem of expressing two separate viewpoints, according to the artist's personality and goal. Some artists, looking at the illuminated subject, wrapped it in shadow, thereby constructing the chiaroscuro. Leonardo da Vinci, for instance, immersed his figures in a dense, shadowy atmospheres that gave life to his work. But other artists saw their subject matter as existing primarily in shadows and used light to expose it, saving their details for the illuminated parts and bringing the forms out of

In accordance with the Cubist view, Léger breaks the figure into geometric spatial shapes, suggesting not only volume, but also the dynamics, rhythm, and anxiety of the industrial era. The viewer has the job of reconstructing the volumes in order to recompose "his" image with lines, planes, and geometric masses into something that has verisimilitude. The diagram brings out the central volume of an "abstract" portrait that is more than Cubist.

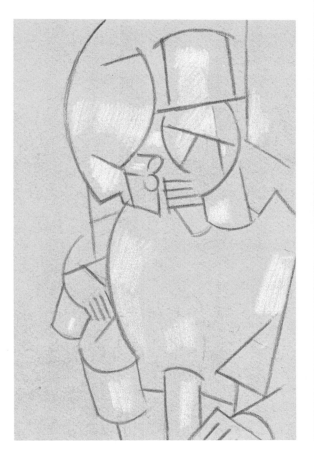

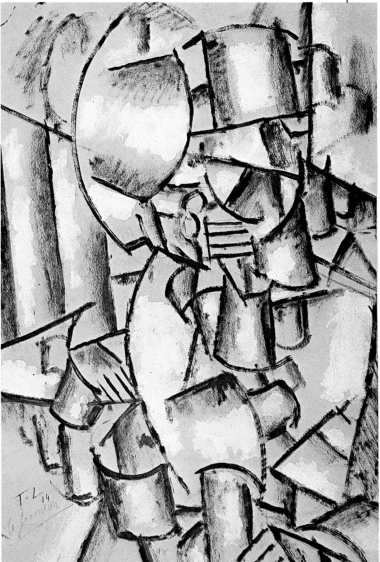

Fernand Légar (1881-1955): The Smoker, *1914. Charcoal, ink, white gouache, 620 x 400 mm. Private collection.*

the depth by means of light. Caravaggio, for example, illuminated his figures with light rays that gave them life. Coming from outside sources, these rays acted virtually like spotlights shining into the darkness of night. Thus the depiction of volume is based essentially on two elements: the shade of an object and its cast shadow.

- Drawing an object's shaded side, noting the shape of the shade, and then filling it in with shading, hatchwork, sfumato, or spots tends to give body to the image, bringing out its fullness and suggesting the unseen sides of the object.
- Drawing a cast shadow, on the other hand, aims at detaching the subject from the surface, confirming its existence in space and its location on a horizontal plane that extends forward or backward from the surface of the paper.

In order to render volume, you can use the general methods of chiaroscuro. Here are some ways to do this:

- You can put the illuminated part of the subject in relief against the background tone, and even deepen it with respect to the illuminated profile.
- You can increase the sense of depth and volume when you put tones in relief by stressing the transparency on the surface of the subject.
- You can emphasize the reflected lights within the cast shadow by making it darker on the edges and lighter in the areas closest to the subject. In this way, you can detach the subject even more from the surface it is on.

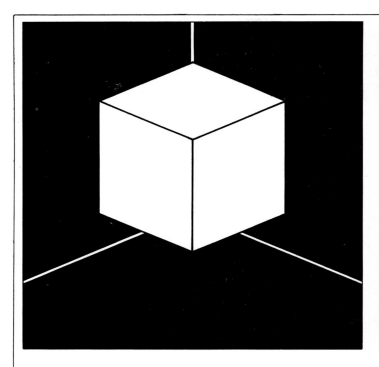

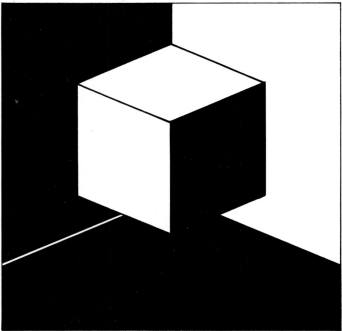

If the visible faces of the cube are all illuminated with the same intensity, the cube tends to lose relief.

If the light source is situated asymmetrically, and two surfaces of the cube have an equal light intensity, while the third surface has a different light intensity, you will still perceive the solid as having volume.

The Dimension of Light

The existence of light is the indispensable condition for visually perceiving the reality that surrounds us. We see matter wherever there is light, and light wherever there is matter. Take the fine dust in the atmosphere. Light penetrates the environment and makes visible minute particles of dust which, when illuminated, seem to create a beam of light. This phenomenon is due to the coexistence of matter and light.

We cannot ignore the role of light in the definition of objects as elements and even as a dimension of the objects themselves. Nor can we overlook the importance of light when we depict objects in colors or in black and white.

In his *Treatise on Beauty,* the British painter William Hogarth writes: "Light contributes no less than converging lines to show how much objects or parts of them withdraw or move away from the eye." Without light, a horizontal plane, for instance a floor, might even appear vertical, as straight as a wall. We use many reference points in order to recognize the distance of objects from our eyes. Nevertheless, we are often deceived by optical illusions or by a lack of shadow. Ultimately, if light falls upon objects from a different angle than what we are accustomed to seeing, creating shadows that are different from what we are used to, not only is our sense of space confused, but, as Hogarth notes, it may happen that "round things appear flat, and flat ones round."

To understand the dimension of light, we can perform a very interesting experiment with a cube that is illuminated in various ways:

• Imagine a white cube. Place it symmetrically inside a larger, black cube; i.e., with the sides of

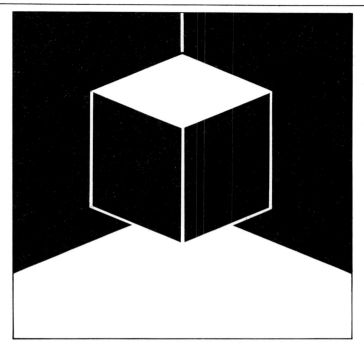

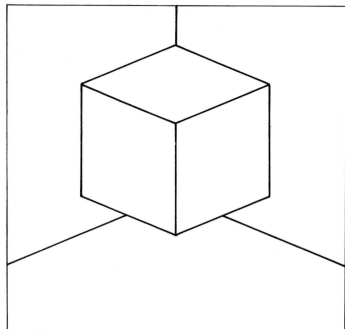

If the light source illuminates only one face of the cube, you will perceive the cube as a flat surface and not as a solid.

If the visible surfaces of the smaller cube and the larger cube are illuminated with the same intensity throughout, you will not perceive any solid at all.

the smaller cube parallel to the sides of the larger cube. Then focus six light sources of equal intensity symmetrically on the axes of the concentric solids. The surfaces of the white cube, absorbing the same amount of light, will all be of the same luminosity. And because contrasts between the different surfaces have been eliminated, the cube will look flat. Our eyes have been deceived and only our experiences with volume and our geometric knowledge will help us to know that we are perceiving a solid.

• Now repeat the experiment, but this time place a single source of light asymmetrically within the black cube. The surfaces of the white cube will now have different light intensities, and the resulting contrasts now accentuate the relief and give the illusion of volume to the solid form. If

only one face of the cube were to be illuminated, though, we would perceive it as a single flat surface again.

• This time, imagine that the surfaces of both cubes are of the same material and color. If we illuminate the surfaces of both solids with an equal intensity of light, we will be unable to distinguish the smaller cube from the larger one. This is because a solid cannot be perceived if there are no light contrasts.

After performing these experiments, we may conclude that the three dimensions that define space (height, width, and depth) are less important than the phenomenon of light, and that the perception of reality can change under various and illusory aspects and even be annulled by means of light.

Sfumato

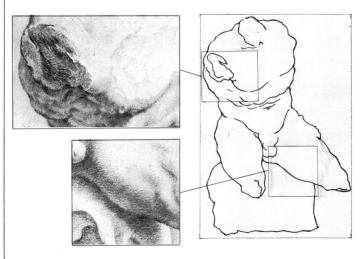

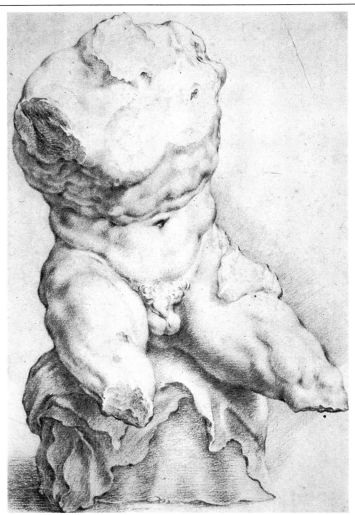

Hendrick Goltzius (1558-1617): Copy of
The Belvedere Torso. *Red pencil, 255 x 166 mm.*
Teylers Museum, Haarlem.
In the Goltzius drawing, the chiaroscuro technique is articulated
in the shading, which is obtained with adjacent and crosshatched
pencil strokes. The artist was attentive to the reflections and to
even the slightest tonal variation (as shown with great precision in
the details).

The Italian word *sfumato* refers to the methods and effects of the delicate and imperceptible gradation of values in a black-and-white drawing or in the colors of a painting. It also refers to the imperceptible change of colors and tones in the relationship between light and shadow.

Even if the concept is the same, there is an obvious difference between the concrete manifestations of sfumato in various drawn or painted artistic works. However, it is interesting to note that the problem of sfumato was discussed in the very first writings on artistic technique. In his *Book on Art,* Cennino Cennini advises "darkening the tinted parchment!" He then specifies: "Go with your pen, shading the movements of the major folds; and then add *sfumato* when darkening the folds." This is particularly interesting because although six centuries have gone by, the problems of sfumato are still the same, and even the approaches to it have not changed.

In the late nineteenth century, John Ruskin, in his marvelous book *Elements of Drawing and Paint-* *ing,* advised practicing sfumato as one of the first exercises in learning how to draw:

"For some time, you will not be able to draw an object in which the tonal gradations are varied and complicated; nor would it be a bad sign of your progress and your artistic goals if the first thing you wished to draw were a small stretch of sky."

Place yourself next to a window and then draw a portion of the evening sky through the branches of a tree, beyond the backdrop of antennas and houses. Use sfumato in the tones.

Naturally, it is hard to capture the gradations of the colors in the sky on a sheet of paper with the limited hues of pastel or watercolor, or with the black and white of a pencil or pen. However, Ruskin points out that one result is certain in any case: "The sense of the beauty that you demonstrate that you have mastered will be a fine gain."

Leaving color aside for now, let us try to draw the sfumato of the sky cut out by a windowframe (and hence in the more or less perspective rec-

"In his colorings, the extremely graceful Raphael outdid all earlier painters, both in oils and in frescoes, and even more in frescoes, as I have heard from many people, and I can tell you that in his murals Raphael advanced the coloring of many fine masters in oil by using sfumato and uniting the color with beautiful relief and with everything that art can do." (Ludovico Dolce: *Dialogue of Painting*, 1557)

In Raphael's paintings, the Italian writer Ludovico Dolce (1508-1568) seemed to find the confirmation of Leonardo's precept that Raphael was the father and indisputable champion of sfumato: "Make sure that your shadows and light are united without strokes or lines with the use of "smoke" [i.e., haziness]. And when you have devoted your hand and your mind to this exercise, you will master this practice sooner than you realize."

Renzo Vespignani: Multiplications, *1970.*

In his self-portrait, Renzo Vespignani achieves a particular volumetric effect, a three-dimensional rendering, by using the fourth dimension, time. He aligns and superimposes the depictions of his face, seen from different viewpoints. The mixed media sfumato colors contribute greatly to the effect of fullness.

tangle of our rendering of the window on our paper). Using a pencil or pen, draw a series of lines as fine as you can in the section of the light. Or draw the gradation of light by gradually making the lines further and further apart. Or, without worrying about whether they are long or narrow, let the lines crisscross freely and focus only on gradating them to get the effect you want.

There is also an exercise within this exercise: to use an eraser (a soft eraser or a kneaded eraser) to achieve better shading.

After using a pencil (or several pencils of different hardnesses) to draw the chiaroscuro tones, from the darkest to the lightest (not only in the sky but within the room, in the objects closest to the window), you will see that by using the eraser you can achieve better results in fusing tonalities and in creating particular light effects:

- Retouch the chiaroscuro with an eraser (sharpened with a penknife or if using a kneaded eraser, made soft and sharp between your fingertips). In this way, you can obtain a better, continuous gradation of tones from the darkest to the lightest parts.

- Lighten and mellow the chiaroscuro, the lines, and the shading wherever you wish to obtain reflections and luminosity.

Is this exercise too academic? Is it based on past rather than present-day experiences and demands? I don't think so. First of all, it is only by mastering a technique that you can use it freely and spontaneously, focusing purely on *what* you are doing, not on *how* you are doing it. Then, too, you can be knowledgeable only about something that you know. Finally, during the past few years there has been a renewal of interest in the depiction of reality; such art, by means of a refined technical knowledge, interprets reality in order to transform it into a new reality.

The Quest for Volume

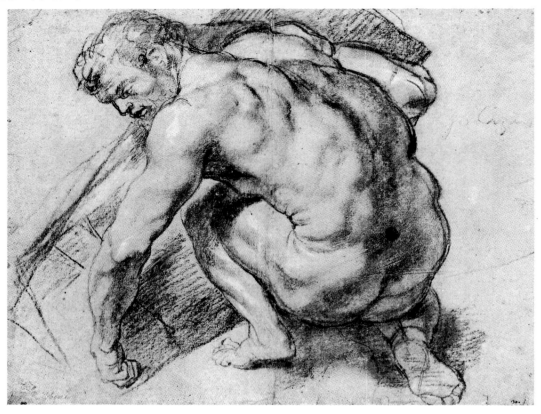

Peter Paul Rubens: Male Nude Squatting, *1617-18. Charcoal with stump and white lead on yellow paper, 428 x 539 mm. Louvre, Cabinet des Dessins, Paris.*

The reversal of the development of Rubens's drawing is exemplified in these three diagrams.

1. The first diagram suggests the stage of the drawing before it was completed with white-lead highlights that accentuate the plastic values, illuminating the entire left side of the figure.

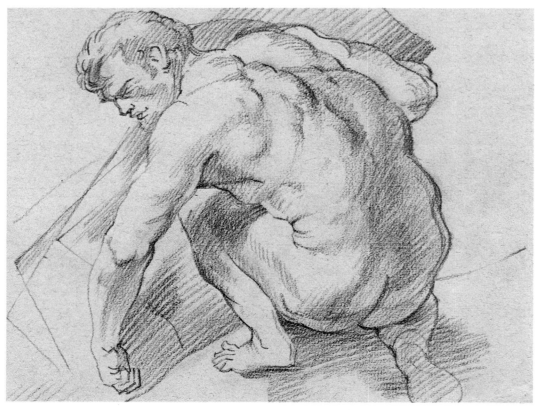

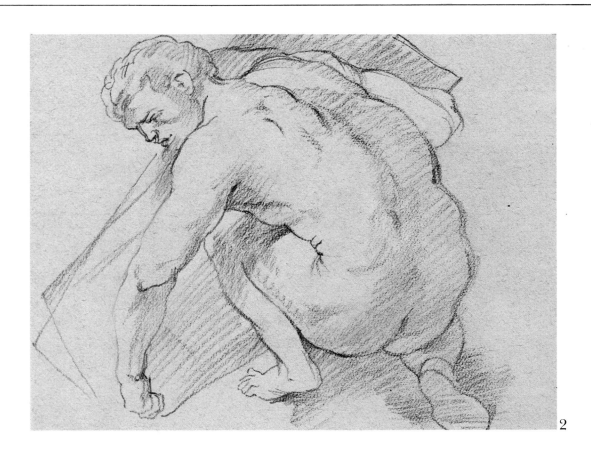

2

2. *The second diagram imagines an intermediate stage of the drawing, with the first chiaroscuro drafts. As we can see, the relationship between the various shaded parts are constant throughout the development of the drawing, so that the picture remains in proportion.*

3. *Finally, the third diagram, indicates the geometric matrix of the composition in the concrete realization of a life study, and shows us Rubens's interest in circular composition. Everything together— the composition, the pose, the chiaroscuro—contributes to accentuating the sense of relief and plasticity of the figure.*

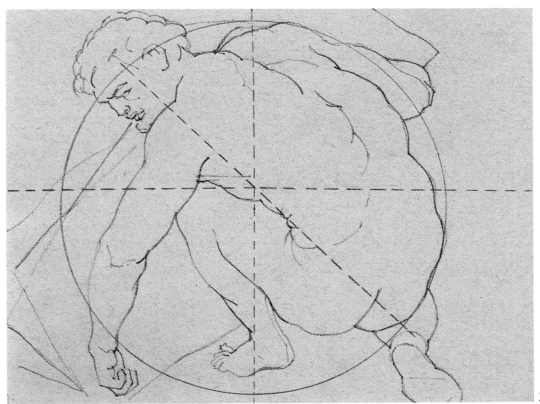

3

A Drawing a Day

The subject proposed for today's exercise is a group of circus horses at a barrier. You can easily find such a subject in the countryside, but it is not impossible to find it in the city, especially in the suburbs.

The horse is a subject that has attracted many painters, sculptors, and draftsmen with its elegance, lines, proportions, and volume. Let's try to draw a horse. Pretend you're in a circus tent where a group of horses is waiting its turn to enter the arena.

1

2

1. *A division of the picture along axes* a *and* b *immediately reveals that the bodies of the animals are all below the median horizontal line. Vertical lines and sloping lines can help us define the main proportions. The second horse from the right is within the intersection of the axes, and the positions of the other horses can be located in reference to this horse.*

2. *In the second phase, we see the overall shape. The straight lines indicating the geometric dimensions are replaced by the curved lines of the rumps and necks.*

3. *Having established the shape, we can start to add the chiaroscuro, beginning with the point that strikes us as darkest: probably the belly of the second horse from the right and the shadow of the front leg.*

4. *Gradually adding chiaroscuro, in order to give weight and volume to the animals, we use an airy crosshatching for the background and the ceiling of the tent. We should try to render the overall transparency and the reflections of the light.*

3

4

Stereoscopic Vision

Among the many organs that occur in pairs in the human body, the eyes, like the ears, collaborate with one another. They receive and transmit information in a system based on their being a pair. They can thus achieve results that are impossible for a single organ working alone.

The images we receive through our pupils are formed on the curved surface of the retina; they can be considered two-dimensional. The two images, although different in the singular perception of objects situated in three-dimensional space, are synthesized by the visual system.

Human eyes are placed frontally on the face (unlike those of many vertebrates, whose eyes are located on the sides of the face). The two human eyes share the same visual field and rotate internally in order to see nearby objects, whose distance is pinpointed by the angle of convergence of the optical axes. This is demonstrated in the figure below. Such a visual system may be useful for an isolated object, but it cannot furnish the brain with the perception of the distances of several objects simultaneously. A different system is used for such perception. The distance separating the two eyes causes a slight difference between the images formed on the retinas, a disparity that gives us stereoscopic vision.

In his diaries, Paul Klee writes: "It's interesting to perform the following experiment: Look at a painting with only one eye and you will see that the depicted objects maintain their sculptural relief. Why? One eye alone is unable to perceive the sculptural effects, and even though the brain integrates the defective impression, such a method of looking causes an erroneous appraisal of the spatial elements."

This experiment can be done in regard to a diverting experience. Close one eye and try to insert a finger through a ring held at a certain distance. You will not succeed.

The same principle of stereoscopic vision is used in the stereoscopic apparatus that was created for scientific research. The stereoscope is a device that places upon each eye a separate photograph of the respective image, which is generally made with a pair of cameras placed apart at the same distance as the space between the eyes. This is done so that researchers may investigate the disparity of the images utilized by the brain for stereoscopic vision.

However, stereoscopic vision functions only for objects that are fairly close. For distant objects, the two images that form in the eyes present only a tiny difference, so that human vision is practically monocular for distances greater than sixty yards.

Even if we do not fully understand the mechanism by which the brain grasps the perception of spatial relief, we can still state that it is the disparity between the two images received by the eyes that brings about this transformation.

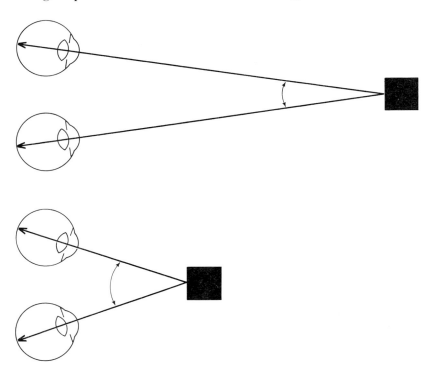

Chiaroscuro in Color

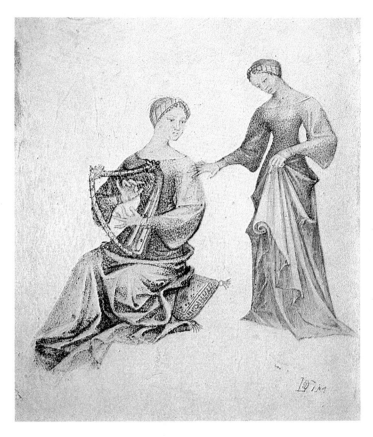

Giovannino de' Grassi (active in Milan from 1389 to 1398): Two Female Figures, One Playing a Harp, Codex VII 14 f. 5 r. *Ink and watercolor on parchment, 258 x 187 mm. Biblioteca Civica, Bergamo.*

Beyond the elegance of the composition and the two figures, and the perfect harmony of the colors, we are struck by the surprising use of Pointillism. During the second half of the fourteenth century, Giovannino de' Grassi was way ahead of his time in anticipating, by several centuries, the technique of Divisionism—rendering colored light and shadow through adjacent brushstrokes or dots of color tones.

Chiaroscuro need not be rendered just as monochromes or grays. We can also see light and shade in terms of the colors that accompany them. And we can also analyze the components of various hues and surround these basic colors with their fundamental or complementary colors.

Which colors do we choose? We already know that light contains all the colors of the spectrum. So when we do a drawing or painting, we have to determine the color of the light that falls on the scene. That is, we need to know the colors that describe the luminosity of the air, the transparency of the atmosphere, and the light and dark tones of the illuminated and shadowy parts.

How do we select these colors? Our choices depend on our individual personalities, on the optical and scientific knowledge available at the time, and above all, on our aesthetic convictions

and conceptions. Our ideas on painting, in turn, are influenced by the prevailing artistic movements of the time and the way they interpret volume and depth—that is, by the way they render light and shade.

When we think of the colors of light and shadow—which is in a way a kind of colored chiaroscuro—then we recall the ideas of the Pointillists. This movement was active chiefly in Italy (where it was called Divisionism) and in France (as Pointillism) during the late nineteenth century. This method of painting was based on optical studies of the time, and their research focused in particular on grouping complementary colors (blue/orange, green/violet, red/green) to generate a new kind of optical painting. The idea was to interpret light by dividing its hues into their original components in the spectrum. Then they

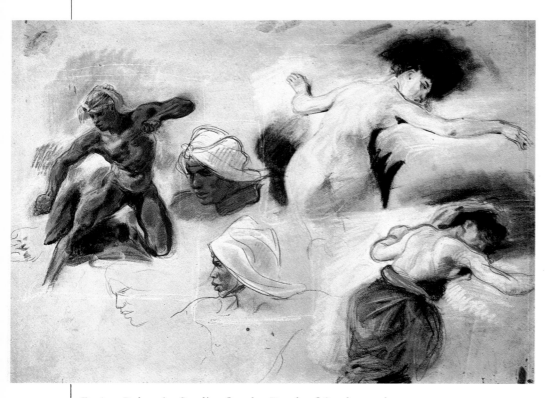

Delacroix's drawing, both in its illuminated and shadowy areas, radiates with the highly vivid colors of his palette. Even the shadows are obtained by placing pure colors adjacent to each other to suggest the reflections of light and color on the subject.

Eugène Delacroix: Studies for the Death of Sardanapalus, *1827. Pastel, 440 x 580 mm. Louvre, Paris.*

placed strokes or tiny dots of these pure colors next to each other and, according to the laws of optics, these colors fused in the observer's eye, mixing visually to form a third color, the actual hue they were trying to recreate.

Among the Italians, Giovanni Segantini was the head of the movement and Gaetano Previati was its theorist. Previati set down these theories in 1913 in an excellent little book, *On Painting*.

Written in complicated language that was inspired, however, by direct practice, *On Painting* details the basic elements of the new painting style. There are three different ways of mixing a color. You can do it with an *impasto* or direct painting technique, by blending several colors together. You could do it through *glazing,* by superimposing several layers of paint, one over the other, when each layer is dry. Or you could use a *pointillist* technique, placing adjacent strokes of pure colors next to each other, to be blended by the eye.

Using the color pink as a example, Previati writes, "Assuming that this hue is a pink that can be obtained by blending white and red cinnabar (a color like our modern alizarin crimson), you have three methods available to achieve the pink you want:

- *Impasto:* You can blend the colors with the brush to produce a homogenous paste of the desired pink.
- *Glazing:* You can place a coat of white on the canvas, and when the white has dried, add a thin coat of red cinnabar, so that the transparency effect will produce the desired color.

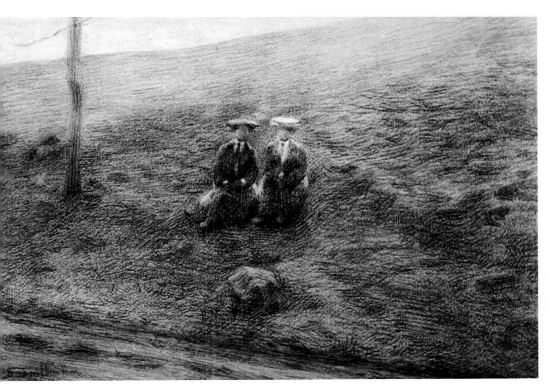

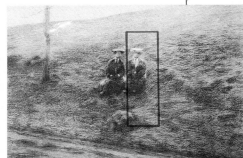

In Segantini's drawing, the hatchwork of the colored pencil strokes renders the crepuscular tones that give the image a particularly suggestive atmosphere. It seems to envelop the two immobile figures in the melancholy of a waning light.

Giovanni Segantini (1858-1899): Two Women in a Landscape. *Black pencil, colored pencils, and white chalk-pencil, 190 x 290 mm. Castello Sforzesco, Milan.*

● *Pointillism:* You can apply alternate strokes of white and red cinnabar, which then blend together in the observer's eye to produce the desired pink."

Naturally, Previati prefers the latter method for creating colored light and shadow. He then adds: "Assuming that by means of an extraordinary exertion, the artist managed to create three identical pinks by means of these three approaches, he would nevertheless see sharp differences in the degree of light if he placed the three pinks side by side. The glazes would look darker than the impasto, while the Divisionist pink would be the brightest. In other words, these three methods are not equivalent to one another, nor could any one of them replace any of the other two."

Previati concludes with a further piece of very useful advice based on the experience of a painter who, like himself, has a sense of the material properties of the paint. "In closing these comments on the intrinsic diversity of impasto, glazes, and pointillism, we have to mention a technical method that can be of great help in painting: *scumbling.* You soak the brush in the pigment and then pass it quickly and lightly over a painted portion, so that instead of a massive stroke, the color attaches only to the most protruding points of the surface."

Here too, the goal is not a uniform color, but rather an effect of transparency and permeation: the color added to the surface of the painting sticks only to a few spots, and in the viewer's eye it blends with the color underneath, which appears through the interstices.

The Colors of Light

Turner

The English painter Joseph Mallord William Turner (1775–1851) is known as the painter of light. In his drawings and watercolors, he used the whiteness of the paper, and, with delicate and transparent touches, suggested the clarity and splendor of light at dawn or sunset. At first, Turner's range of colors was relatively restricted and, we might say, more respectful of reality, without the freedom that he was often accused of later on. However, by 1819, when he was in Rome to paint the portraits of the pope and Cardinal Consalvi, his watercolors showed splashes of yellow and red, the "ultimate" colors according to Goethe, whose theory Turner followed, even though he was trained by the palette of the Vedutisi of the eighteenth century.

Turner looked at the physical world in order to create a different reality. He looked at the colors of the sky and the sea in order to invent his own colors. For instance, yellow, the color of light, soon became one of his favorite colors (after his death, more than a dozen different tonalities of yellow were found in his studio). In some four-hundred studies, Turner indulged in experiments and technical innovations, hoping to melt light and color without losing the sense of form or, above all, depth.

Turner frequently jotted down everything that interested him in pencil sketches, redoing them as

Joseph Mallory Turner (1775-1851): Colored Structure, *1828. Watercolor on cardboard, 305 x 490 mm. British Museum, London.*

watercolors in his studio, hoping to achieve rarefied and complex atmospheric effects.

His experiments led him more and more toward pure color. He had learned from Füssli, a visionary painter, that "one color is more forceful than a combination of two colors…and a blend of three colors tones down that strength even more." Turner himself said: "Beyond that, monotony, discord, corruption." Turner replaced the limited space of the old landscape with the grandeur and mystery of the vastest scenes on earth. "He went to a waterfall for the colors of the rainbow, he turned to an explosion for its flames, he asked the sea for its most intense blue and the sky for its purest gold" (John Ruskin: *Modern Painters*, 1848).

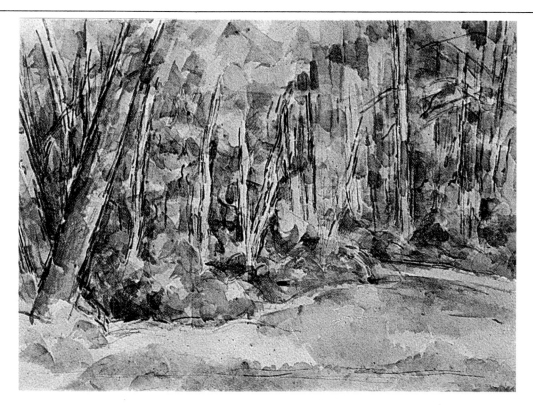

Cézanne

"Make Impressionism into something solid and lasting like the art in museums," Cézanne said. He sought the freshness and immediacy of the feeling he wanted to express through form, construction, and color.

The form in Cézanne's work is not closed and defined by the chiaroscuro or the modeling. Cézanne liberates the form, exposing its internal structure, giving body to air, mist, atmosphere, to the most fleeting and impalpable things; and he seeks the third dimension by creating an echelon beyond all rules of perspective.

But how could he express the world, the air and atmosphere, without resorting to the chiaroscuro of the old masters, to the decomposition and reflections of the Impressionists?

Cézanne discovered something that became fundamental for all subsequent painting: he realized that light and shadow do not exist as such; they are expressed in terms of color.

Modeling was replaced by tonality, chiaroscuro by the interrelations of colors. He modeled by means of color and, respecting the local tone, replaced the blend of colors, the interplay of gradations, with pure tones and contrasts of pure tones.

Thus, Cézanne invented a painterly light with a new interpretation of drawing and volume. Now that the shape was brought out by the brush,

Paul Cézanne: The Forest, *1890-1900. Watercolor, 435 x 560 mm. Private collection, France.*

draftsmanship and color were no longer distinct disciplines: "The richness of the color involves the fullness of the form." His imprecise subdivision of tone was followed by the juxtaposition of opposite tones or the adjacency of a hot and cold tone.

The brushstrokes became colored planes beyond the meaning of the subject. The painting was now a concrete and complete world, an autonomous reality, an end in itself, an architecture of tones and forms that neither illustrated nor depicted a particular story or object. Instead, the painting produced a new reality tied to nature.

Thus, Cézanne declared himself the master of all painters who were to come after him: "I am the primitive of the life that I have discovered."

Colored Shadows

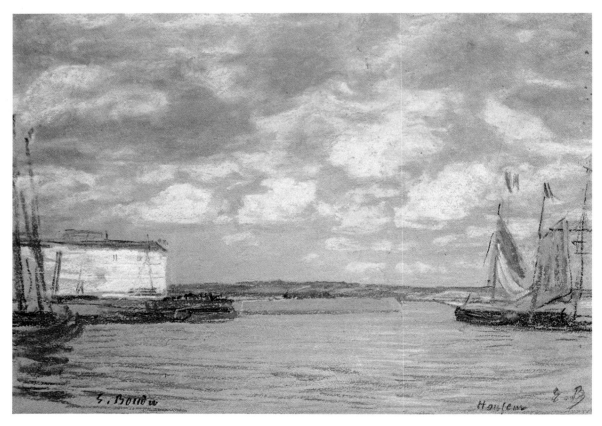

Eugène Boudin (1824-1898): View of the Port of Honfleur, *c. 1860. Pastel, 220 x 280 mm.*
Collection of Mme Howard Johnston, Paris.

Reflections and Shadows in Impressionism

In 1874, Monet, along with several other painters, exhibited in the shop of the photographer Nadar, at 35 Boulevard des Capucines, Paris. Monet's painting *Impression, Sunrise* depicted the reflections of the sun on the banks of the Seine by means of the separation of tones and the swiftness of the coloristic touch. A reviewer in the April 25th issue of *Charivari* made fun of these painters, disparaging them as "Impressionists."

The Impressionists method is explained by the writer and journalist Duranty: "From intuition to intuition, they gradually came to decompose solar light into its rays, its elements, and to recompose the whole in terms of the general harmony of the iridescences that they arranged upon their canvases." And the journalist Rivière points out: "Treating a subject in terms of tones rather than the subject itself is what distinguishes the Impressionists from other painters." The more or less academic depiction of a subject was thus replaced by the contemplation of the "motif"—a tree, a

Boudin's Palette.
Light dominates Boudin's work, Light, together with the transparency of the clouds and the reflections of the sea, is the true subject of his seascapes. Boudin painted still lifes, figures, and landscapes. Above all, however, he anticipated the Impressionist vision in his paintings of the sea. Even today we feel the emotions that he must have felt when we see his drawings and paintings. Gazing at this drawing of the harbor of Honfleur, we can easily understand that Boudin was interested not so much in painting the view per se as he was in conveying the way the light enveloped the scene, making it come alive. He also saw the possibilities of expressing the quality of light.

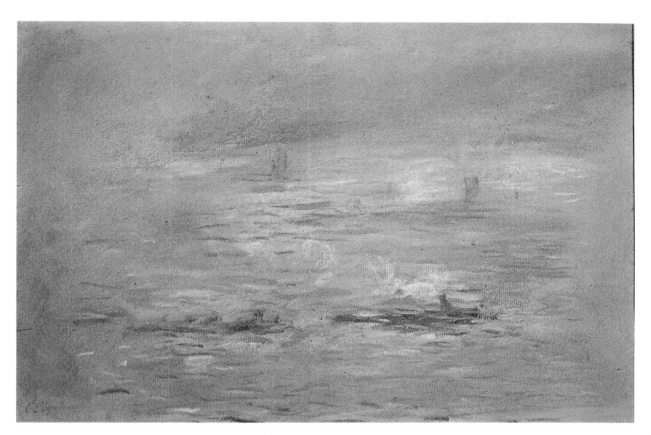

Claude Monet (1830-1926): View of London. *Pastel, 295 x 445 mm.*
Private collection, Paris.

house, a landscape, separated from time and space and finding its *raison d'être* within itself.

The Impressionist style quickly spread and commanded respect. Grays and browns were replaced by the pure colors of the spectrum, harmonized or contrasted by optical blending, according to the law of complementary colors. The fragmentary quality of the brushstroke, which was necessary for translating the reflections of water, was also applied to all the elements of a landscape as well as to figures. The range of colors tended to become lighter. Even shadows were colored.

This unity of vision was followed by a unity of technique. By heightening and vibrating light as a dominant element, Impressionism eliminated the outline, the modeling, the chiaroscuro, and the overly precise details of academic art. It replaced all these things with "atmosphere," rendering it in the immediacy of the rough sketch and in the fascination (so surprising to their contemporaries) of the unfinished. Above all, Impressionism concentrated on eliciting the active participation of the viewer, whose vision recreated form and color, space and atmosphere.

Monet's Palette.
In this pastel of London, we can see the characteristics of Monet's way of seeing and drawing: the vibrations of the light, the glistening of the water, the transparency of the atmosphere, the scintillation of the reflections. And in the pastel strokes, we find not so much movement as time, captured in the colors of dawn and sunset, autumn and spring. Monet does not draw just any view. He depicts a specific view in a particular moment, and his colored light and shadow rendered with adjacent touches of pastel, creates the illusion of sunshine, cold, and mist.

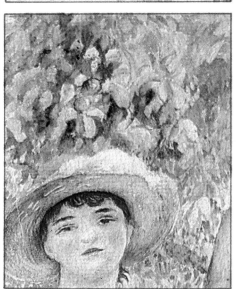

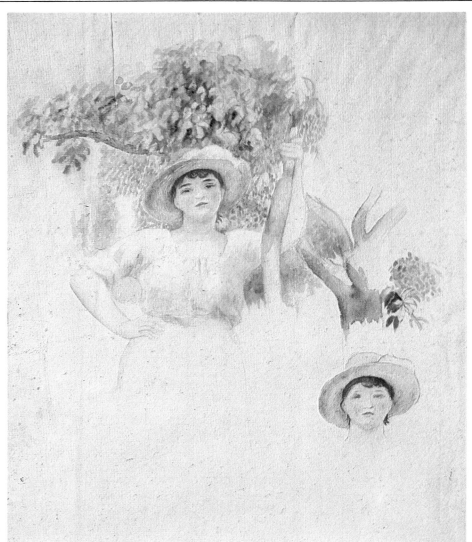

Pierre-August Renoir (1841-1919): Harvest, 1883—86. Watercolor and graphite lines, 475 x 310 mm. Louvre, Cabinet des Dessins, Paris.

In this watercolor, the "Impressionistic" interest in color takes advantage of this particular chance to depict foliage. The drawing of multicolored leaves replaces putting brushstrokes of various colors next to one another, to achieve this "coloristic" rendering. Such a rendering was sought by the Impressionists, who used an adjacency of pure tones to produce this type of effect.
Thus, the foliage of the tree (as demonstrated in the details) becomes a triumph of light, color, and transparency. This is a significant example of the Impressionist technique.

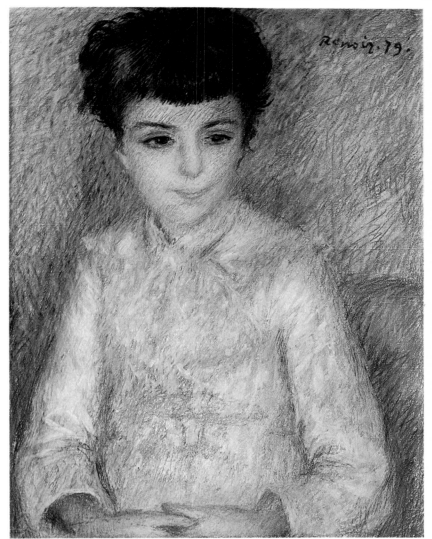

Pierre-August Renoir: Portrait of a Seated Girl, *1879. Pastel, 605 x 470 mm. Louvre, Cabinet des Dessins, Paris.*

The fascination of Renoir's drawing lies in the refined harmonies and in the interplay of colored reflections rendered with juxtaposed pastel strokes. This extremely luminous hatchwork is characteristic of the "Impressionistic" Renoir. The white of the dress and the pallor of the face (emphasized by the tone of the eyes and hair, the only black areas) emerge over the hatchwork of tones in the background and the armchair. The two details of the drawing demonstrate the technique of superimposing and crosshatching pure colors to achieve the effect of compound colors. Renoir creates a compound color on the surface of the paper in order to recreate it on the retina of the viewer's eye.

A Drawing a Day

Among the many subjects you can draw in colors (pencils, pastels, chalk-pencils, or watercolors), we have selected a "colored" subject: colored like the face of this baboon drawn from life (in a circus cage). You can easily find the following in the proposed exercise:

- The red and blue tones, clear and hot, of the face, and the yellow of the eyes, accented by the shadow of the eyebrows.
- The soft mass of the hair on the head in colors that vary from gray to brown and are darker than the forehead.

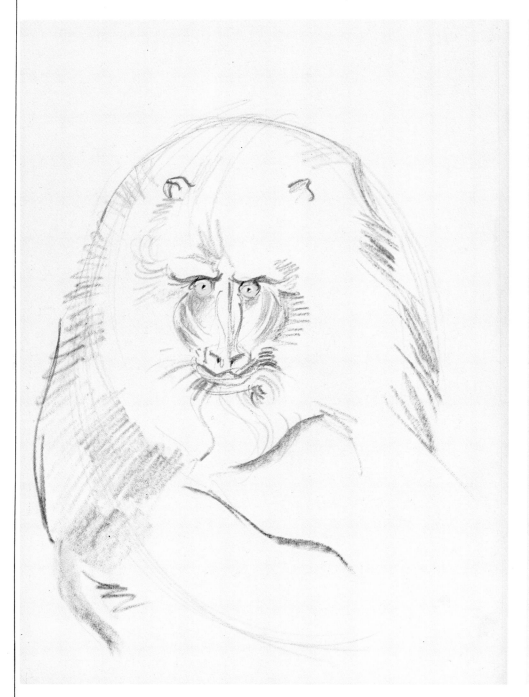

- The various shadings of gray and brown on the body and the paws, which are barely indicated.
 We can now see the procedure to follow in executing such a drawing with colored pastels:

- Sketch the overall proportions with an ochre or light-brown pastel.

- Indicate the vertical line of the nose and the horizontal line of the eyes within the mass of hair on the head.

- Draw the red and blue face and the yellow disks of the eyes with their black pupils.

- Proceed with the tones of the fur. Make sure you leave enough space to suggest light and volume.

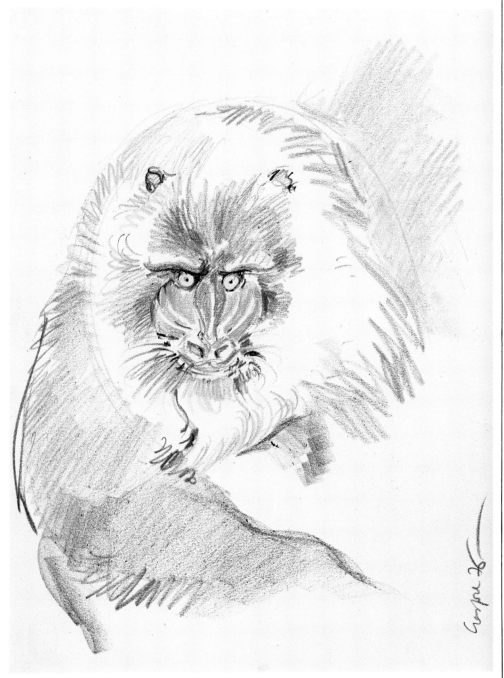

Color Exercises

Here is an amusing exercise you can try with colors. You will be amazed at the results and the optical effects. It consists of placing basic and complementary colors next to one another in order to produce color blends on the retina.

- Cut out five large pieces of paper, each made up of two equal squares that together compose a large rectangle.

- Place a large brushstroke of color in the left-hand square of each rectangle; for instance, orange, green, violet, brownish green or whatever color you like.

- In the right-hand square, place a series of small strokes or dots of red with the tip of the brush. Leave enough distance between them to make room for dots of a different color.

- When the red dots have dried, apply dots of a different color between them. Choose the color you would have to mix with red to arrive at the color in the left-hand square. For example, in the first square, there is orange on the left and a combination of red and yellow dots on the right.

- Repeat this same procedure in the other rectangles: a color blend in each left-hand square, and the respective components in the right-hand square. Thus, in the second example on this page, we see a green dab on the left and dots in the colors that make up green on the right: blue and yellow. In the third rectangle, we see violet on the left and its components, red and blue, on the right.

- In the fourth and fifth examples, we have indicated the analysis of tones composed of more than two colors, a grayish green and a brownish green. At the right of the former, we see dots of yellow, blue, and brown; and at the right of the latter, we see dots of red, yellow, violet.

Obviously, you can develop this exercise in any way you like. You can blend new colors and analyze their compositions by indicating their components. You can decompose them with different types of brushstrokes—larger, smaller, closer together, further apart, overlapping, distinct. Or you can use dots placed in a variable order.

DEVELOPING THE DRAWING

The joy of selecting an image from real life or recording an idea in a drawing, that is, the pleasure of knowing, imagining, and depicting makes us forget the "how" of drawing. When we draw, we have to move freely without worrying about following any one line of reasoning. However, in order to achieve such freedom, we have to understand how a drawing develops. We have to know how to begin and how to proceed so we can attain what we want, what we have in mind.

In order to complete a drawing, even if the image is unified, you have to perform certain operations in a specific order—and this will naturally require a certain amount of time. You have to place lines on the paper, define the outline, work out the proportions of the shapes, note the chiaroscuro, and bring the image into proper focus. The time spent may be brief for some and long for others, especially beginners. But nonetheless an artist has to follow certain specific, orderly procedures, especially at the outset.

In developing a drawing, it may not be possible to establish a schedule of successive elements within a rigid chronology. We can, however, work out a method.

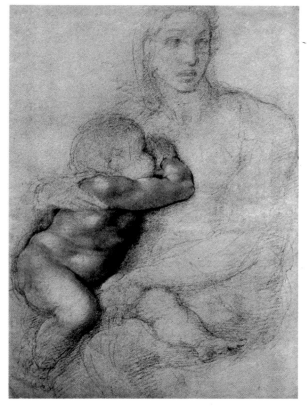

Michelangelo: Madonna Nursing the Son. *Black and red pencil. Galleria Buonarroti, Florence.*

Michelangelo's drawing reveals an extraordinary interest in "reading," in understanding the development of a drawing. In fact, while the baby's figure is fully deepened and completed in its shape and chiaroscuro, the mother's figure is barely sketched. Furthermore, we can discern the various phases in the development of the child's figure. The left leg is sketched only with a bit of chiaroscuro, as is the head. On the other hand, the right leg seems to gain body gradually as the red strokes are added to the black. Finally, the baby's torso has all the weight and volume of Michelangelo's compositions.

A Method of Drawing

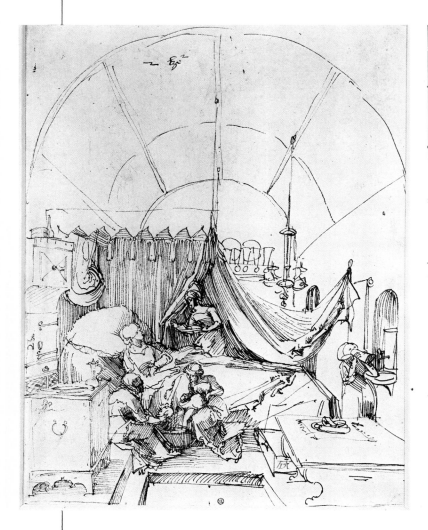

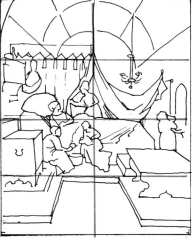

These diagrams reveal the difference between the two frameworks. The second (the original) is arranged on the circular vault that contains and protects the scene, which is therefore seen from a real observation point: a man's eye level. The first layout, in contrast, is from a higher point of view. It places the figures at the center of the scene, in a more impersonal depiction.

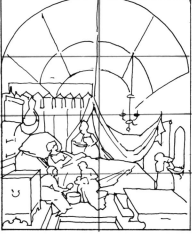

Albrecht Dürer: The Nativity. *Pen and black ink, 288 x 313 mm. Staatliche Museen, Berlin.*

There are many procedures for drawing, but you may find this method the most useful:
- Select the framework.
- Sketch the image and its layout on the paper.
- Decide on the overall shape and proportions.
- Work out the chiaroscuro.

The result is an overall synthesis, the picture itself. Let's examine these steps more closely.

Choosing the framework. Never go by the first impression. Don't be satisfied with the first framework you like. It may be the best, but before you decide, try other possible frameworks. Check those that seem more interesting and meaningful.

Ultimately, you will pick the one that best expresses the character and significance of the subject.

You can choose the framework with the help of the viewfinder: Place your composition precisely in the rectangular cutout of the paper, so that the framework coincides with the layout, that is, with the position of the drawing on the sheet of paper.

On the other hand, if you select a framework by defining the limits or boundaries purely for visual reasons, then you have to lay it out. That is, you have to examine the prechosen cropping in advance through a careful and meaningful sketch to see if you have an attractive arrangement of the

Bartholomeus Breenbergh (1599-before 1658): View of Tivoli. *Pen and brown ink, brown wash, 516 x 383 mm. Louvre, Cabinet des Dessins, Paris.*

In the diagram, the repeated motif underscores the presence of the setting in the foreground left. Above all, we note the usefulness and value of the backdrop, taken as a shape in itself, silhouetted against the houses of the village.

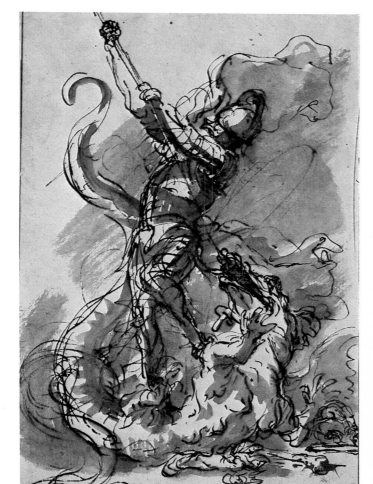

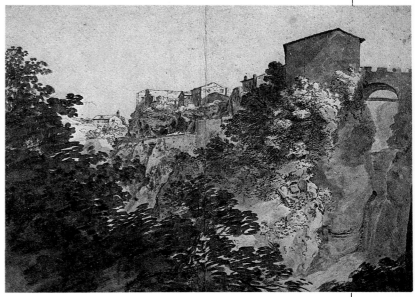

Salvator Rosa (1615-73): Saint George Killing the Dragon, *ca. 1668. Ink and watercolor, 224 x 147 mm. École des Beaux-Arts, Paris.*

The diagram illustrates "the contrast between the guidelines": the networks defining the direction of the lance, the figure of Saint George, and the serpentine line of the dragon, which seems to twist around the knight.

image in the rectangular space of the paper. We will go into this more thoroughly in the chapter on layout.

Sketching the image. Immediately after choosing the subject, when you sketch the framework on the paper, try to define the overall form, and, before anything else, the proportions of the subject. Construct your drawing by relating and confronting the various elements: see them in terms of one another rather than in isolation. Delacroix writes in his diary: "The first and most important element in painting is the outline. Anything else can be neglected, but if the outlines are there, then the painting will be solid and complete." He

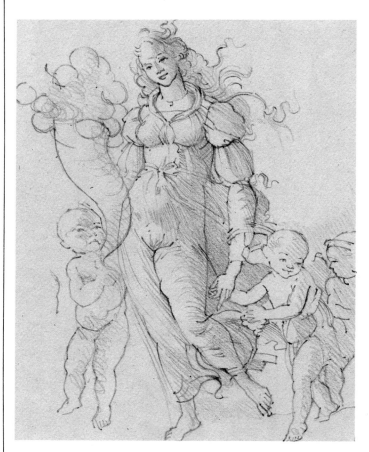

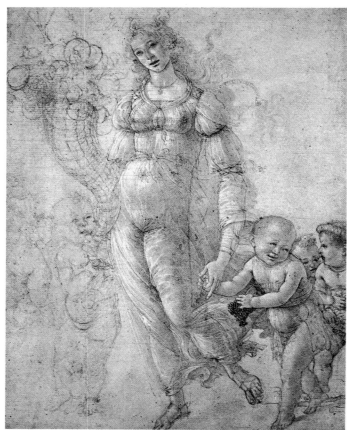

Sandro Botticelli (1445-1510): Abundance *or* Autumn. *Black pencil, pen and brown ink, watercolor, white-lead highlights on prepared pink paper, 317 x 253 mm. British Museum, London. (right).*

Botticelli's drawing interests us, partly because it illustrates, in the contrast of the completed right-hand part and the sketched left-hand part, the development of the drawing itself. The pencil diagram already has light and volume in the thickness and the sensitivity of the lines. The final drawing, in watercolor ink and white lead, has color and atmosphere, luminosity and transparency in the folds of the garment, the windswept curls, and the softness of the flesh tones. (left)

then adds: "In all objects, the first thing to select in order to depict them in a drawing is the contrast of the main lines. Before putting your pencil to paper, make sure you have a clear impression of them....Do not wait for the moment of execution to study the dimensions. A long time beforehand, you have to possess the precision that will help you in your impetuous need to depict nature." For a better definition of the shape of the subject, you should not be content with just seeing it directly. As we have said, you should view it in terms of its various components and their relationships.

When you zero in on your subject, whatever your technique and approach, whether you do a line drawing or employ chiaroscuro, you must never forget the meaning or purpose of your drawing.

Therefore, you will need to have a *focus* or focal point—that part of the subject which is at the center of your vision and bulks largest. Just as the edges of your eyesight blur in an out-of-focus image, so your picture will ultimately be open on the edges of the drawing. This is especially true in the blank spaces, which are pinpointed by a correct layout. However, there is a further and equally important focus, the one that constitutes the significant element—the focus of the drawing or *center of interest*. This is the part of the subject that seems most important and that we emphasize most strongly. We think of this part as the "protagonist" and we draw the viewer's attention to it with composition, form, and chiaroscuro.

A series of proportions and relationships, constantly confronted and tested, have guided us in the definition of shape and form. They must now guide us in the chiaroscuro, in a gradual and always proportioned deepening of the space.

Charles Le Brun (1619-1690): Nude Woman Kneeling and Holding a Baby. *Red pencil with white-lead highlights on beige paper, 298 x 272 mm. Louvre, Cabinet des Dessins, Paris.*

The preparatory study for one of the figures in The Massacre of the Innocents *immediately strikes us with its dramatic violence, the emotional frame created by the woman's posture and facial expression, and its technical brilliance.*

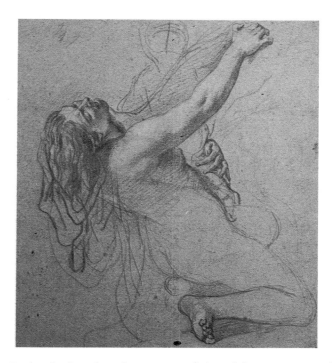

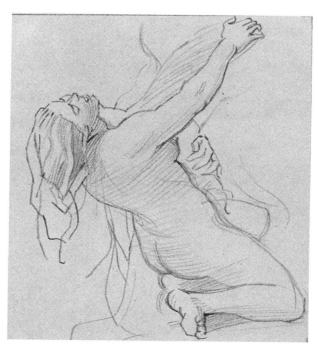

In both the development of the chiaroscuro and the sketching of the color, the center of interest is the element to which we pay constant attention in achieving the final result.

Establishing the proportions. But let's proceed with the drawing. The drawing develops gradually, balanced and strengthened by the chiaroscuro as simultaneously as possible. What does this mean?

It means that you should not start and complete one part of the drawing and then proceed to others, completing each in turn. If you carry out one part at a time, you lose sight of the overall unity. The result will be a series of "episodes" that do not relate to each other properly but remain separate and complete within each area, not as a whole.

Handling the chiaroscuro. Sometimes you may have to start from a given point of the drawing (for instance, as many masters advise us, the darkest part) without getting to the definitive values. But generally, you begin by doing an initial drawing on the paper and then gradually darken it as you add the successive tones. A word of advice: once your values have been established, make sure you do not change the tonal relationships between the grays.

What accounts for a good result is a unified procedure from the very beginning in establishing the outlines, chiaroscuro, and color. You have to succeed technically and practically in gradually strengthening the dark parts of the drawing without smearing or messing them up. You also have to maintain the characteristic airiness of real-life shade and shadow. To achieve the proper results, you should, at the very beginning, use hatchwork for the shading rather than rubbing (sfumato), and then keep darkening it.

There are many ways of drawing shaded areas with a pencil (to name the simplest and most immediate technique). The method we will use most frequently is that of chiaroscuro obtained by means of a hatchwork of strokes slanting from upper right to lower left, according to the natural motion of the right hand. The hatchwork is accomplished as follows: The chiaroscuro is sketched initially in terms of a more or less constant slanting for the reinforcement of the tones. Upon this, we place slightly different slants. We can also correct and lighten the chiaroscuro with an eraser. The advantage of this type of chiaroscuro is that it manages to retain the freshness of the line and the airiness of actual shadows.

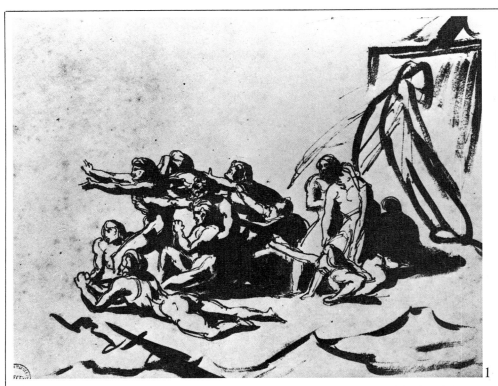

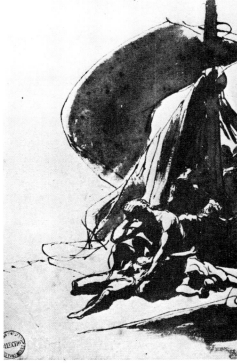

Théodore Géricault (1791-1824): 1. The Rescue of the Survivors. *Pen, ink, sepia watercolor, 206 x 260 mm. Musée des Beaux-Arts, Rouen.*
This extraordinarily expressive sketch constitutes a basic document for understanding the creative process of Géricault's work. Note the thrust toward a unified composition underscored by the postures of the survivors holding their arms toward the left.

2. Ship in Sight. *Pen and brown wash, 206 x 286 mm. Musée des Beaux-Arts, Rouen.*
3. The Wreck of the Méduse, *1818. Second study, 650 x 830 mm. Louvre, Paris.*
In these two studies, we note several elements that remain throughout the various solutions: for example, the bellying sail and, above all, the figures of the abandoned men.

Developing the Idea Through a Drawing

The examples presented here show the development of an idea through sketches and drawings, from the first draft, to the elaboration, corrections, variations, and details, up to the definitive work. Among our many possible choices of examples, I have chosen the sketches and drawings that reveal the invention and development of *The Raft of the Méduse,* a famous painting by the French artist Théodore Géricault.

I have said repeatedly that the idea precedes the drawing. In this case, Géricault's work was inspired by two things: the tragedy of the shipwrecked voyagers and his need to protest against the Restoration.

The story was that the French frigate Méduse was commanded by an incompetent aristocrat who had regained his rank in the Restoration. When the vessel was wrecked, 150 people took refuge on the raft, only to be abandoned by the longboats. Géricault wanted to depict the final moment of the tragedy, when the Argus sighted the last fifteen survivors twelve days later.

Géricault's studies document the genesis of the painting and its various phases of development, with all the references and variations. These drawings show that he studied earlier and contemporary masters. For example, the face of the woman at the center recalls Michelangelo, the dazzling light that tragically illuminates the mass of the bodies reminds us of Caravaggio, and the compositional rhythms go back to Rubens.

Géricault writes: "Genius is like volcanic fire: it has to erupt." And indeed, these drawings, these agitated limbs turned toward salvation, this chiaroscuro that is already light and color—all these things seem to emit the flames that constitute the fire of genius. The *Raft* is basically a narrative. It shows the conclusion of a tragic story and yet it contains within it the whole of the preceding tale. The sketches and studies that prepared it and made the painting possible constitute the chapters, the premises. They describe the characters and present the details. Above all, they reveal the "plan" of the narrative, its creation and development, from start to finish.

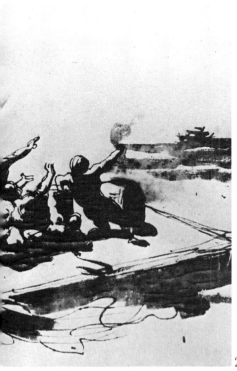

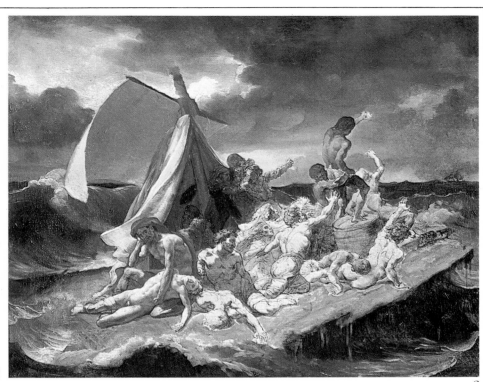

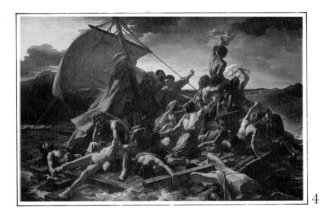

4. The Wreck of the Méduse, *1818-19. Painting. Louvre,*
Paris.
5. *Study for one of the figures in* The Wreck of the Méduse.
Charcoal, 289 x 205 mm. Musée des Beaux-Arts, Besançon.
6. *Study for* The Wreck of the Méduse. *Pen and ink on pencil,*
203 x 299 mm. Fogg Art Museum, Harvard University,
Grenville L. Winthrop Legacy, Cambridge, Mass.

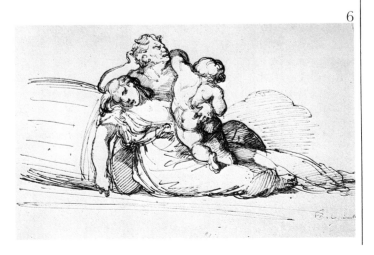

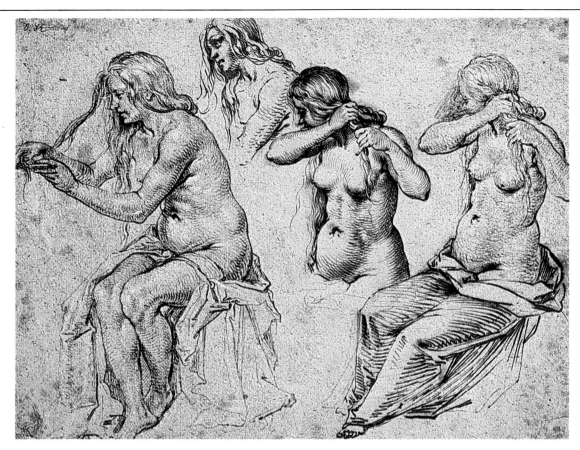

Jacob de Gheyn II (1565-1629): Four Studies of Women Braiding Their Hair. *Stump, ink, and bistre wash, 262 x 335 mm. Musées Royaux des Beaux-Arts, Brussels.*

Developing a Drawing

This study by Jacob de Gheyn II is particularly significant in regard to the development of the drawing. Not only do the four female figures show various stages of depth (enabling us to retrace the various elements of the shape and outline of the chiaroscuro), but the technique, in its extreme clarity, allows us to retrace the entire procedure.

Above all, it is interesting to note that de Gheyn uses his drawing to attempt to "see" the subject, a girl combing her long hair. He moves around her, capturing the framework in four accurate sketches. The drawing truly becomes a method of seeing and knowing.

However, de Gheyn is not content merely to sketch. He studies the nude anatomy of the figure, the drapery, and the exquisitely feminine posture (note the hands tying the hair). Let's look at how the artist goes about this task.

• First, he draws the shape of the figure. While combing her hair, she leans forward with her legs uncovered. The artist then seeks a different framework for the face, as seen from below. He now changes his position and draws the woman (only the bust) braiding her hair. Finally, he draws her entire figure, with her legs covered, while she knots her long braid.

• Having established the overall form, Jacob de Gheyn moves on to the chiaroscuro. His use of a pen with black ink and bistre wash enables him to find an intermediate phase, in the initial sketch of the first strokes of the shading. For his chiaroscuro, the artist employs a system of roundish, crisscrossing, even-hatched strokes. The chiaroscuro can be deepened by means of further strokes at different angles.

Obviously, de Gheyn's treatment is not the traditional use of parallel strokes all slanting equally. Adjusting the stroke, his pen lines follow the forms of the figures, curving the chiaroscuro along the roundness of the arms, breasts, torso, and hair. On the other hand, the drapery is treated in a freer and more immediate fashion.

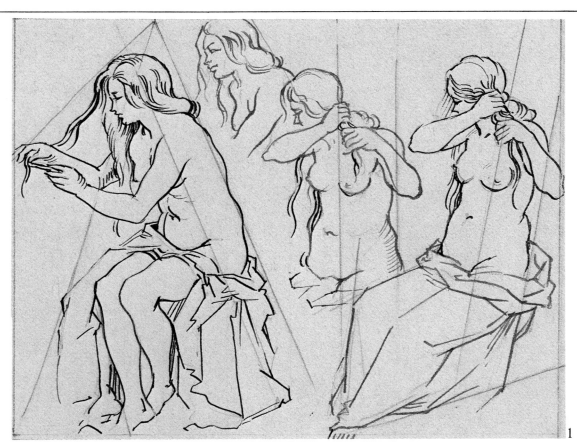

1

The first diagram illustrates the definition of the shape. It points out the lines and axes that establish the positions and angles of the figure (which seems to move from the forward lean in the first sketch to the slightly rotated erect position in the second and the barely leaning position in the third. The second diagram illustrates an intermediary phase of the chiaroscuro, with the first strokes of shading done by means of hatchwork. Further hatchwork is placed upon the initial curved lines, which follow the rotundity of the figure. The shadow succeeds in rendering the volume and the reflections with extremely simple and effective means.

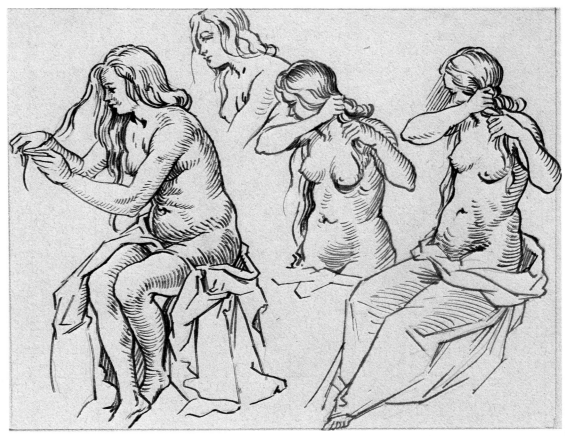

2

A Drawing a Day: Portrait of a Woman

These four sketches illustrate four phases in the development of a drawing. Above all, they show the need to advance the drawing gradually, always maintaining an overall control of the entire page.

Obviously, if you wish to emphasize one part over the others, the above advice is meaningless.

But from an academic viewpoint, these drawings illustrate the normal procedure. To review the method once again:

• Choose the overall framework and lay it out on the page in terms of the vision and image that you want to convey. Just draw the outlines at first. Remember that together with the face,

which is placed along the diagonal of the rectangle, the framework also includes the arm, which closes off the composition.

- Next, begin sketching the dark areas you consider most important. You can take advantage of the various tones of the black pencil and the red pencil.

- Little by little, strengthen the primary tones while gradually adding the more subtle ones; that is, the tones that follow in the gradation.

- In this way, the chiaroscuro relationships will remain constant throughout, from the first sketch to the last, which, obviously, can be deepened further if necessary.

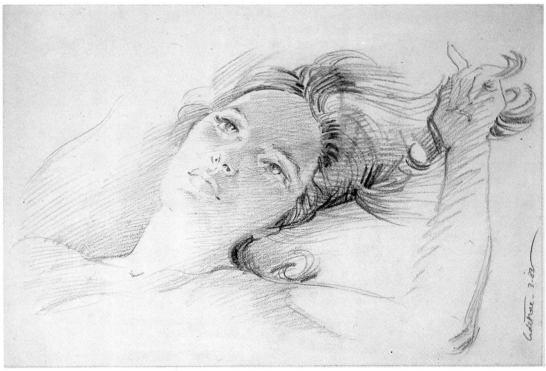

Finished and Unfinished Drawings

The reasoning that should guide us in developing a drawing demands that we proceed by degrees, advancing all parts of the drawing simultaneously if possible. We should not complete the drawing sector by sector. This would mean having a detailed chiaroscuro in one part, while another part remains to be worked out and defined. It is only by going forward simultaneously that we can maintain and achieve a unified result. The drawing can be regarded as complete once we have correctly related and proportioned all its parts, both in the form and the chiaroscuro.

But the normal procedure does not always work best. Sometimes an artist will deliberately leave certain parts of the drawing undeveloped and in outline form in order to emphasize other parts with the chiaroscuro.

At other times an artist may do preparatory drawings and complete only some sections either because of lack of time or to work only on certain areas. Such preliminary sketches help the artist clarify problems that interest him most. Thus, to solve problems of chiaroscuro or volume, for example, the artist merely has to pinpoint one area in his study without deepening or completing the other parts.

Typical examples of this approach can be found in the drawings of Emilio Greco. Using the graphic pattern of a female body, he seems to be searching for the mystery of life, the mystery of the eyes, and the smile in the hatchwork of the velvety shadow that concentrates and pinpoints the face.

Even in a case like this, we have a choice. Both experience and our sensibilities teach us how to select the detail that we wish to focus on in the drawing.

Emilio Greco (1913): Female Figure. Pen and ink. Private collection.

Greco uses only a line to define the shape of the figure. To show chiaroscuro, he thickens the line on the face. This area, together with the detail of the fingers, constitutes the focus of the drawing.

The Sketch

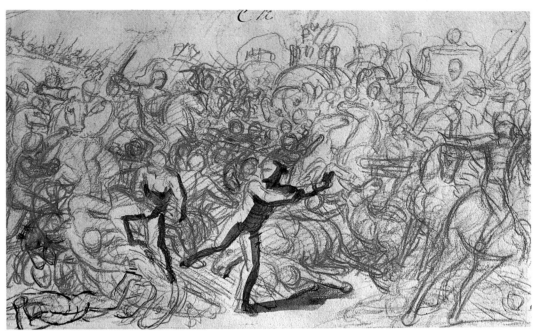

Charles Le Brun: Study for the Battle of Arbela. *Black and red pencil, with highlights in pen and black and gray bistre watercolor, 268 x 425 mm. Louvre, Cabinet des Dessins, Paris.*

Why do we often prefer a sketch to a finished drawing or at least one that's fairly well along? The reason, I think, is that a sketch has the fascination of suggestiveness. It invites the viewer to see something that isn't there, to develop the drawn idea and complete the idea offered by the artist. The viewer "enters" the drawing and is transformed into a protagonist rather than a spectator.

This is why, although seemingly easy and immediate, a sketch, more than any other type of drawing, actually demands experience, background, concentration, and a capacity for synthesis and expression.

There are, I feel, two characteristics that should define the most successful sketches:

- *The expression of the idea.* The artist's ability to render the real or imaginary image in a few strokes, directly, as a logical consequence of the idea, without snuffing the spark of invention,
- *The principle of procedure.* The quality of suggesting the entire pictorial, sculptural, or architectural project in a few strokes that suggest the

finished work and allow the viewer to imagine its "reading," its procedure.

The fundamental point is this: The artist has to succeed in developing the sketch, the embryo of the idea, without betraying the initial spirit. He has to bring out this spirit without destroying the synthesis, and while pinpointing the details. "It's done only when it's done," said Ingres. But it's hard to say when a drawing is really finished.

The sketch as a draft must therefore be viewed as the first phase of the drawing. Yet there is another type of sketch, too, the self-sufficient kind. This is often an immediate drawing, done in a few rapid strokes of a moment, an impression or idea, and is complete within itself.

A sketch also interests us as the first stage in the development of a drawing. This kind of drawing emerges from a continuous mutation where each figure is born and developed in terms of several diverse figures. In this case, in seeking the precision of a movement, you may, for instance, attach several arms to one shoulder.

Among Dürer's most characteristic features—indicative of his mentality, his way of seeing, and his imagination, his approach to measuring and inventing—is a watercolor drawing in which he tried to depict a nightmare, that had left him "all atremble" upon awakening, as he writes in his diary.

In regard to this nightmare, he notes: "In the year 1525, after during Wednesday night, I had this vision in my sleep: I saw many huge waters cascading from the firmament. And the first cascade hit the earth approximately four leagues away from me with great violence and tremendous din, immersing the earth. I was so terrified that I woke up before the other waters fell. And these were enormous. Some fell very far away, others close by and they came from such a great height that they all seemed to plunge at the same velocity."

What strikes us in this beautiful description is, no doubt, the logic and the acute observation. Even in a dream, Dürer cannot help measuring distances and velocities, almost drawing his nightmare—and eventually, he did draw it.

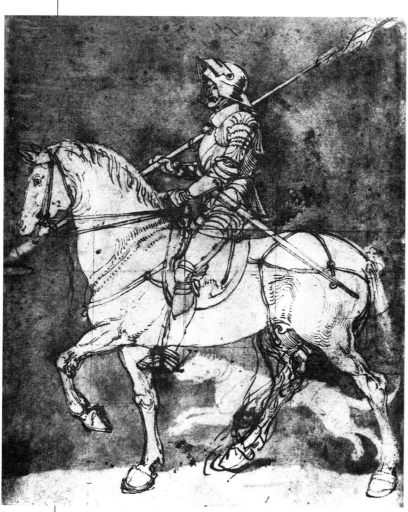

Albrecht Dürer: Knight Facing Left. *Recto, pen and ink, 246 x 185 mm. Biblioteca Ambrosiana, Milan.*

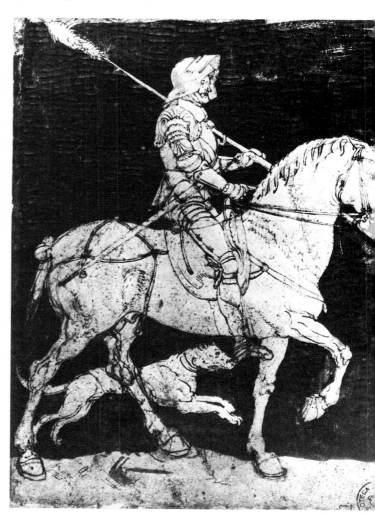

Albrecht Dürer: Knight Accompanied by Dog. *Verso, pen and ink, brown wash. Biblioteca Ambrosiana, Milan.*

Dürer's *Knight, Death, and Devil*

Although "inspired from on high," Dürer felt "impotence" and dejection in his extraordinary artistry, perhaps because he was both an artist and a scientist and knew the limits of the discipline he loved—geometry. Thus, he wrote, "I don't know what absolute beauty is. No one knows but God." Yet he also wrote: "Geometry can reveal the truth of several things. In regard to other things, however, we must go along with human opinion and judgment."

Dürer's two drawings, made on the same sheet of paper, illustrate two phases of his preliminary work for his celebrated engraving. Not surprisingly, in the first idea to be drawn, the knight faces in the same direction as in the final engraving. It is not a preparatory drawing for the engraving (which will be reversed). Rather, it constitutes the image of the ultimate result.

In the journal of his travels in the Netherlands, Dürer brings up the engraving known to us as *Knight, Death, and Devil.* The artist calls it simply *Reuter* (knight, horseman). His diary also contains

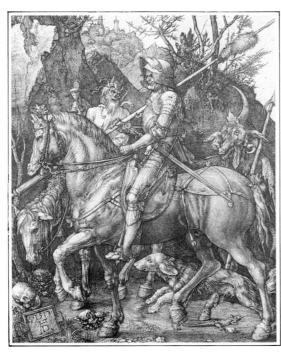

Albrecht Dürer: Knight, Death, Devil: *1513, etching, 246 x 190 mm. Uffizi, Gabinetto dei Disegni e delle Stampe, Florence.*

hero who rides past his adversaries, bugbears, and nightmares, following his route calmly and serenely (as analyzed in an essay by the art critic Erwin Panofsky).

The proportions of the horse, the modeling of the anatomy, the perfect rhythm of the pace (all taken from studies of Leonardo da Vinci), the structure of the knight, the precise details in the armor—all these elements recall Dürer's intention to depict only a horse with a horseman, at least originally. And the preparatory sketches seem to confirm this.

But beyond the symbolic and religious meanings, there is the intrinsic value of the drawings themselves.

The first drawing is interesting for several reasons: the orthogonal construction on the horse for guaranteeing the exact proportions; and for the study of the position of the horse's right back leg (on the ground in the first solution, raised slightly in the second). Above all, we note the perfect balance of the composition: we realize we can change nothing, not even the least detail, without disrupting a perfect drawing.

The second drawing, in contrast, is clearly a preliminary study for the etching. Here, the knight rides toward the right, so that, once the picture is printed, he will face the correct direction (left).

Furthermore, the background is painted with a brown watercolor hue, on which we see the dog running alongside the horseman (the dog was barely sketched in the first drawing).

The engraving, brilliantly executed, is certainly a unique masterpiece in the history of this genre. Yet both studies, with their perfect outlines, marvelous chiaroscuro (just a few strokes, barely indicated), and the contrast and relief against the dark background, have a monumentality and expressiveness that seem to reaffirm the primacy of drawing.

a precise lead for an interpretation. Saddened by the rumors of Martin Luther's murder, Dürer launches into a passionate diatribe against the Papists and appeals to Erasmus of Rotterdam: "Oh, Erasmus, what position will you take? Do you see the dominance of the unjust tyranny of worldly power and the forces of darkness? Listen, you 'Knight of Christ,' riding at the side of our Lord, protect truth, obtain the crown of the martyrs!"

There is an obvious link between this "knight of Christ" and the horseman in Dürer's engraving: a

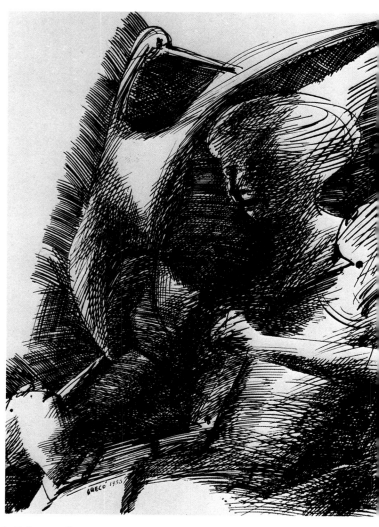

Emilio Greco: Two sketches for the Pinocchio monument. Pen and ink. Private collection.

Emilio Greco's *Monument to Pinocchio*

"In 1953, I received notice about the national competition to do a Pinocchio monument, and the idea of setting up a monument to the most famous puppet in the world and to his extraordinary adventures turned around in my mind. We have all loved Pinocchio, but basing a sculpture on an abstract fact, the invented character from Collodi, did not stir my 'strings.' I left the notice on the table amid other papers and put it out of my mind.

"In the summer of that same year, I was on the examination commission at the Academy of Carrara together with Enzo Carla. He asked me if I had prepared anything for the Pinocchio competition. 'No,' I said, 'frankly, I can't think of anything, and above all, I can't picture the puppet as a sculpture.'

"'I would advise you to send in a sketch anyway,'

Emilio Greco: Monument to Collodi's Pinocchio.

himself and becomes a real boy.

"I didn't have any paper on me, nor could I obtain any, because the train was lumbering off again. I instinctively reached into my pocket. I realized I had a letter from the Academy of Carrara with the schedule of examinations. I made a rapid sketch on the back of the envelope, and the image that I recorded was subsequently unaltered. The puppet was born from a sort of hollow olive trunk, and the upward composition rose in a rhythm of full and empty spaces to the tip of the fantastic bird's wing, which was linked to the fairy's hat.... I then won the competition together with the sculptor Venturino Venturi, who was commissioned to do the 'magic square'. ...Using money donated by children throughout the world, they bought the plot of ground for the park dedicated to the famous puppet....

"An American citizen, who had been born in Collodi, offered to pay for the bronze smelting, while I was to set up the plaster model at my own expense....I instantly encountered major technical problems because of the hollowness of the monument, which made me anxious about its stability....

"I began to take apart all the old boxes lying around in the basement, and I thus constructed the armature on which to model the plaster. It was a carpentry work somewhat similar to the labor on the keel of a boat. I didn't bother with scaffolding; instead, I made do with a rickety ladder. I grew so accustomed to going up and down hundreds of times a day that the training made me as agile as a monkey. I worked during the summer in a sauna-like temperature, I couldn't open the ventilation window because of the rust that had welded the frame. I ended up panting heavily, but I was happy.

"The model was taken to a foundry in Rome for the wax and the bronze casting. After many adventures, the day of the inauguration in Collodi arrived. Gronchi, the president of the Italian Republic, was present, along with authorities and journalists from all over the world. ...Little carriages arrived with children dressed up as characters in the famous book. It was a truly festive atmosphere, with anticonformist speeches consistent with the character immortalized by Lorenzini...."

he said. 'If you think about it, you won't lack for ideas to do a sculpture with a new idea of Lorenzini's masterpiece.'

"In Pisa, the train stopped for the usual pause, and I remained inside. I believe I was looking for the beverage vendor when the idea for the monument suddenly hit me. I thought of the episode about the fairy and the puppet at the moment of purification; the amorous meeting, almost in a ballet key, when the repentant puppet redeems

Domenico Ghirlandaio: Apparition of Saint Francis at the Capitol of Arles.
Pen and ink. Gabinetto delle Stampe, Rome.

The Apparition of Saint Francis by Ghirlandaio

Domenico Ghirlandaio's two sketches illustrate two phases in the development of the original ideas for a scene in *The Tales of Saint Francis* for the Sassetti Chapel in Santa Trinità, Florence. The scene depicted in these two sketches is the one in which Saint Francis appears and brings a dead boy back to life.

The first sketch shows Ghirlandaio's obvious attempt to define the idea. The locale is the same in both versions. But in the first sketch, virtually a "drawn intuition," the artist positions the figure of the saint freely in the air. Logically, then, the first image is that of the hovering saint seen from the front. Then Ghirlandaio repeats the figure, drawn slightly larger but practically in the same position, almost as if to confirm his choice. The figures of the monks are barely sketched, while the architecture and the decoration of the surroundings, the arches, and the steps are imagined and sketched with extreme care. However, in its articulation, especially in the proportioning between earthly

and heavenly space, the scene still remains to be defined.

A basic step appears in the second sketch. Here Ghirlandaio seems to demonstrate that he has found what will be the definitive solution. The sketch clarifies the various elements of the scene: the central perspective with a fairly high viewpoint (and hence, high horizon), as if the brothers were witnessing the scene from an elevated eye level rather than from the normal viewpoint. This helps to create an unusual and unreal at-

—86—

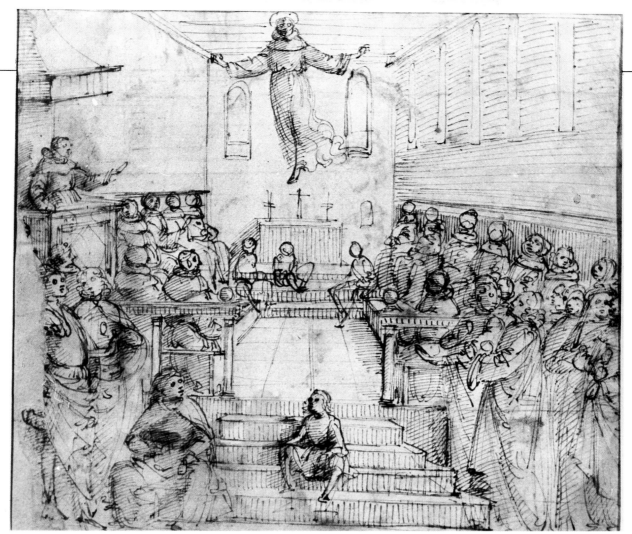

Domenico Ghirlandaio: Apparition of Saint Francis at the Capitol of Arles. *Pen and ink on white paper, 190 x 220 mm. Gabinetto delle Stampe, Rome.*

mosphere. Also in the sketch are the crowds of priests sitting in the stalls, with their raised faces, gazing stupefied at the event; the group of knights to the left and the women to the right; the boy sitting on the small stair at the lower center; and the figure of the saint, above, at the center of a horizontal fascia at the top third of the drawing. The saint floats in the air, but the body is erect and seen from the front, with arms open perhaps in a less dynamic posture than in the first sketch. But this time, the saint is more noble, more classical, and possibly even more unnatural (the first figure "flew," this one "walks" in the air).

Beyond the extraordinary value of the two sketches in understanding the developmental phases of the artist's idea is the fact that they constitute two modes of expression that are particularly significant and didactic.

In the first sketch, the lines are purely outlines, extremely simplified. The heads are merely small circles, the figures are summed up in two lines, the architectural construction is superimposed upon the figures.

In the second sketch, the lines, although synthetic, are extended, enriched, overlapping, placed side by side to render the draperies, the expressions, the light, and the volumes. Note, in particular, the sureness and simplicity of the shading (an open treatment typical of Ghirlandaio's graphics) throughout the drawing and especially in the figure of the saint.

—87—

Giovanni Michelucci: Two sketches for the Church of Longarone.

Giovanni Michelucci's *Church in Longarone*

In his sketches for the church of Longarone (as in all of Michelucci's sketches) we find the entire idea of the church, the whole project in its full spatiality.

Michelucci's sketch contains not only the ground plan of the building, the section or perspective image. We also find every single component of the project, always expressed in rapid lines, usually pen and ink or brush, sometimes with watercolor strokes. Thus, the section becomes a perspective as well, and the observer is able to see both the inside and the outside.

In the first sketch, the prime element is the section of the church, which contains the basic idea of the project: an internal basilican space covered with a gradated space that can also be used, an amphitheater embracing the Pietà and ending with Golgotha.

However, next to the sketch of the section, the interior of which is seen in perspective with an imaginative effect of transparency, we see the structural design, the motif of the steps that surround the statue of the Pietà, the first dia-

grams. Few sketches manage to illustrate this concept of the sketch as the expression of the first ideas and as the nucleus of the development of the project more completely and more immediately than this sketch by Michelucci.

The second sketch was done more than two months after the first. Now, the project is clearer. The artist has modified not the overall idea, but the structure, the architectural realization. The structure has become almost symmetrical in its

interior space. On the other hand, we see Michelucci's typical "outburst" in the amphitheater, which rises higher, on one side, towards the cross of Golgotha, which crowns it. Michelucci indicates the sacristy and the choir and draws the space of the church, the steps of the outdoor amphitheater. To clarify his vision, he sketches a partial view of the roof from something like a bird's-eye view. And he once again completes his drawing in a network of depiction methods, with great freedom.

Michelucci draws with great passion and loves to talk about drawing and architecture. Drawing, he says, "means finding the relationship between ourselves and the object, a relationship that, in its best expressions, becomes an identification; when we draw a flower, we ultimately feel how much the flower enjoys air, light, sun."

Architecture, for Michelucci, is something that should belong to everyone. Form should be not a problem, but a natural task, and once the task has been resolved, it should become an "eloquent" fact.

"Architecture is defined by a space characterized by the very nature of the activity taking

place within it and by the full range of interests that this activity encompasses and on which our minds focus. And the vaster these interests, the more essential the space becomes for the dynamics of life. We can say that every architectural space is all the more defined or achieved (that is, as a work of art) the more man recognizes himself in it and the more his mind is aroused for new interests that make his knowledge of himself and other things more complete."

Sketching a Drawing

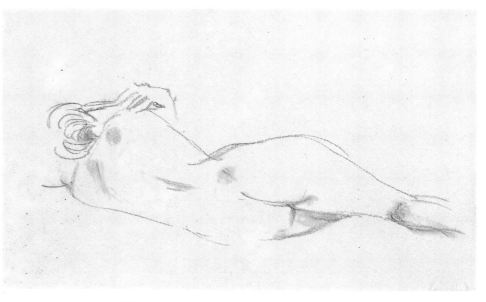

This picture of a Roman square, characterized by the sacred shrine in the corner of the palazzo and animated by a reclining nude female, was preceded by several studies, including:

- An overall sketch of the figure and the landscape. The surroundings are contained in the Palazzo Cancelloti (in whose corner the little Madonna triumphs with the stucco halo and the angel with open wings). The square opens beyond it. In the foreground, the artist imagined the reclining woman, seen from the back.
- Three sketches of the female nude from which the definitive one, with her hand on her shoulder, was chosen.

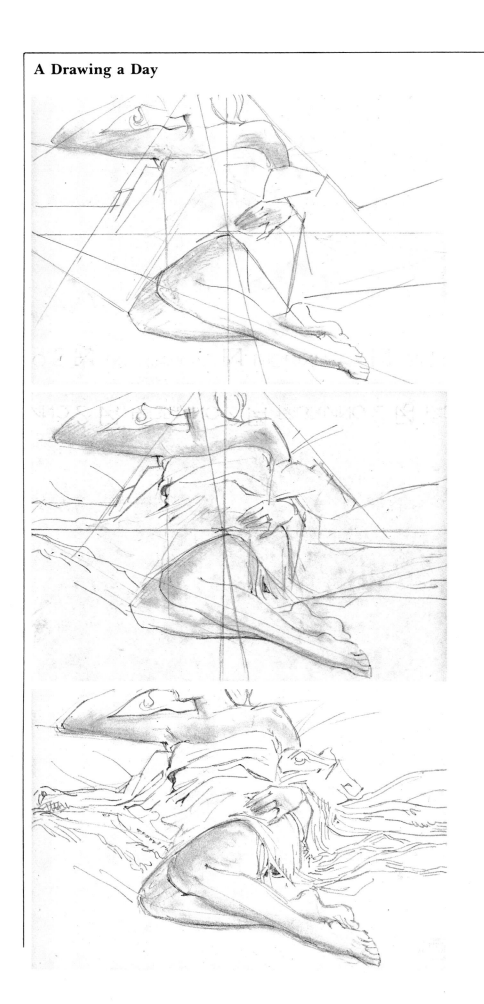

The sketch is of a female figure. The artist cut off the top of her face in order to bring out the composition of the figure and the shawl. These diagrams illustrate two phases of the development. The first reveals the geometric guidelines that contain the figure. The second has a more sensitive stroke, which tends to characterize the figure and the drapery.

The Framework

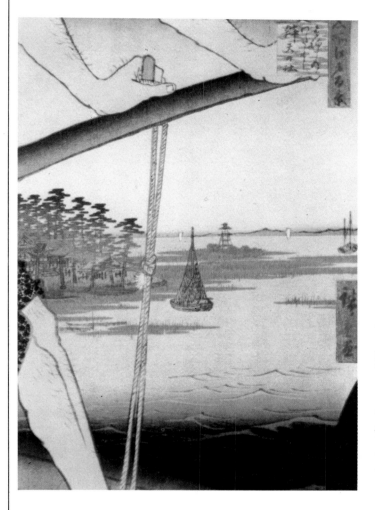

Andô Hiroshige: Tempio della Prede, *in the series* One Hundred Famous Views of Edo, *c. 1858. Woodcut, polychrome, 353 x 240 mm. Museum für Ostasiatische Kunst, Cologne.*

This is a characteristic framework used by Hiroshige. We are astounded by the boldness of the perspective cut that slices off the fisherman's arms and legs. Startlingly original, it suggests new visual angles and, above all, new illusions of movement and depth. For several years, this concept of motion influenced European art in its choice of frameworks.

A good framework, the choice of a good viewpoint, are basic to a drawing. Once you select the subject, you must then define the framework before you start drawing. An extremely helpful device in this phase is the viewfinder or crossframe, which we have discussed in Volume One. This simple device is made up of a cardboard frame containing a transparent sheet on which the axes of the rectangle are indicated.

When you hold up the viewfinder (or even the simplified version of Leon Battista Alberti's *velo,* as interpreted by Dürer), you have a perfectly delineated framework.

The viewfinder is useful not only because it lets you decide on the perspective or depth of the scene you want to include. Since it is hand-held, by shifting the crossframe up, down, or sideways, you can also vary the borders of the composition, constantly redefining them. Of course the choice of the framework varies from subject to subject and from artist to artist.

What are the major problems that you will encounter most often in choosing and defining the framework?

The most common difficulty is one of proportion in inserting the whole subject or a given part of it within the rectangle of the paper. The difficulty is in measuring the space and volume of your subject, which must fit within the dimensions of the paper while leaving enough surrounding

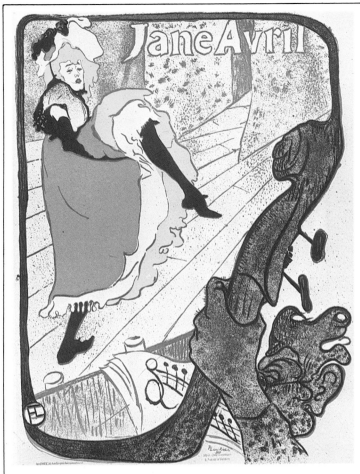

Henri de Toulouse-Lautrec (1864-1901): Jane Avril, *c. 1893. Poster, 130 x 95 cm.*

The most effective meaning of this poster is in the framework of the dancer within a framelike stroke that emerges from the double bass in the foreground. The hand holding this instrument makes us sense that the space continues. The asymmetrical position of the cancan dancer on the stage, which is cut in a diagonal, suggests that the action continues beyond the framework.

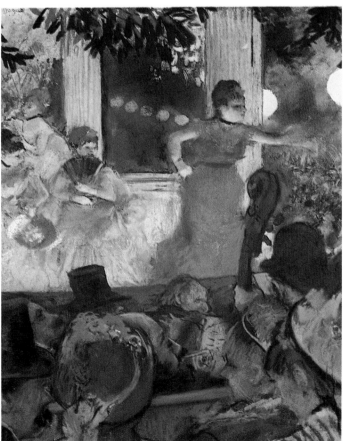

Edgar Degas: Café-concert at Les Ambassadeurs. *Pastel on monotype, on paper, 370 x 270 mm. Musée des Beaux-Arts, Lyon.*

This pastel is typical of Degas's frameworks and can be called cinematic. The focus of the drawing is the stage, where the red color of the soubrette is triumphant. The space between us and the stage light is emphasized by the heads of the spectators and musicians; the women's hair and the scroll of the instrument are brought out clearly.

space for the drawing to "breathe," to open up and complete itself in a layout that corresponds to the framework, suggesting rather than explicitly stating things. The problem of not allowing enough space for the entire drawing is particularly prevalent among beginners because they tend to draw on a large scale, often failing to allow sufficient room to complete the composition at the top or the bottom.

Another fairly common problem is in deciding the correct position of the horizon line. The horizon line coincides with our eye level. One common error is that artists frequently raise the viewpoint, as if they were watching the subject not from their normal position, but from a higher one; this shifts the emphasis to the upper part. This is easily solved. If you wish to position the framework correctly on the paper, you must take careful note of the axes of the viewfinder. To place the horizon precisely, look at the horizontal axis and determine what appears above and what appears below it. Then, using this horizontal axis as a guide, pinpoint the vertical and diagonal angles and lines of the image (for instance, the angles of the walls in a room).

Although there are no precise rules in laying out a composition, we can generally advise beginners as follows:

- *Seek* the best framework possible and don't make do with the first solution. In a portrait or a figure drawing, place the model in various positions until you find the most meaningful one. In a landscape, look for the most expressive foreshortening and, especially in your early efforts, put something in the foreground (a tree, a hurdle, a building) to emphasize the illusion of depth.

- Make sure you gauge the drawing accurately within the area of the paper so that you can include everything you want to depict without hitting the edges of the sheet.

- Avoid shifting the composition toward the top. If anything, move it down to leave a breathing-space at the top of the paper.

- Remember that the fulcrum or, the center of interest or focal point of your subject, does not have to be at the center of the paper. On the other, hand, the entire composition must be arranged to lead us to the fulcrum. That is, it must be laid out so as to virtually create a narrative around the primary element.

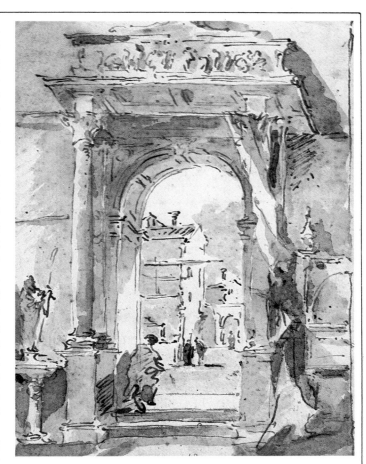

Francesco Guardi (1712-1793): Caprice. Inner Portico of Church, *c. 1770-80. Pen and brown ink, brush and brown wash, 195 x 148 mm. Museo Corror, Venice.*

Guardi's fanciful framework is typical of a way of opening a "window", a space (in this case, the portal of an imaginary church) onto a landscape: the "frame of the frame." The effect is accentuated by the rapid watercolor strokes, by the cloaked figure standing against the light, and by the awning on the right.

—95—

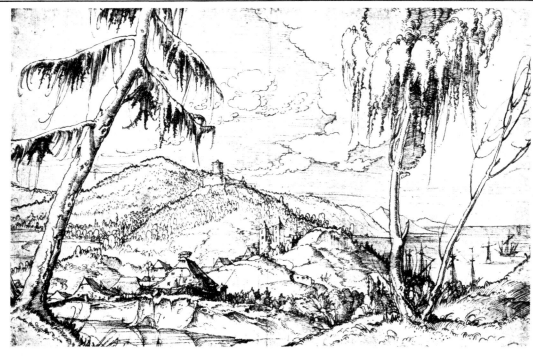

Erhard Altdorfer: Mountain Landscape Near Bay. *Brown ink, 206 x 311 mm. Albertina, Vienna.*

The mountain overlooks the village, which faces the bay on the right. Above, the cloudy sky occupies the upper half of the

paper. However, the framework finds its depth and significance mainly in the foreshortening suggested by the three trees in the foreground. Their function is made obvious by a comparison of the two diagrams.

Foreground and Background

A composition traditionally contains both a foreground and a background, though it is possible for a drawing to consist purely of all "foreground" (as in a portrait of a seated or standing figure against a monotone background) or all "background" (such as in the view of a landscape with no framing element).

When we think of a framework or when we wish to choose one, especially for a scene or a landscape, the search for a foreground is almost self-evident. The foreground is the element that "cuts" the scene, that frames it, that gives us a feeling of depth in shadow or light. It is an element that artists in all eras like to put on the surface plane of a work in order to evoke the distance between foreground and background and hence give the illusion of depth. But choice of a foreground is not the only way to suggest space. Sometimes the perspective (linear or aerial) can also give depth and atmosphere to a drawing.

The foreground has had an interesting development. While we find many foreground elements that frame the most diverse scenes throughout the history of drawing, the fore-

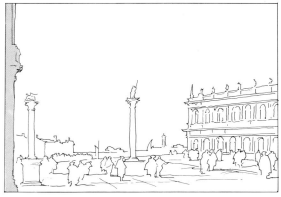

Francesco Guardi: La Piazzetta in Venice. *Brown pen and ink, and brown watercolor on a black pencil sketch, 293 x 210 mm. Louvre, Cabinet des Dessins, Paris.*

The framework draws its precise strength from the terse architecture on the left. Although this is a barely perceptible element it constitutes a basic support for the entire composition: the diagram from which this left-hand architecture is removed shows how important it is.

ground really came into its own during the nineteenth century. Employed in very different ways, it gave many drawings (including pastels and watercolors) a new cut, virtually a cinematic quality. In fact, this type of framework was born and developed, or at least decisively influenced, by the invention and spreading use of photography.

The camera can catch an instantaneous framework, "slicing" a scene into bolder and more original foreshortenings. It thus suggested a new way for painters to see and compose. And indeed, many painters began to photograph their subjects, either to frame them in a new way or to freeze them in motion. They then referred to these photographs when they did their drawings.

We need only think of Degas and his ballerinas, with their extraordinary original and modern frameworks (seen from above, in foreshortening), and their exciting movements (they are always caught lacing their slippers or corsets). Or we can think of his race horses—surging into a gallop or trot, in an accurate rhythm of hoofbeats. These are just some of the most significant examples of the new way of seeing and fixing the image.

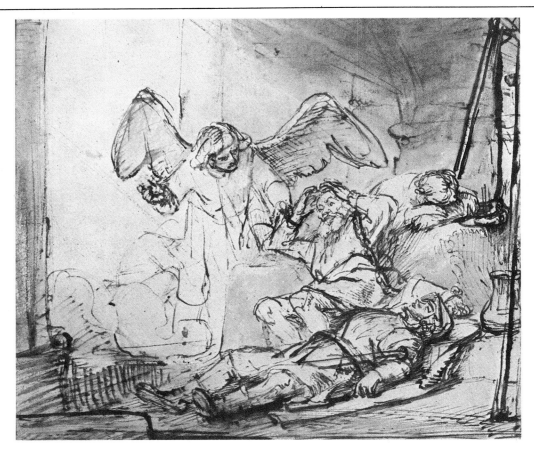

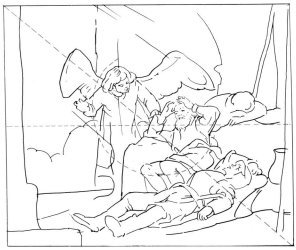

Rembrandt: Release of Saint Peter from Prison.
*Pen and ink, sepia tinting, 220 x 195 mm. Städelsches
Kunstinstitut, Frankfurt.*

The Choice of a Framework

There are as many frameworks as there are draw-ings. There are frameworks that contain a
foreground and background; frameworks with a
low or a high skyline; frameworks with a "cin-ematic" cut; vertical or horizontal, static or dy-namic frameworks; frameworks cut out against a
background that continues to the edges of the
framework; and frameworks that are sharply
defined....

It's more useful to study the frame-works of the great masters in order to ferret out
the principles that have guided them in defining
the focus of an image. The framework not only
serves to define the "space" of the drawing within
the rectangle of the sheet, but, together with other
elements (e.g., chiaroscuro), it contributes to lead-ing the viewer's attention to the meaning of the
drawing—toward the focus. The focus is not nec-essarily the center of the drawing. It is the part
that interests us most and that we intend to
emphasize in some way, through elements such as
the foreground.

Rembrandt's sketches once again form a special
chapter in this area. His drawing *The Release of
Saint Peter from Prison* catches the moment when

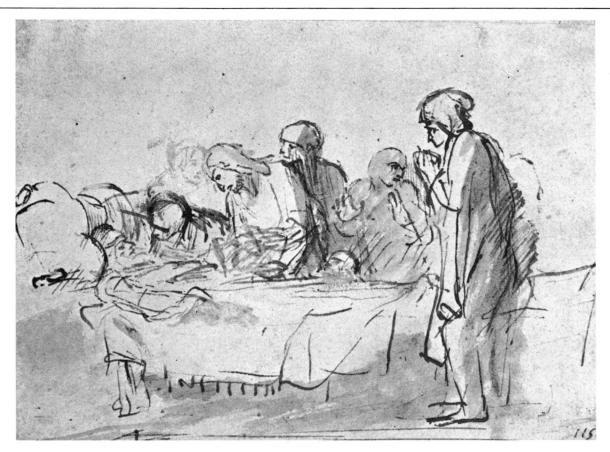

the prisoner awakens. "And wonder of wonders, the Angel of the Lord came down to him, and a light shone in the prison; the angel struck Peter on his side and raised him up, saying: 'Arise, instantly.' And the chains fell from his hands."

As always in Rembrandt, the framework is not exceptional. The artist seems to take us by the hand to witness the scene. The framework is emphasized by stronger lines in the foreground. The composition is placed on the diagonal, which, running from the bottom left, guides us to the figure of St. Peter. The diagonal begins with the angel with open wings and concludes with the figure of the soldier, who sleeps heavily. The framework, the layout, and the composition are all elements that, while treated separately for pedagogical reasons, join together to form the meaning of the drawing.

Let's look at another sketch by Rembrandt, *A Sick Man Revived by Christ.* Here, we find the same naturalness in the simple and expressive framework. The figure of Christ emerges luminously as the focus of the scene. This focus is arranged by means of a composition that places the figures next to one another from right to left, toward the sick man's bed, and through the few essential bistre brushstrokes in the figures around Christ.

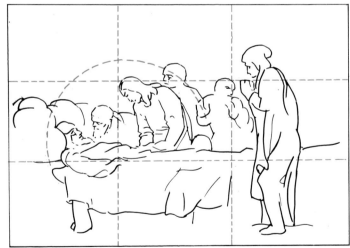

Rembrandt: A Sick Man Revived by Christ. *Pen, brown ink, and watercolor, 193 x 144 mm. Royal Museum of Fine Arts, Gift of the Ny Carlsberg Foundation, Copenhagen.*

Various Frameworks for the Same Subject

In order to understand the meaning of a framework, it is useful to look at several art works and analyze those that have used the same subject, but viewed from different points. The repeated theme—observed, studied, drawn, painted two, three, or more times, almost obsessively as an exercise or simply as an expression—is a phenomenon found frequently in art. Just think of Mont Sainte-Victoire, repeatedly drawn and painted in oils or watercolors by Cézanne. For him, it was not just a random theme, but a subject in which he found everything he wished to express in drawings and colors, beyond the mere technical problems of light and volume. It was an utterance of the tensions and aspirations intrinsic to the meaning of his vision and apparently linking the earth to the sky.

Throughout the various interpretations of Mont Sainte-Victoire, Cézanne's framework never changes. Here it is not so much the viewpoint that interests us as the way the subject is seen and depicted: as an expression of a way of seeing and conceiving of nature "according to the cylinder, the sphere, and the cone," through the air that charges the azure tints and the atmospheric rays. This type of exercise "on a motif," as the French artists defined it, is the premise for changing the viewpoint, the point of observation and depiction. This phenomenon replaced the change of sub-

Polychrome woodcuts from Thirty-Six Views of Mount Fuji. *1. Katsushika Hokusai:* The Wave—Fuji Seen Through the Trough of a Wave, *1823-32. 253 x 382 mm. Österreichisches Museum für Angewandte Kunst, Vienna. 2. Andô Hiroshige:* Fuji Seen by Ryōgolu Tôto, *1858. 340 x 222 mm. Private collection.*

1. *Katsushika Hokusai:* Mount Fuji in Fine Weather *from* Thirty-Six Views of Mount Fuji. *Österreichisches Museum für Angewandte Kunst, Vienna.*
2. *Andô Hiroshige:* View of Mount Fuji with River and Bridge *from* Famous Views of More than Sixty Provinces. *212 x 364 mm. Private collection.*

jects, which was normal, especially in landscape painting, until Impressionism.

The examples presented here to illustrate diverse frameworks for a single subject are taken from Japanese drawings, or rather lithographs. They were done in the nineteenth century by two extraordinary artists: Katsushika Hokusai and Andô Hiroshige.

Hokusai, who did exceptional paintings and drawings, signed his works "the old drawing lunatic." His books, *Manga,* form a sort of encyclopedia of drawing: an infinite series of graphic depictions covering all themes of human activity, from Japanese wrestling to farming. And his landscapes are equally fascinating. Among them, there is the *Thirty-Six Views of Mount Fuji,* the volcano that is a mythical figure in the life of the Japanese archipelago: like a beautiful woman or a god, it is "framed" by trees, human figures, wagon wheels, or oars.

Hiroshige, a painter of courtesans and landscapes, likewise could not forget Mount Fuji. His views are equally creative: profound landscapes rendered with the extraordinary essentiality that is typical of Japanese painting.

The factors that contributed to making Hokusai and Hiroshige famous in the Western world (as we can see from these examples) are their exceptional color sense and their highly original compositions.

Different Frameworks

The views of the Acropolis in Athens, particularly of the Parthenon, exemplify a diversity of frameworks for the same subject. Each depiction seems to acquire new and different meanings because of the specific viewpoint chosen.

1. View of the Acropolis: on the right, the tympanum of the Parthenon.
2. View of the Parthenon from the Propylaea.
3. The face of the Parthenon.
4. The inside of the temple.
5. The Parthenon with, on the right, the Erechtheum and the gallery of the caryiatids.

1

2

—102—

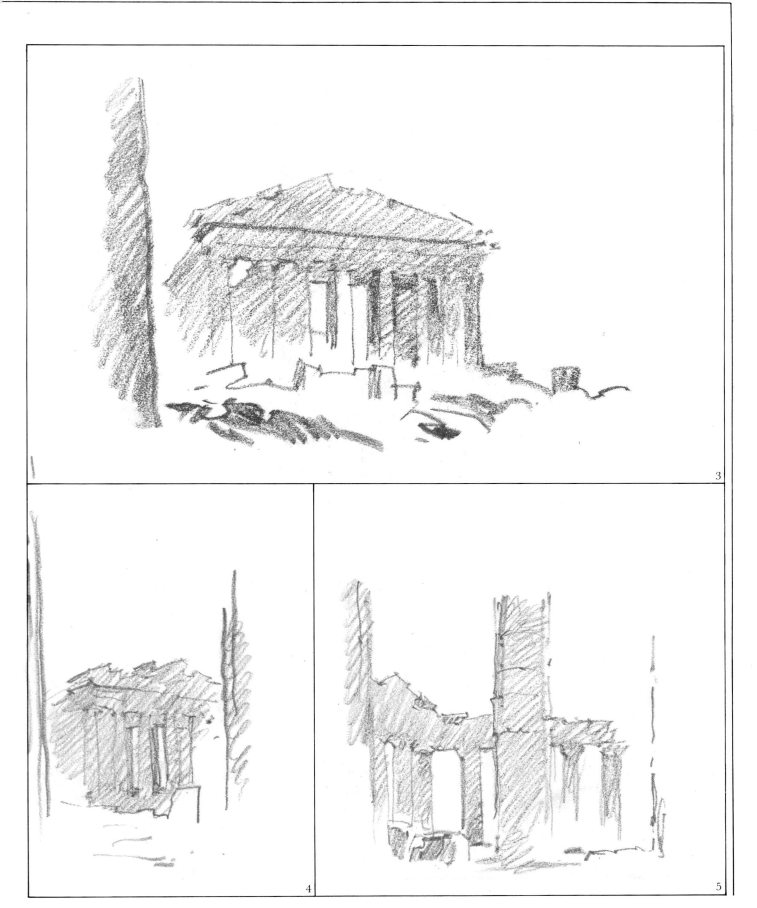

3

4

5

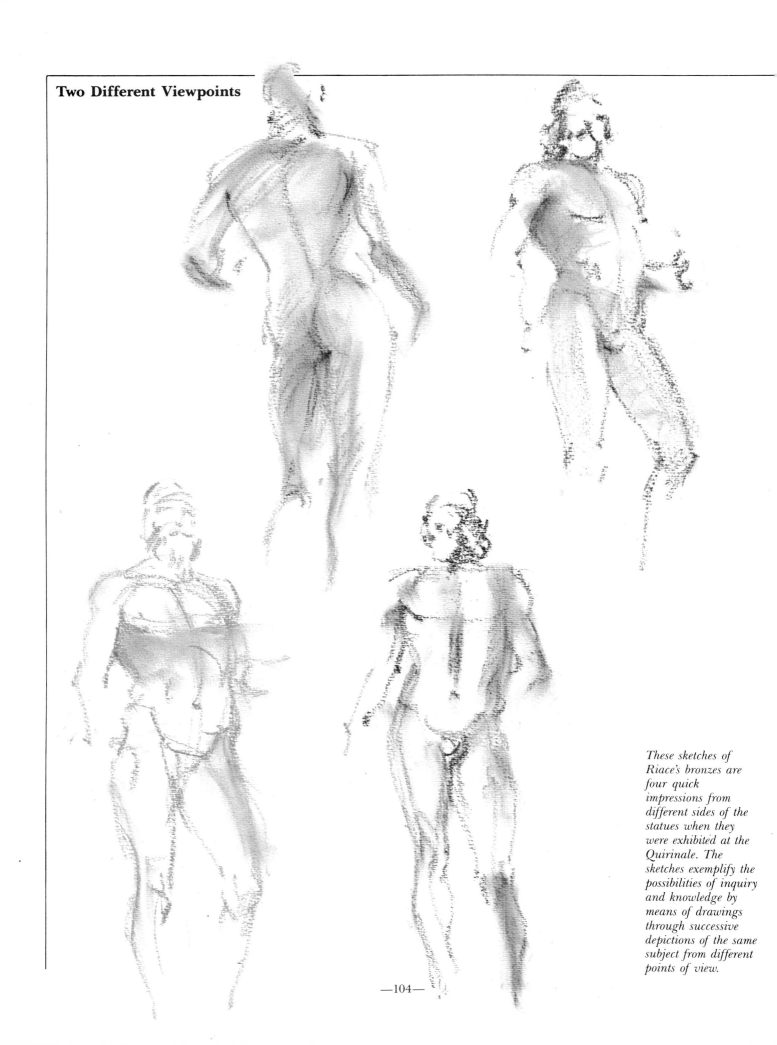

Two Different Viewpoints

These sketches of Riace's bronzes are four quick impressions from different sides of the statues when they were exhibited at the Quirinale. The sketches exemplify the possibilities of inquiry and knowledge by means of drawings through successive depictions of the same subject from different points of view.

The Layout

The layout of a drawing is its arrangement within the space of the sheet of paper.

If we succeed in placing the image within the rectangle of the sheet, then we may say that the layout coincides with the framework.

The viewfinder helps to fix the boundaries, the outside rectangle, of your image. And once the subject is transferred to the paper, the drawing itself becomes the layout, pulling different meanings and overtones from the subject.

Yet another way to establish the layout is to sketch the subject first in a corner of the paper and then indicate the proportions of the paper around the drawing to define the exact layout before you start to draw.

You can often arrange the layout to give the composition a particular meaning, an expressive charge. This can be done by positioning the horizon within the rectangle of the paper, or by placing a figure to the right rather than to the left, or higher rather than lower; or through variations in the proportions of blacks to whites and of drawn to undrawn areas.

How can we make the drawing go beyond the edges of the "frame"?

When you look at a subject, you not only see the part on which the eyes focus, but you also sense the lateral areas on the edges of the visual zone. You then place the drawing on the paper in terms of your natural (or visual) framework. Thus the

David Wilkie (1785-1841): Mrs. Grant Knitting. *Pencil and watercolor with white-pencil highlights, 373 x 273 mm. Henry E. Huntington Library and Art Gallery, San Marino, Calif.*

Now that we are used to photographic and cinematic cuts and frameworks, we are not unduly impressed by this profile of an Englishwoman absorbed in her knitting. But if we view this fine drawing within the climate of its era, the early 1800s, we will sense the boldness and originality, which slices through the sitter's turban, shoulders, and arm, emphasizing the profile, the heavy earring, and the hands at work.

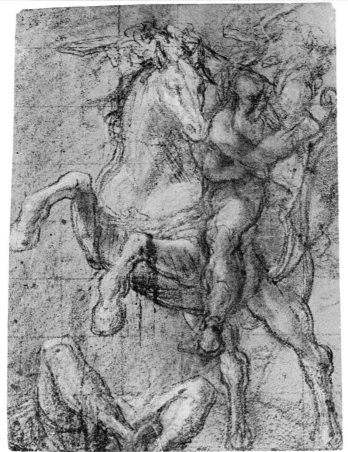

Titian: Horseman and Fallen Warrior. *Charcoal and white chalk, colored paper, 346 x 252 mm. Staatliche Graphische Sammlung, Munich.*

Compared with Murillo's horseman (below), the rearing horse in Titian's drawing does not move forward. What determines this difference in the effects of movement or stasis? Simply the framework and the layout, and, hence, the "openness" of the drawing toward the right or the left. If the motion is from left to right, the normal direction of reading, then the horseman seems to be entering the scene; if the motion is from right to left, then the horse seems to be rearing.

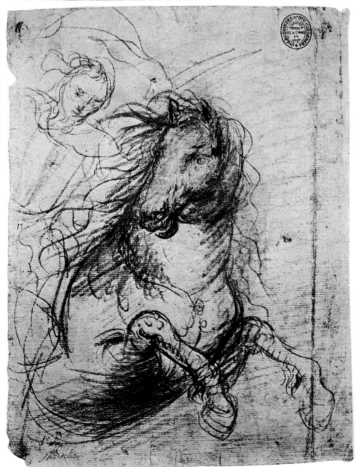

Murillo (1618-1682): Horseman and Galloping Horse. *Black pencil, 274 x 200 mm. Biblioteca Nacional, Madrid.*

In this drawing, positioning the horse and the horseman in the left of the sheet of paper gives the group a particular thrust because the framework cuts it in half. The horseman almost seems to be charging into the space of the paper in order to dash beyond it along the reading direction of the drawing, from left to right, and along the diagonal.

layout contributes to communicating our perceptions and the effect of our visual framework, so that we give the drawing a special meaning according to our goals.

Even if there are no geometric rules in making a layout, there are nevertheless certain shortcuts. For example, the beginner doing his first drawing, say of an outdoor scene, tends to put the skyline at the wrong eye level. That is, he places the horizon in the upper part of the paper, thereby shifting the entire framework upward and leaving a relatively large amount of space for the horizontal plane and little for the vertical plane. The result is the exact opposite of what actually happens when we look at something: the horizontal plane is usually extremely foreshortened, while the vertical plane stretches upward, above our visual angle. It is therefore better to lay the drawing out more toward the bottom, leaving a large space for the sky. Just think of the highly imaginative landscapes done by Canaletto or Rembrandt where the sky is the main feature, extending vastly or dominating the strip of landscape.

As an exercise, it is interesting and entertaining to shift the position of the skyline in a landscape or the position of a figure in a scene with respect to the rectangle of the paper. Vary the layout in this manner and observe the way the meaning of the image changes. The relationship between the figure and the perimeter brings about this change and contributes decisively to helping the viewer participate in and read the drawing.

The beginner must understand what the layout of a drawing or a painting means. He must see how the positions of the compositional elements within the rectangle of the paper create a precise meaning or at least add to it. To clarify this process, we have selected several drawings by masters, focusing our attention on how to read a specific layout that is based on conscious or instinctive choices by the artist.

Both the layout of the subject and the layout of the sheet of paper make the composition seem static or dynamic, and they suggest the completion of the subject or the extension of the space.

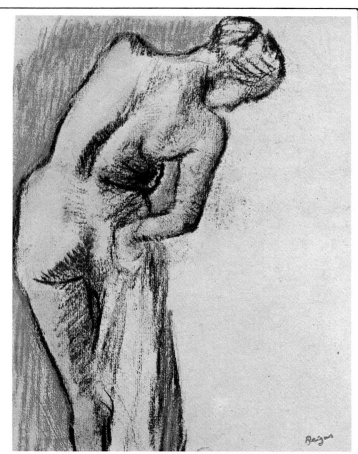

Edgar Degas: Nude After Bath. *Charcoal, pencil, and pastel on cream-colored paper, 321 x 248 mm. The Metropolitan Museum of Art, Rogers Fund, New York.*

Among Degas's many female figures portrayed drying themselves, this one stands out because of the left-hand layout. Half the drawing, the right side, is meant to emphasize and bring out the posture and profile of the woman who, in this particular layout, is given the more meaningful line.

Lyonel Feininger (1871-1956): Baltic Sea. *India ink and watercolor, 280 x 450 mm.*
Campione d'Italia, Collection Roman Norbert Ketterer.

Selecting the Layout

As we have indicated, the framework does not always equal the layout. That is, the chosen perspective cut (the part of our vision defined as the "frame") is not always rendered in the same proportions on the rectangle of the paper.

Often, after an artist has drawn the framework of the real or imaginary scene, he then modifies the edges. That is, he tries out a different framework on the drawing itself, a different definition of the position of the scene within the rectangle of the paper or canvas.

Basically, a photographer does the same thing. After shooting and developing a picture, he trims the cut, emphasizing certain elements and omitting others. (Admittedly, some photographers do not go along with this method. They feel that the photographic cut is the one fixed by the photograph when it is taken, and that it should not be subsequently manipulated.)

To illustrate changes in the framework in the layout, we will examine the art of Tintoretto, Manet, and Feininger.

In the preparatory drawing for *Venus and Vulcan,* Tintoretto fixes the moment in which the goddess of love (in the foreground) catches sight of her approaching husband, the limping Vulcan. As in nearly all of Tintoretto's works, the composition is based on the diagonal, which here runs from top left to bottom right. Venus remains within the left part and the celestial blacksmith in the other, weighing it down with his heavy step and his body. Perhaps in order to stress this feeling, Tintoretto places a huge, round convex mirror behind Vulcan, virtually an enormous curious eye that reflects the scene.

The figures seem to acquire a circular movement in the mirror, and in order to accentuate and contrast their curving parts, Tintoretto modifies and works out the layout of the drawing upon the paper using a rectangular pattern. This structures the composition precisely as he concentrates the action and creates space (see diagram).

In Manet's *Woman Dressing,* the proportions and essential forms of the figure are blocked in by a synthetic line, with a few chiaroscuro jottings. Thus Manet has "cut out" a different layout. We may say that by squeezing the frame, he achieves a new framework for the subject. He has eliminated the legs in order to focus attention on the bust and the folds in the drapery. The diagrams underscore the various results suggested by the diverse frameworks and layouts.

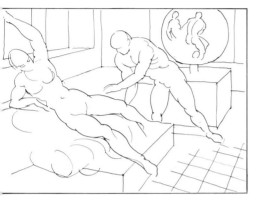

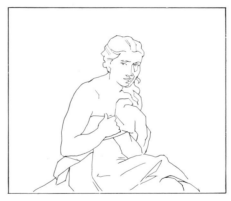

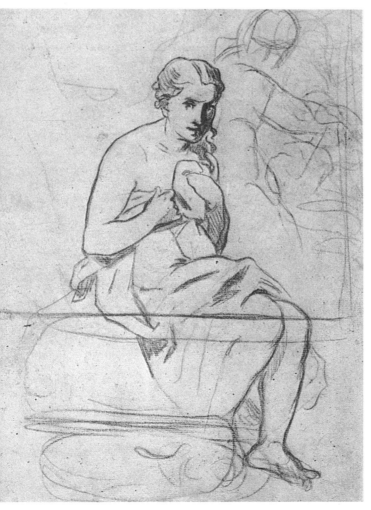

Feininger, in his watercolor *Baltic Sea,* has sketched the icy landscape with skillful brushstrokes on a semi-wet paper to obtain the particular effects of glazes and transparency. The main features here are the atmosphere and the sea. Depth is suggested by the profile of the boat and the high horizon. Feininger has covered the entire sheet of paper with watercolor, leaving no frame. He has then "framed" it with a thin rectangular line that encloses the layout.

In addition, by permitting the wake of the boat to break up the linear outside framework, Feininger suggests the vastness and continuousness of space beyond the limits of the paper.

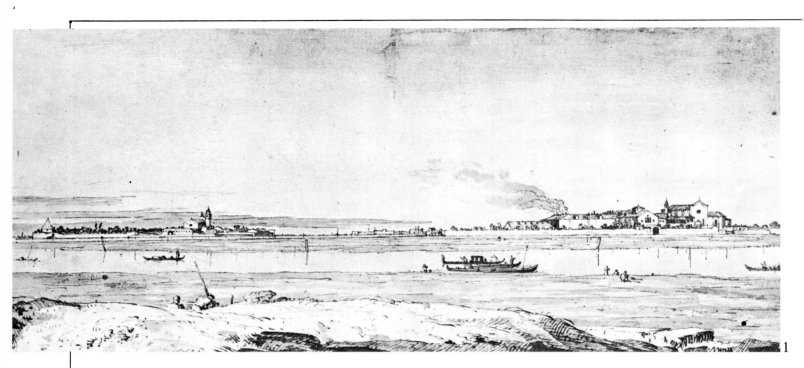

Canaletto: View of Saint Helena with Charterhouse. *Black pencil, pen, brown ink, brush, gray ink, 155 x 352 mm.* Windsor, Royal Library, England.

The Format of the Paper

The choice of a format is as important to the drawing as the layout.

In general, a sheet of drawing paper is rectangular, with the sides in a 3:2 ratio. That is, the longer side is about one and one half times the length of the shorter side. This format, whether large or small, instantly offers two possibilities: vertical or horizontal use. And while it may sound superfluous to talk about it, I believe that it is useful to pay some heed to the position of the sheet, vertical or horizontal, in relation to the chosen framework.

Obviously, if the subject has a vertical movement (a trimmed tree, a standing figure, even a portrait, bust, or head), the paper should be held vertically. And if the subject has a horizontal movement (a landscape, a wide vista, a reclining figure), then the paper should probably remain horizontal. All these factors are linked to the framework and hence to the layout because the framework must be transferred to the rectangle of the paper, virtually unfolding within its boundaries, to suggest continuation and completion of the idea.

The described proportions are the normal ones for a sheet of drawing paper and most often used in various measurements. But we sometimes use special formats, such as a square or an unusually long or narrow paper.

There is no rule for when to choose a normal or a special format, a square or an extra-narrow one. But logically it should depend on the subject, or rather on the framework and on the meaning you wish to emphasize with a particular format.

For instance, if you want to stress the compactness and symmetry of the foliage of a tree, you should choose a square sheet of paper. And if you want to depict a vista, a flat landscape, or a seascape viewed from a low point, an elongated horizontal format will accentuate the impression of amplitude.

Drawings with a high or narrow format are in a special category. It is precisely their curious proportions that suggest special elements or solutions, some of which are truly bizarre and effective. Although at first they may seem limited, they ultimately stimulate the artist's taste and inventive faculties.

1. *As in many of Canaletto's landscapes, the wide, sprawling view obviously demands a special format: a rectangular sheet of paper, the larger side of which is more than twice the length of the shorter side. This creates and emphasizes the effect of vastness and depth. The fundamental feature of this view is the position of the horizon in relation to the height of the surface, which also defines the height of the viewpoint. Depending on whether the horizon is raised or lowered, it will bring out the foreshortening of the surface of the sea or the vastness of the sky.*

2. *Anonymous Japanese Master:* Girl Behind a Half-Open Sliding Door, *first half of the nineteenth century. Scroll, 130 x 38 cm. Museum für Ostasiatische Kunst, Cologne.*

3. *Gustav Klimt:* Woman Standing Among Flowers, *1898 (appeared in Ver Sacrum, vol. I, no. 3). Black ink on paper.*

2

3

Changing the Layout

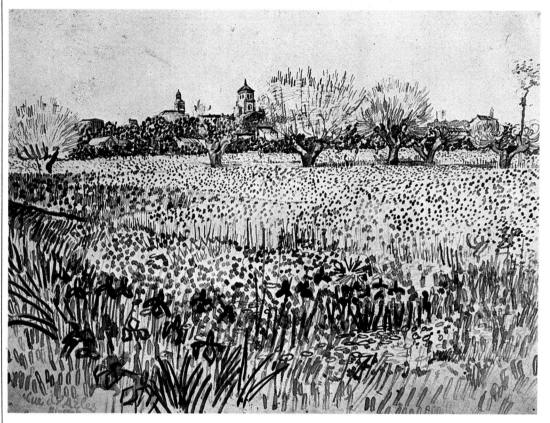

Vincent van Gogh:
View of Arles. *Reed pen and India ink, 430 x 547 mm. Rhode Island School of Design, Museum of Art, Mrs. Murray S. Danforth Donation, Providence, R.I.*

1

1. The diagram of Van Gogh's original drawing brings out the three horizontal bands into which the compositional space can be divided. The top third is for the sky, the bottom two thirds are for the field.

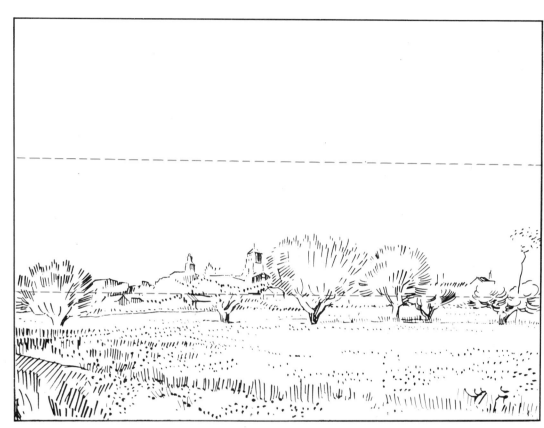

2. Try to lower the horizon, that is, move the layout further down, leaving twice as much space for the sky. Obviously, the effect changes everything. In the original drawing, the main feature is the field. In the second drawing, the main feature is the sky, while the field becomes far less important.

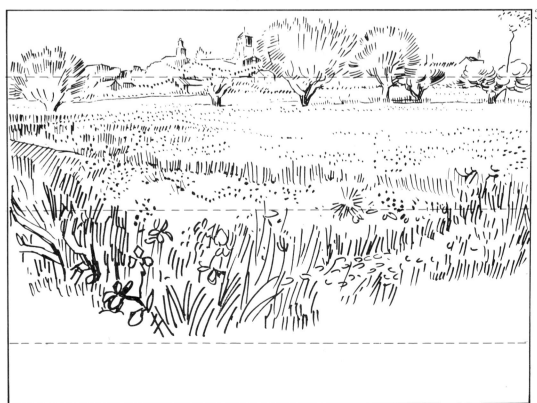

3. With the space for the sky reduced even more, the landscape seems almost suffocated. Everything—the view of the field, the outline of the countryside—seems to lose its depth.

A Drawing a Day: On the Side or the Center, Up or Down

1. The original portrait of this little girl shows the head on the right side of the paper. Space is left for the arm and, above all, for a sense of continuation of the drawing into the blank area. Now imagine the drawing with the girl's head at the center of the paper. This seems to wipe out

1

the feeling that the drawing, and hence the figure, can be continued and completed. We have already discussed the importance of blank spaces in a drawing. The value of the blankness here complements the value of the line.

2. In the original drawing, the female figure on the bed is placed in the upper part of the paper. If we shift her to the horizontal center, we change the effect. We no longer feel as if we were participating in the drawing, and the image becomes banal.

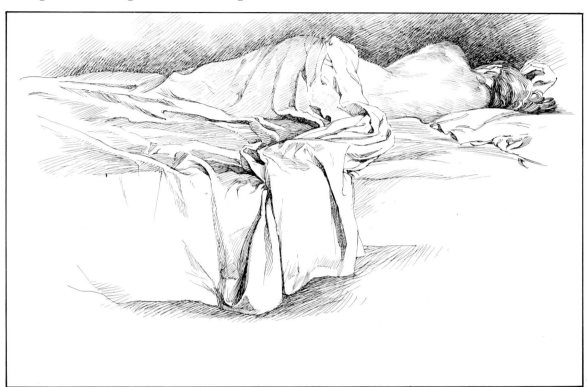

2

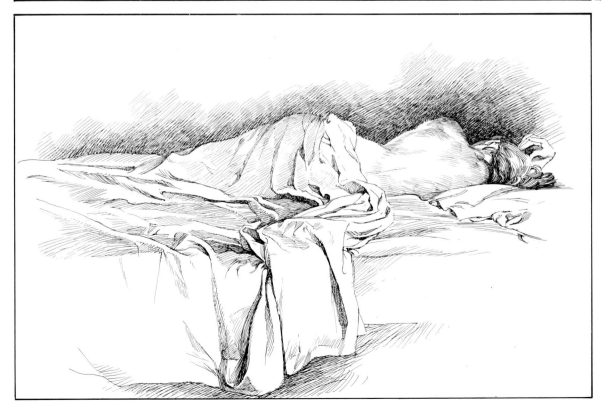

Layouts of Sketchbook Notations

Certain layouts are effective not for drawings, but for pages of notes and sketches. I don't mean a typographical layout (which will be discussed later). Rather, I am referring to the kinds of compositions artists create instinctively in their sketchbooks when jotting down impressions and comments.

Often these written and drawn notes are direct and immediate expressions of their experiences. Captured only in pen and ink or with touches of color, and interwoven with written comments, these sketches form a composition, and the more natural it is, the more meaningful it becomes.

Numerous artists have left behind pages of such notations. From many examples, we offer a page by the French painter Charles-François Daubigny, who recorded a voyage on his studio-boat Le Botin in rapid pen-and-ink sketches. Settling on the bank of the river Oise, he would paint from a boat that he had transformed into a studio. He then sailed the waters of Ile-de-France and Normandy. This page of his sketchbook, in addition to any analytical or documentary value, invites us to look around, to see, to get to know, to comment on our own surrounding world through similar notations in our sketchbooks.

Charles-François Daubigny (1817-1878): Episodes of a Boat Trip *(from a letter to Geoffroy-Dechaume), 1857. Pen and brown ink. Louvre, Cabinet des Dessins, Paris.*

The Synthesis

Pablo Picasso: Minotaur, *1928. Collage. Paris, private collection.*

Throughout his long life, Picasso covered thousands of sheets of paper with his strokes and lines, and he tried his hand at all techniques, from ceramics to collages.
This is a collage that, in the synthesis of its precise lines and its materials, sums up Picasso's numerous drawings on the theme of the minotaur. It is a logical conclusion to his many studies and experiments.

Throughout your work on a drawing, never lose sight of the fact that your image of the subject must be unified. The final result is an interpretation of the unified impression received by the eye. In the gradual stages of the development of a drawing, you must work toward that synthetic vision.

We have often said that in order to see synthetically, you have to squint your eyes at your subject. This makes the details vanish or melt into an overall vision. However, synthesizing a drawing does not only mean reducing the image to a small number of strokes and lines. You also have to render the essential significance of what you perceive in a direct and immediate relationship between the real or imaginary vision and yourself (and therefore the observer).

If you can produce a synthesis of the image or the idea, you will discover the secret of drawing—uncovering the relationship between you and the surrounding world and transmitting what you observe. This synthesis is attained as the conclusion of a process of gradual conquest, by way of study and practice, through the acquisition of the essential. It is not an expression of simplification.

Seeing and drawing synthetically requires the fortunate combination of various factors and circumstances achieved by both artists and scientists, although in different areas. Scientists react to the equation of the personality and nature. They find synthetic meanings in analysis by dealing with the constitutive elements of an object, its properties and potentials. Artists, on the other hand, instinctively or by synthesis, manage to see the subject, to perceive the necessity of its outline and light. They not only see it with the intellect, as

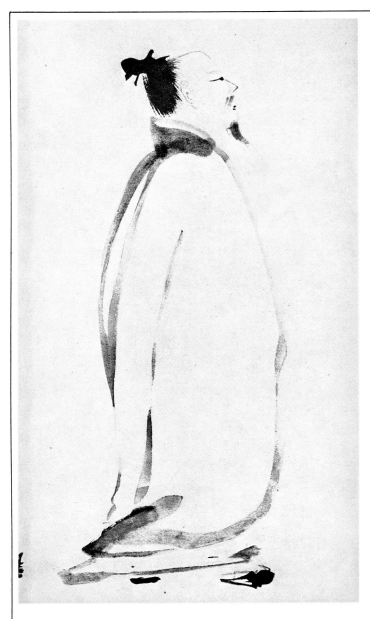

maintain that unity and achieve the synthesis, everything in the drawing must be worked on at the same time if possible.

Shape and chiaroscuro, no matter how interdependent or differentiated, actually embrace the entire subject in a single problem of synthesis. Every element, every detail, is seen in terms of everything else—outlines, chiaroscuro, within the whole of the framework.

The subject, although analyzed in its particulars, is constantly seen and drawn in terms of its entirety, according to a series of relationships that unify and proportion all the aspects, allowing the artist to check the relativity in a correct rendering.

We must remember that while a detail may seem distinct if examined separately, it will fuse harmoniously into the vision of the whole and thereby aid the synthesis of the drawing.

Such synthesis may be instinctive for an artist. But it requires reasoning in a beginner dealing for the first time with the problems of drawing a real or imaginary subject. This reasoning must then guide any drawing, whether it is merely sketched or worked out precisely in its chiaroscuro.

If I may bring up a personal memory, I would like to talk about my experience in a life-drawing class at the Academy of San Luca, Italy, which I attended many years ago. During the week, a group of draftsmen and painters were studying the human figure every day but working quite independently of each other. Inexperienced as I was, I attended the nude studio for the two hours assigned daily. I drew the model with pencils and watercolor, doing my best to faithfully reproduce the shape, color, and chiaroscuro, thus completing my drawing in two or three sessions.

This was certainly a useful exercise. But it wasn't until the end of the year that I realized something important: A classmate, who later became one of our best contemporary painters, had a method that was far more productive, intelligent, and exciting than the one I was learning.

scientists do, but they also reexperience it spiritually, identifying with their intuition. Hence, the synthesis constitutes the result aimed at by any quest for shape or chiaroscuro, light or atmosphere, by means of any technique or medium.

The fact that we have not discussed this matter until now does not mean that it follows the others in the development of a drawing. We have already said that in a methodology of drawing, the various aspects are separated and arranged in an operative order so that we can deal with and develop each one in terms of the others. None of them can exist without the others. They are linked by contingent demands and technical necessities, constituting a unity that begins with the formation of the unified image on the retina and ends with the synthetic rendering of that image. In order to

1

2

3

Ernst Ludwig Kirchner (1880-1938): 1. Woman Sitting in Front of a Mirror. *Pen and India ink. Galleria del Levante, Milan.*

In this sketch, Kirchner, a member of Dresden's Die Brücke (Bridge) in the early 1900s, uses a synthetic and incisive stroke to render the presence of the female figure with all its vital energy.

2. Henri de Toulouse-Lautrec: Cover of the album "Yvette Guilbert," *1894. Lithograph on drawing in pen and black ink, 410 x 382 mm. Private collection.*

How did he work? He spent almost the entire two hours simply gazing at the model. It was only after watching her for a long time that he sketched, on numerous sheets of paper, the general lines of the shape, the principal tones of the chiaroscuro, and a few details. However, the actual time he spent drawing was brief compared with the time he spent observing. It was only during the last few minutes, when he felt rich with the experiences he had acquired, that he took a larger sheet of paper. With a quick, sure gesture, he drew two continuous lines, bringing out the front profile and back profile in an extremely synthetic depiction of the model. This drawing contained the artist's entire analysis, his observations, and the numerous sketches and studies he had done during the two hours. Everything was now reseen and synthesized in perceptive lines that conjured forth both shape and volume, line and color.

Toulouse-Lautrec, who liked to take his subjects from real life, often did his drawings over again in the privacy of his studio. And in these sketches, he redid reality, managing to find lines and shapes capable of an extremely effective synthesis, more expressive than real life.
The drawing of the long female gloves on the edge of the bed (which is actually only suggested by the fold in the gloves and by no other element) is one of the most famous examples of the essentiality of the message in Toulouse-Lautrec's art.
3. White Villa in Hamburg, *1910. Lithograph, 390 x 345 mm. Bremen, private collection.*
This second drawing by Kirchner testifies to the same desire and capacity for synthesis: the white volume of the villa stands out between the two bands of color barely brought out by the outlines.

Synthesis and Sensitivity in Matisse's Drawings—As an Exercise

I believe that if you wish to understand fully what "synthesis" in a drawing means, there is nothing more convincing than to look at a work by a master who has achieved true synthesis in his drawings. Even better, you should listen to what

dashed off in a minute or two. "These drawings look more complete if the viewer compares them with a sketch. They generate light. Along with the savor and sensitivity of the line, they contain luminosity and the differences of values corresponding to color."

Matisse considers his line drawings (the most synthetic) also the most complete and expressive.

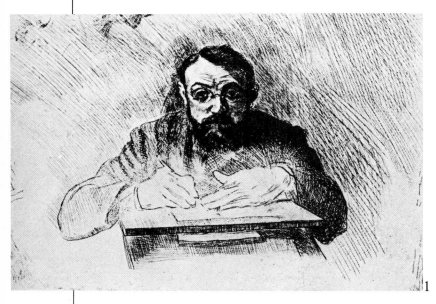

Henri Matisse:
1. Self-Portrait, 1904.
The Metropolitan
Museum of Art, New
York.

2. Self-Portrait, 1949.
Museum of Modern Art,
New York.

3. Four self-portraits,
1939. Museum of Art,
Philadelphia.

he has to say about this problem. In this regard, we offer exerpts from Henri Matisse's *Writings and Thoughts on Art* as well as several of his drawings. In their synthesis of the line, which seems so simple and natural, these drawings camouflage the study, analysis, and research of a life devoted to art.

"Isn't a drawing," writes Matisse, "the synthesis, the result of a series of sensations preserved and reunited by the mind and then unleashed by a final sensation, so that I do the drawing almost with the nonresponsibility of a medium?"

For Matisse, a drawing is the purest and most immediate translation of his emotion in that "the simplification of means makes this possible." But we should not be taken in by the simplicity of a drawing, even one that looks as if it had been

"These qualities…derive from the fact that the drawings are always preceded by studies done with a rigorous medium for strokes: for instance, charcoal or stump. This allows me to simultaneously consider the model's character and human expression, the quality of the surrounding light, the ambiance, and everything that can be expressed purely in drawing.

"It is only when I feel I have performed this labor, which can go on for several sessions, that I can trustingly let my pen go its way in a clarifying spirit.

"I then lucidly feel that my emotion expresses itself by means of plastic script.

"Once my emotionally moved line has modeled the light of the blank paper without depriving it of its poignant candor, I cannot add or subtract

These self-portraits by Matisse testify to the long development of his drawings; the stages of this evolution are lucidly explained in this passage from Matisse's Writings and Thoughts on Art: *"Among the drawings that I have so carefully selected for this exhibit, there are four...that reproduce my face as if it had been viewed in a mirror....These four drawings show the same subject, and the calligraphy in each one presents a seeming freedom in the strokes, outline, and volume. Actually, however, none of these drawings can be superimposed on any of the others, for each has a different outline. The upper portion of the face may be the same, but the lower portion is always completely different. In the first drawing, it appears square-shaped and massive; in the second one, it appears elongated in relation to the upper part; in the third, it ends in a peak; and in the fourth, it bears no resemblance whatsoever to any of the other three.*

"Nevertheless, the various elements that make up these four drawings present the organic composition of the subject to an equal degree.

"Although these elements are not always depicted in the same way, they always refer to the same sensation—the position of the nose, the position of the eye, the attachment of the lower jaw, the way the glasses perch on the nose and eyes, the tension of the gaze, and its uniform density in all the drawing—even if the shading of the expression varies from one drawing to the next.

"It seems clear that this sum total of elements describes the same man, both in his character, his personality, his way of looking at things, and his reaction to life, the qualms with which he faces it and which help him to stand up against it. It is thus evident that the anatomical and organic inexactness of these drawings has not damaged the expression of the inner character and inner truth of the personality; on the contrary, it has contributed to clarifying them. Can these drawings be called portraits? Just what is a portrait? Isn't it perhaps a depiction of the human sensitivity of the sitter?"

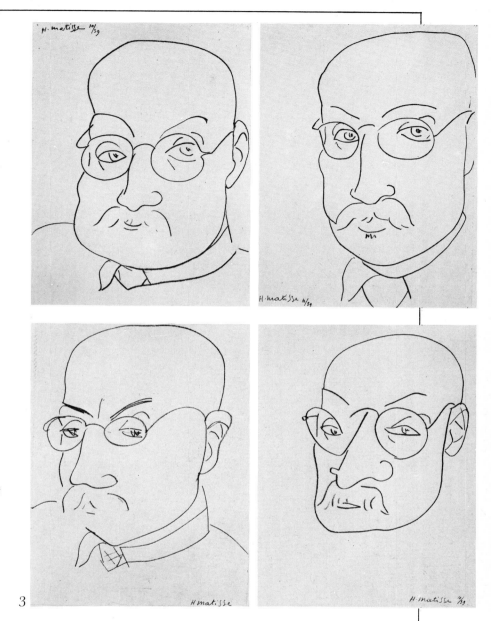

3

anything."

Along with the importance of the blank spaces on the surface, Matisse reaffirms the importance of the drawn line: "The drawing contains, in an amalgamation based on my possibilities of synthesis, the different viewpoints that I have been able to assimilate more or less in the preliminary study."

Matisse is explicitly inviting us to pick up a pen and draw. He is advising us to use a sensitive and synthetic line—the kind we have studied for a long time with pencil and charcoal, in shape, form, and chiaroscuro, with shading and the stump.

You can select a subject: a simple vase of flowers or the reflection of your face in a mirror. Draw the subject carefully on a sheet of paper. First, look for its shape and lay it out in the rectangle of the paper. Then, add the shading: first with the stump, rendering the light, the volume, and the variations in the tones of the leaves and petals. Then draw the vase and flowers or your face from the same viewpoint and then from another. Add a hatchwork shading, indicating the tones of light and dark in order to render the shape and the volume.

Finally, take a pen and record your experiments with a pencil or charcoal on a different sheet of paper. Draw the outline of the vase or your face with a synthetic line, a line that is "emotionally moved," as Matisse puts it. He is referring to a line that is born, that develops, and that conjures up the subject with all its capacity for expressing form synthetically.

"I consider my dialogue with Kokoschka this summer the most beautiful experience that I have had.

"[Kokoschka is] a great artist who fascinated us with his enthusiasm for art and life. We met late in the afternoon at the tavern of the castle that dominates the town…and it was really a joy listening to him….I had known Kokoschka at the Venice Biennale of 1948, and I had been struck by his vitality, his passionate words in defense of poetry, at a time when we felt the symptoms of a moral collapse that would inevitably lead to the search for nothingness. I saw him fleetingly at successive Biennales, but I got to know him better in Vienna, when he came to my show at the Künstlerhaus in spring of 1961. I remember that after looking closely at the sculptures and drawings on exhibit, he wrote a postcard to our mutual friend J. Paul Hodin, a British art

Emilio Greco's Synthetic Line

Emilio Greco is a Sicilian artist who has done the Pinocchio monument, the monument to Pope John in San Pietro, Italy, and the gates of the Cathedral of Orvieto. Among contemporary artists, he is one of those who tirelessly look for the synthesis by means of study and analysis.

Some of his female figures, for instance the three studies reproduced here, are caught in a foreshortening of abandonment. He uses a sure, essential outline interrupted by a soft, almost palpable light. These studies, more than any disclosure, can tell us what a synthetic drawing is.

When looking at them, we can practically hear his words:

"There are so many different motifs in the human figure that one never grows tired of depicting it. I never weary of the human figure, but that doesn't mean that I have something against abstract art. I would go so far as to say that the human figure is infinitely abstract. My choice is instinctive. I have remained faithful to figuration because I feel it instinctively and never tire of drawing it. I don't have to change because I have no reason to change, and I think that the theme itself can always suggest something….

"Synthesis…basically means abstraction; it corresponds to abstraction. If we interpret figurativeness as a realistic or veristic fact, then we have to look for other ways [to express ourselves]….

"The artist's intervention, interpretation, stylization, filtering are what modify, change, transform everything. It is through this filtering and synthesis that we can appreciate the artist's imagination."

historian. Kokoschka had me read the card and add my signature. I read the following words:

"'Greco is the Utamoro [Japanese painter, engraver, and poet of the eighteenth century] of sculpture.' Who knows why he described me in such terms.

"At the Academy of Rome, I finally managed to work with students as in a Renaissance workshop, despite the poor conditions.... I used my personal studio as a lecture hall. I believe that a stimulating everyday relationship, so necessary for teaching, was beneficial to both sides.

"All the sculptures I did during twelve years came from this school environment, where we still use a wood-burning stove and the thick smoke burns our eyes."

(from Emilio Greco: *Memory of Summer,* Bologna, 1980]

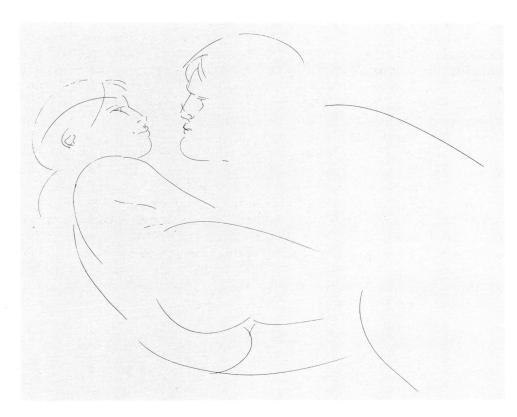

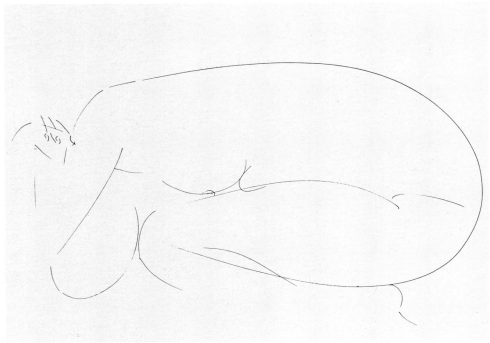

Picasso's Synthesis: *The Bull*

This series of twelve drawings or rather twelve lithographs shows the passage from an initial, true-to-life image of the bull to its complete stylization.

The successive phases are particularly interest-ing in that they illustrate the way Picasso works. From the first and rather realistic drawing of the animal, Picasso goes on to bring out the characteristics of the bull in the second and third images. But in the fourth stage (an artist's proof showing the state of the plate at a given moment), we see the "energy lines," which become more and more

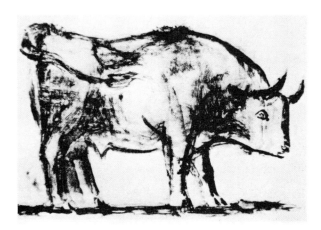

one

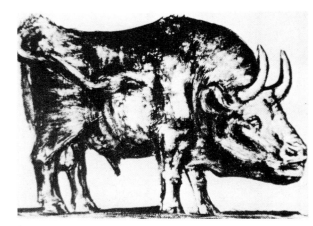

two

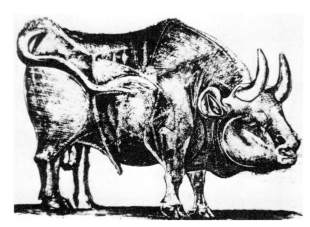

three

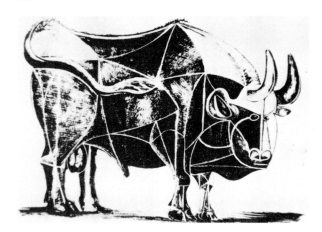

four

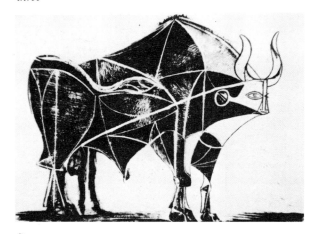

five

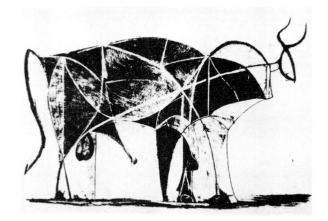

six

Pablo Picasso: Bull, *drawn by the artist on lithographic stone at Mourlot Printers, December 1946.*

important in the fifth and sixth stages. In the seventh and eighth, they constitute the warp and woof of the drawing. In the most essential lines, the ninth and tenth images prepare for the ultimate synthesis, in which the bull is interpreted in its essential form.

It is interesting to note that the conclusion to Picasso's process of synthesis is very close to cave drawings, which, as we recall, emerged from an instinctive expression in a magic rite. Their purpose was to help the hunters capture the prey. On the other hand, Picasso's drawings are the result of a long, rational experimentation.

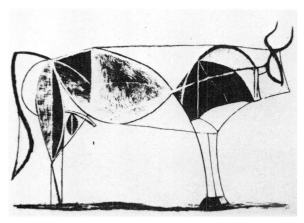

seven

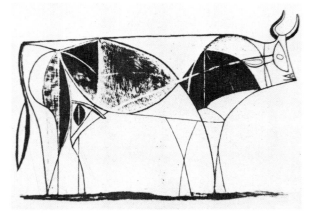

eight

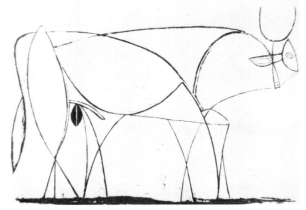

nine

ten

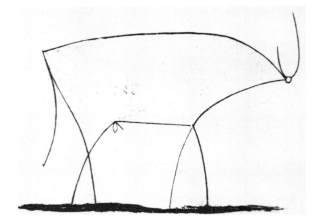

eleven

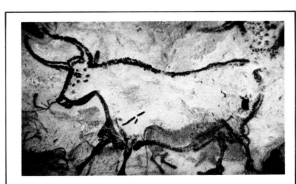

Cave painting from Lascaux

A Drawing a Day: From Analysis to Synthesis
The drawings presented in these pages illustrate efforts to achieve a synthesis of a female figure. The subject was drawn and studied in its form and chiaroscuro, noted in the differences and blurrings of the tones. Then, it was traced with a sensitive line that tried to synthesize these analyses.

Sometimes it helps to place a sheet of tracing paper over the drawing. Look for the line that appears to be already synthesized and trace it.

The position of the curled-up figure, virtually

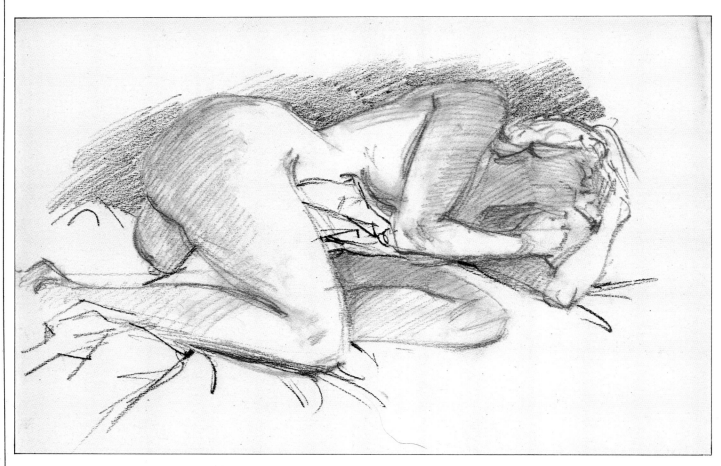

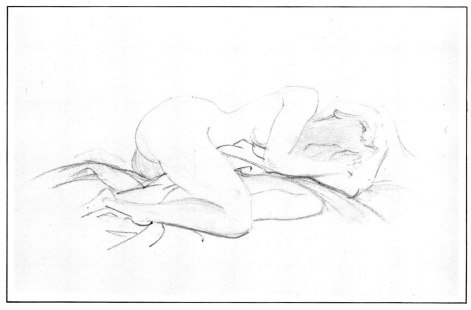

fragmented by the folds of the legs and arms, may at first seem more difficult than a stretched-out position. Yet it is precisely the references of the angles and directions of the limbs that make it easier for us to see, read, and draw the subject. Just look at the first drawing, and note, for instance, the sloping lines, the axes that guide the position of the upper parts of the legs and arms, and the horizontal lines of the lower part. The contour of the figure's sides and back help us to draw the shape of the background cut out by the woman's outline.

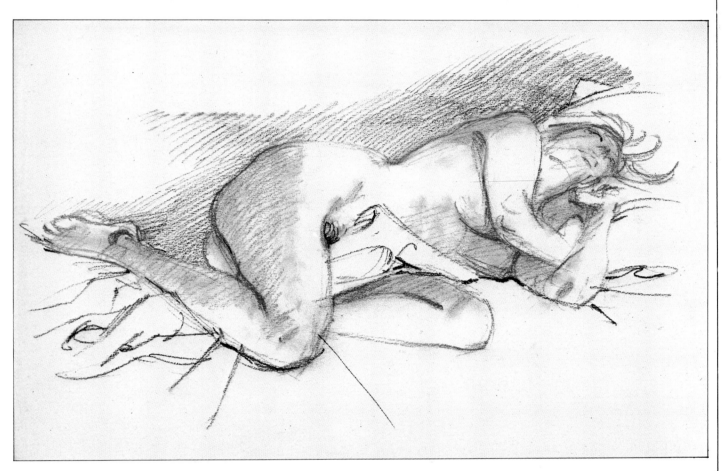

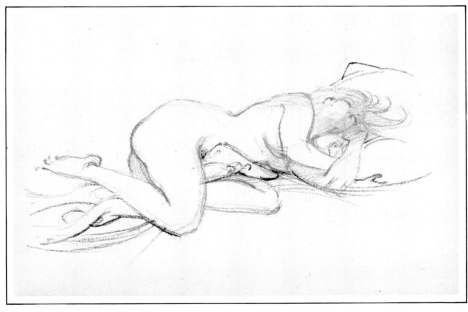

1. *Armando Testa (1917):* Punt e Mes the Great Vermuth. *Poster. Artist's collection, Torino.*

2. *Leonetto Cappiello:* Bouillon Kub, *Poster, 1930. Bibliothèque des Arts Décoratifs, Paris.*

3. *Paul Colin:* La Revue Nègre. *Rough sketch of the poster for the Théâtre des Champs-Élysées, 1925. Collection of the artist.*

The Language of the Poster

Synthesis is the goal of any art work, as an expressive meaning and as an interpretation of an image or idea. Thus in a particular graphic genre, the poster, the search for the synthesis is all the more important.

In fact, we may say that a synthesis is present twice in a poster. The first synthesis is when we try to extract the meaning of what we want to show, the significance of the product or message. Then we try to bring out the essence and synthesize the quality and characteristics on the rectangles of the paper by means of lines and colors. And we achieve a second synthesis when we try to express these characteristics and transmit them to the viewer. Once again we do this in a synthetic fashion; that is, we try to capture and depict the essential and meaningful data that distinguish and define the message.

Above all, the visual advertisement must instantly capture the viewer's attention and excite his imagination. We must remember that a poster is almost always viewed by someone in motion, usually on foot or in a vehicle. The advertisement must therefore have qualities and characteristics that grab our attention, so that we look at it and remember it.

The synthesis of the concept to be expressed and the synthesis of the way in which it is expressed are thus fundamental. Indeed, in the history of advertising, the most significant posters are those that use only a few strokes, a form, or a symbol to express their idea.

COMPOSING WITH GEOMETRY

Composition refers to the distribution and organization of the individual components of a drawing to arrive at a harmonious structure of the whole. The idea of a composition is fundamental to painting.

In his *Treatise,* Leon Battista Alberti pinpoints three basic aspects of composition: circumscription (the definition of outlines), arrangement, and the reception of light (which includes shadows and colors). In other words, first there is the drawing; last, the chiaroscuro and the colors; and in the middle, the composition—the dynamic and determining factor "that unites all the elements of the painting." Thus, according to a humanistic concept, the composition is a method for arranging the parts of the subject within the whole. Furthermore, the composition guides our eyes from the bodies to the limbs, and from the limbs to the surfaces.

Leon Battista Alberti is not the only artist to regard composition as central to the work process. We find the same order in *Dialogue of Painting* (1548) by Paolo Pino. This artist divides painting into three parts—drawing, invention, and color. Then he divides drawing into four—judgment, circumscription, practice, and composition.

Thus composition belongs to drawing and serves to maintain its dynamic and determining value. It is the plan that is realized in the artist's imagination, enabling him to carry out the drawing according to the arrangement of the parts.

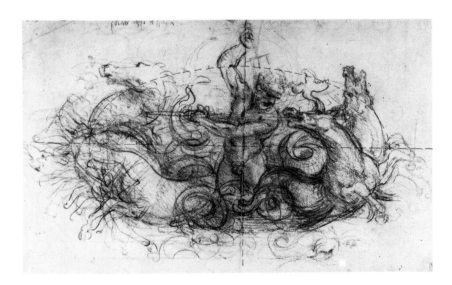

Leonardo da Vinci: Sea God in Chariot. *Black pencil on white paper, 251 x 392 mm. Royal Library, Windsor, England.*

The axial composition is underlined by the perfectly orthogonal spears held by the god while the galloping seahorses whirl around him in an eddy of tails, heads, and hooves.

Composition in Giotto

The composition of a work of art is what integrates it, the basic element of the work itself. Often, it is the main component in the reading and the analysis of the work.

To see the importance of composition in bringing out the intentions of the artist, let's look at the works of Giotto di Bondone, perhaps the greatest Italian painter, and focus on the compositions of his frescoes. Why Giotto? Because few other painters are as instructive in their compositions. Once you have found the key to his composition, it emerges clear and immediate, offering a unique lesson and much pleasure.

Given the limits of an interpretation based solely on composition, we may say that the essence of Giotto's work resides in his emphasis on mass in his depiction of landscape and architecture.

In Giotto's time, the pictorial conception was changing. The main figure was no longer at the center of the scene or seen as gigantic in relation to the figures near it. Also, colors were no longer versions of flat tints but tones were now enriched with chiaroscuro. The background was no longer abstract but was animated with earthly landscapes and blue skies. And composition was becoming a basic factor in the process of painting.

Giotto is known for the role that mass and volume played in his works. We may say that, summarizing or at least "didacticizing" the concept, the main figure in Giotto's compositions is the one with the most "weight," the greatest mass.

Giotto also uses color to pinpoint the main figure and relate it to the rest of the composition. With their varied and brilliant range, these colors enrich and complete the painting. The surrounding figures and their arrangement and movement are all caught up in successive passages, both close and distant. The landscape is certainly not realistic, but acts as an integrating and determining element to define the surroundings, suggest directions, and bring out events. Finally, the architecture and its perspective constitute the background element and serve not only to make the surroundings more precise, but also to express deeper meanings.

We need only look at some of Giotto's paintings in Padua or Assisi to instantly recognize the coordinating and compositional force in the treatment of the perspective lines; the pinpointing of the corners, walls, and building masses; the expert interplay of the landscape planes; and the dense or lose spacing of the figures in various areas in a specific direction.

These three essential components—landscape, architecture, and the figure—or rather, considering the components as pairs—architecture/figure, and landscape/figure—are so closely linked that none can be discussed without the other.

In *The Lament* at the Cappella degli Scrovegni, the rendering of the deposition of Christ's body is intensely dramatic. The earthly drama is counterpointed against the heavenly drama with its desperate flight of angels.

The scene centers on Christ's body, which the

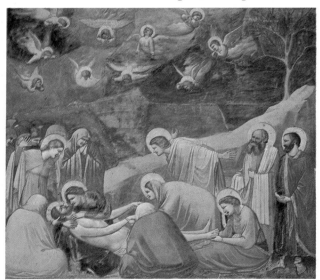

Giotto (c. 1267-1337): Tales of Christ: The Lament, *1304-1306. Fresco. Cappella degli Scrovegni, Padua.*

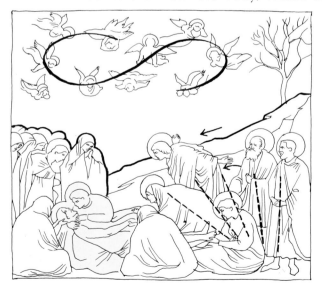

pious women and the apostles surround in despair. The mass of Christ's nude body is enveloped and accentuated by Mary, who holds him, while one of the pious women, synthesized in the utterly pure shape of the mantle, and with an extraordinary expression on her face, cradles his head.

The entire composition moves towards Christ, from right to left, gradually increasing in intensity. It begins with the two erect figures at the extreme right and continues through the figures that gradually lean toward God's son, who has just been taken down from the cross. The composition then goes on through the person with the open arms, the kneeling pious women, and ends with Mary. And because the entire orchestration seems to lead to the union of the two faces, Mary's and Christ's, Giotto once again demonstrates his astounding knack for pictorial narrative. He makes the drama explode by connecting the two profiles. Joined together, united in a perfect composition, the two figures conclude the narrative in the tragic gaze of the Madonna. Weighing upon them both figuratively and symbolically is the mass of weeping women. They are shown in Giotto's typical style, as a cluster of barely visible overlapping heads.

Aside from the progressive movement of the figures, the clear and continuous movement of the contour of the background leads the eye to the main group in the scene. This background shape that weighs upon them is a hill. On its peak, we see the parched branches of a tree that seems to link the sky with the earth. Then the hill descends leftward, a commentary on the action and an aid to the composition. In the sky, the angels, like maddened birds, demonstrate their grief in tormented expressions and in the spiral of their tragic flight.

Joachim's Dream is an elementary scene, enacted with just a few essential elements: four figures and a unified backdrop. There is no sharp division between the vertical background and the horizontal level of the stage. The area meant for the earthly figures continues in the background rocks, which suddenly turn into a mountain in the miracle of Giotto's figuration. The hut, which embraces and intensifies the already important figure of Joachim (enclosed in his mantle and in his concentrated position), is part of the natural surroundings and almost melts into the rock. We should not, however, neglect the richness of the horizontal lines, which define and accentuate the volumetric quality, helping to make the figure of the saint the center of the narrative. As always in Giotto, the main figure is not only no longer in the middle, but he is now at the extreme side; and the whole of the composition—the figures, the landscape, the architecture—leads us to him.

Indeed, the entire composition is directed toward the "mass" of the protagonists accentuated by the volume of the hut and brought out by the fantastic mountain, which looms over him, stressing his pyramidal character.

The figures of the two shepherds at the left initiate the movement with the slight forward lean of the second shepherd (this same "fanning out" is

Giotto: Tales of Joachim: Joachim's Dream, *1304-1306. Fresco. Cappella degli Scrovegni, Padua.*

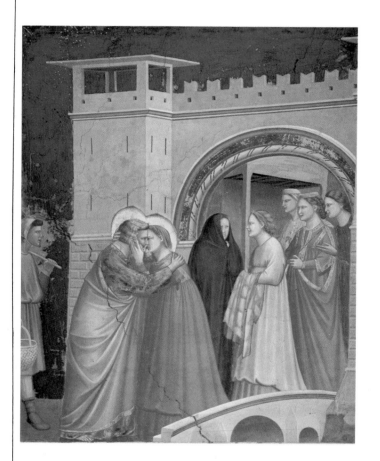

Giotto: Tales of Joachim: The Meeting of Joachim and Anne at the Golden Gate *(detail), 1304-1306. Fresco. Cappella degli Scrovegni, Padua.*

amply used in *Lament*). In the sky, the flying angel precisely indicates the direction of movement toward the saint. The motion of the background hills accentuates and pinpoints the movement of the scene, dropping from left to right toward the hut. At the end of the slope, we see the pyramid of the mountain, which then drops down to conclude the scene in the main figure.

In *Meeting of Joachim and Anne at the Golden Gate*, the figures are all grouped in the center. On the outside to the left, a young shepherd appears, though only in part, virtually suggesting that the space continues beyond the painting, which is filled out with the large turreted gate. Its wide arch emphasizes a group of figures, while the turret at the left stresses the two principal figures, Saint Joachim and Saint Anne.

As always, Giotto uses a small number of elements with great clarity and with the certainty that only his painterly and compositional sense can give them. The embracing saints are watched, at the right, by a group of pious women. Two of them stand out: one in black and one in white. The woman in black is particularly interesting because of the synthesis of the black mantle, which enfolds her, allowing only a glimpse of part of her face and the fingers of one hand. This figurative episode is fascinating in an already extraordinary composition.

The women, unified as a group in their conception, are characterized by their hair styles, clothing, and expressions. Enclosed within the arch of the gate, they form a "chorus," commenting on the scene.

The meeting takes place in the space between the pastor and the women. Here, Giotto once again employs the classical devices of his style: massing the main characters, and using architecture for the composition and to bring out the overall significance of the painting. How? The massing occurs, for example, in the saintly embrace, where the mantle and the clothes seem to melt into a single bulk, making the two figures important and even more "central." The architectural device can be seen in the corner of the turret, the lines of which weigh down upon their heads, runs into the haloes, and continues in the profiles

that unite in a kiss of greeting.

Anne's gentle hands hold Joachim's cheek as she kisses his neck in an extraordinarily interesting gesture, and the saint's right hand embraces his wife. These hand gestures reveal a sense of deep humanity and increase the significance of an encounter that is watched not by spectators, but by actors within the scene.

In the fresco *Saint Francis Honored by a Simple Man* (Chiesa Superiore di San Francesco ad Assisi), the scene is perfectly constructed in terms of the balance of the architecture and the figures. This composition has few figures—only six, distributed in two groups of three on each side. These two groups are linked by a figurative element (the mantle, which has been spread out on the ground as a carpet for Saint Francis) and by an architectural element (the portico absolutely compositional and hardly realistic with its five thin columns!).

Saint Francis and the man are virtually on a *stage*. Their arrangement is theatrical: the figures function as actors or extras and the background is really a backdrop. The two "leads" have a contrapuntal relationship with the four dignitaries. Two of them stand behind the saint and two are behind the man. In the background, the two structures on either side of the temple are barely foreshortened in the axonometric perspective (one of many ways in which Giotto rendered space).

As we can see, Giotto's typical compositional elements are all present. The "mass" of the main figure, Saint Francis, is characterized by the mantle that blocks him in a rigorously geometrical figure. The emerging hands, rendered with particular finesse, contrast with the synthesis of the garment. The "arrow" pinpoints and underscores the "arrow" of the corner of the tower, which, with its mass, helps to make the saint the magnetic pole or the center of the picture. (The center is no longer the geometric center, as in medieval art, but now varies with the composition.) There is also the "niche," which shelters the chorus of extras who seem to narrate the event rather than comment on it, and the mantle (extraordinarily rendered, its folds swelling with air), which links the figures in a single narrative.

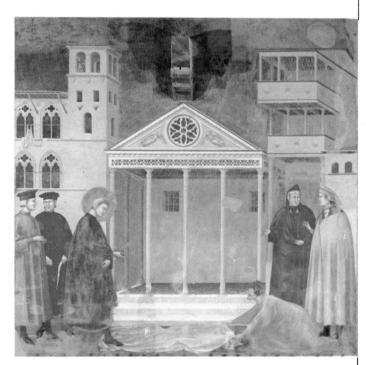

Giotto and Assistants: Tales of Saint Francis: Saint Francis Honored by a Simple Man, *c. 1296-1298. Fresco. Basilica Superiore di San Francesco, Assisi.*

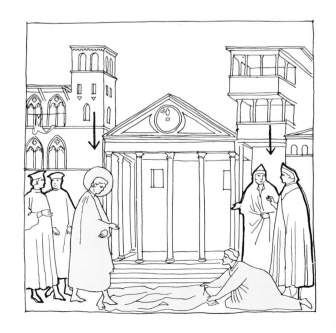

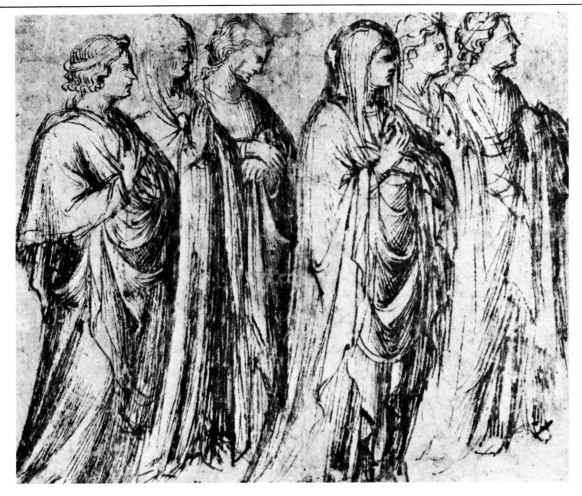

Axial Composition

If we examine the works of past and present artists, we note that many of them favor a particular kind of composition. For these artists, some compositional motif—whether axial, triangular, diagonal, circular, or a blend—remains fairly constant throughout their drawings and paintings. For example, in Veronese's works, the diagonal direction seems to predominate. Raphael, who was influenced by Leonardo da Vinci, used a pyramidal structure in a great number of paintings, often with another upside-down symmetrical structure. A circular composition embraces many of Rubens's scenes and figures.

Let's examine what seems to be the simplest and most immediate compositional form, the axial type. The axial composition is based on either the vertical direction of the median axis or the horizontal direction of the horizontal axis. In any case, it is organized in terms of straight lines that run parallel to the sides of the paper or canvas in a fairly orderly and regular rhythm. Obviously, this type of composition forms the basis for scenes that

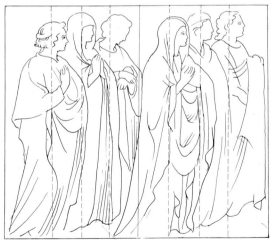

Anonymous Florentine (active around 1400): Six Women in Procession. *Pen and ink, white paper. 150 x 171 mm. Courtesy of the Administration of the British Museum, London.*

The procession of women moves naturally, from left to right, in a serene vertical rhythm, virtually scanned by musical proportions. The women are seen as if they were filing past our eyes, in a foreshortening indicated on three rows. The slight forward bending of the bodies accentuates the rhythm of the group's motion.

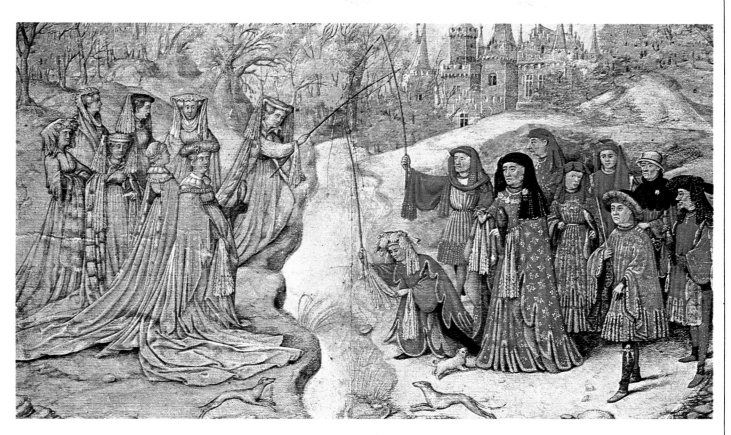

subordinate drama, élan, or upward movement to focus on the narrative and on a quiet, peaceful mood. Often, as already noted, these rhythms reflect musical proportions, scanned by the axes of the figures or other major elements.

The center of a classical composition is based on the vertical axis, and is characterized by its symmetry, the equal balance of both sides with respect to the central axis. When perspective was discovered during the early Renaissance, the use of a perspective with one viewpoint (and one vanishing point) at the center of the picture or at least on the central axis was the favored axial composition. At their simplest, such works were based on a pattern that divided the scene into two symmetrical parts. For example, artists would put the Madonna at the center, and a saint on either side, with a frontal arch framing the scene. Or else, instead of a central axis, they would have several axes that corresponded to the main figures, thus creating a rhythm for the scene.

In the manner of Van Eyck: Fishing in the Court of William VI, *Count of Holland, Zealand, and Hainaut. Watercolor, white and gold gouache, transferred to wood, 229 x 375 mm. Louvre, Cabinet des Dessins, Paris.*

The scene is divided into two parts by the vertical axis, which coincides with the fishing line of one of the dignitaries; the ladies are on the left and the gentlemen on the right. However, the vertical rhythm is the same, scanned by a "pace" that seems to link the figures of both groups, divided by the stream in the continuity of the illustrated narrative.

"The esteemed men who devote themselves to virtue and the women embracing them with all their strength are sometimes, when the expected is lacking, excessively exalted and honored in the sight of all people. This can be openly seen in the labor that Rosso, a Florentine painter, devoted to the art of painting.... In his youth, Rosso drew Michelangelo's cartoon [*The Battle of Cascina*] and there were few masters he cared to emulate, since his mind was set against their styles. It can be seen outside the gate of San Pier Gattolini, Florence, in Marignolle in a tabernacle covered with frescoes by Piero Bartoli, showing a dead Christ. This is where he began to exhibit when he wanted to employ a robust manner, grander than that of other artists, graceful and marvelous.

"...The works were in great demand when several of his drawings were seen and declared marvelous. Rosso was said

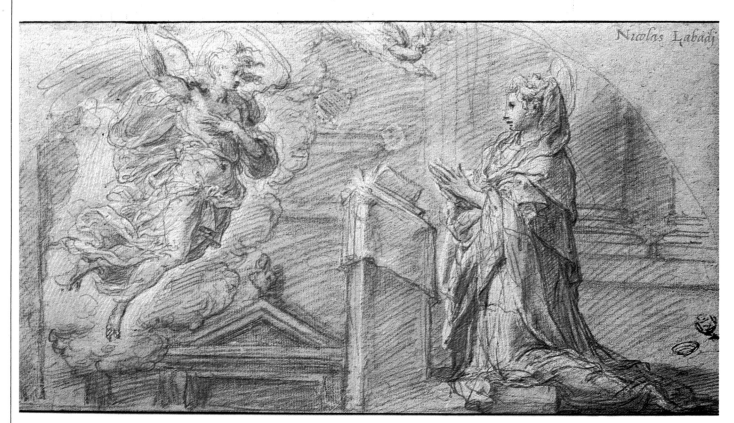

Nicolò dell' Abate (c. 1509-1571). Annunciation. *Red pencil and watercolor with white-lead highlights, 176 x 312 mm. Louvre, Cabinet des Dessins, Paris.*

Axial Composition in the Annunciation

In religious iconography, the Annunciation showed consistent patterns linked to the reading of the image. An angel enters from the left, in the direction of the reading, and the Virgin receives him at the right. The Virgin is always framed or wrapped in some way in an element (a niche, columns, etc.) that separates her and shelters her from the rest of the scene. The composition is thus based on the vertical axes, while the central axis individualizes the two portions of the scene: the celestial part on the left and the earthly part on the right. It is no coincidence that even in the earliest depictions of the Annunciation, the setting is often a portico, seen frontally, in perspective. In this way, the angel is framed within one arch, while the Virgin, absorbed in reading, her arms folded on her breasts, is framed by the second arch, which is separated by a column (the vertical axis).

to draw divinely and with utmost polish."

(*Lives:* Giorgio Vasari: "Life of Il Rosso")

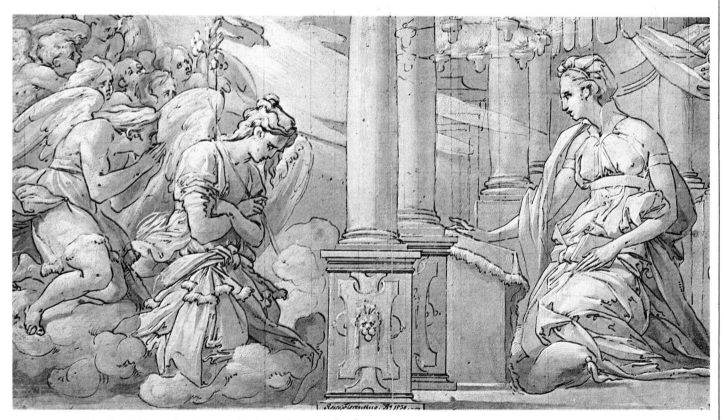

Rosso Fiorentino (1495-1540): Annunciation. *Pen and ink, dark-bistre watercolor, with white highlights on brown paper. 236 x 407 mm. Graphische Sammlung Albertina, Vienna.*

In Nicolò dell'Abate's *Annunciation,* the vertical rhythm is animated by the play of curves and rapid pen strokes, done in quest of light and volume (as demonstrated by the diagram which illustrates an intermediate phase in the development of the drawing and the axes of the composition).

In Rosso Fiorentino's *Annunciation,* the vertical element of the columns individualizes the two spaces in which the angel and Mary move, creating an extremely graceful and serene mood. The contrast between the techniques of the two artists is interesting. Rosso Fiorentino used pen and dark-bistre watercolor with white highlights, on brown paper. The white touches fuse with the bistre washes to give the scene a crystalline light. Nicolò dell'Abate uses red pencil in large strokes that are softened by the watercolor. His white highlights stress the celestial character of the angel and emphasize the folds of the drapery and the volumetric form of the Virgin.

A Drawing a Day

These drawings of a female figure in a mirror and a reclining female figure provide examples of positioning the model in terms of the vertical or horizontal axis.

In the first example, as you can see from the diagram, the vertical axis suggests the plane in which the figure, seen from the back, is reflected. In the second drawing, the nude is "composed" in terms of the horizontal axis, and the contrast it makes with the curve of the body makes the figure highly dynamic. Thus, both the vertical and the horizontal axes form basic references for aligning the direction objects in a composition.

The framework of a composition and the shape of the subject may be seen more clearly through a viewfinder. But even without one, if you see the subject in terms of a vertical or horizontal axis, you will have a faster and better sighting of the angles, curves, and proportions of the lines that bring out the shape. It will also help you avoid mistakes.

After establishing the main spaces and proportions of the composition with the aid of the axes, we can then indicate the outline and then add the light direction and establish the volume of the forms with chiaroscuro, the shading.

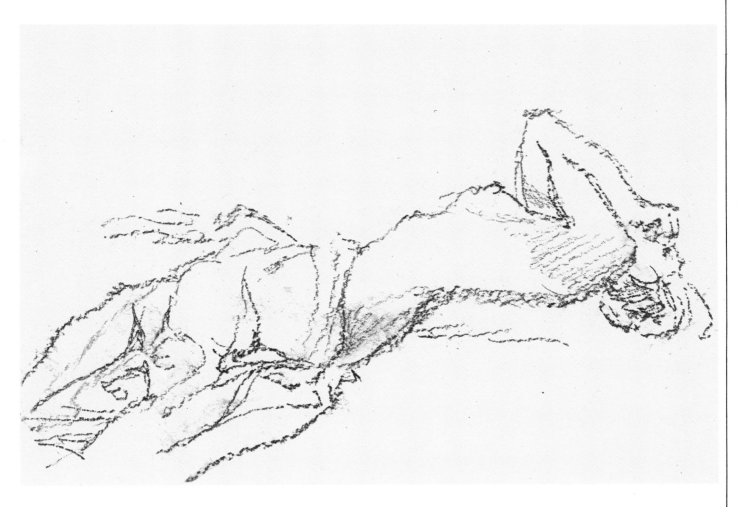

The Central Perspective of Your Room

Even without knowing the rules of perspective, let's amuse ourselves with a very simple exercise. Try to sketch the central perspective of your room.

Take a sheet of drawing paper and hold it in front of a wall, near its center but standing as far away from it as possible. This will make your viewpoint correspond with the central axis of the wall. As we shall see when we discuss the various methods of geometric rendering, the projection of the viewpoint upon the canvas coincides with the vanishing point, which is the meeting point of the straight lines perpendicular to the sides of the canvas. We achieve a particular viewpoint by making all the perspective lines converge at this point, on the horizon. Here, both our viewpoint and our vanishing point will be located on the axis of the wall. But at what height?

The viewpoint is always at eye level, where we, the viewer, are looking. Pinpoint the eyelevel on the vertical line at the center of the paper. The horizon, a horizontal straight line, passes through this point at the level of our eyes. Now draw the horizon in the proper position.

As you draw, you must pay attention to several things:

- Although at eye level, the horizon is generally placed high within the rectangle. However, it's position is lower, especially if we are seated when we draw.
- Make sure that the straight vertical lines that are perpendicular to the sides of the paper (i.e., that of the bookcase, table, bed, picture frame, etc.) converge precisely in the vanishing point, which lies on the axis of the of paper. The straight horizontal lines of the walls, ceiling, and floor must likewise converge in the vanishing point.

Diagonal Composition

The diagonal construction is one of the most popular compositions in art history. The diagonal tension is felt instinctively by many artists, especially a diagonal running from lower left to upper right—perhaps because this direction seems to emphasize an upward aspiration.

Hence, when we look at drawings by old and modern masters, we can readily find compositions organized in terms of a diagonal within the rectangle or square of the paper or canvas. Furthermore, if this diagonal had originally guided the preliminary drawing, then that same composition would be found in the final painting. Thus, the initial sketch or "cartoon," with its diagonal lines, can confirm the general use of this structure.

Many works are not based on a thought-out or projected diagonal composition, but are conceived and executed instinctively in terms of that structure. That is, the layout and organization of the composition develop spontaneously within the imagination and then are developed during the sketching of the work according to an often typical and "felt" order.

Still, we have to ask why the rhythm of vertical or horizontal lines and the dynamics of diagonals that guide axial compositions are among the most frequently used compositional patterns.

One answer is suggested by "reading" drawings by the masters and analyzing their approaches. As we have said, we read a drawing like a written page, from left to right, and we instinctively read the "drawn page" to follow the narrative offered by the artist. Hence the story unfolds in terms of the elements and characters that follow one another in the space of the paper according to the rhythm that the artist wishes to suggest.

This rhythm is scanned by the vertical and horizontal axes in a static compostion, and the dynamic movement is emphasized and revealed by the diagonal lines in a dramatic composition.

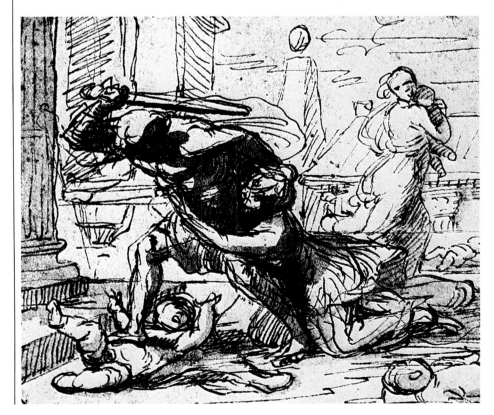

N. Poussin: The Massacre of the Innocents. *Pen and brown ink, brown wash, 146 x 169 mm. Musée des Beaux-Arts, Lille.*

In Poussin's sketch we readily see the matrix of the diagonal, which crosses the group made up of the soldier and the woman trying to stop him from killing her child. The drama and the movement of the scene is laid out in a diagonal composition, which, moving from top left to bottom right, tends to "block in" the warrior and pull him down.

Pietro Testa (1612-1650): The Triumph of Fama. *Charcoal, pen and ink, white lead on blue graph paper, 195 x 135 mm. Teylers Stichting, Haarlem.*

Once again, the diagonal brings out a rising movement, that of Fama ascending and leaving earthly miseries below. The artist deliberately uses a figure resembling that of Christ in a Transfiguration.

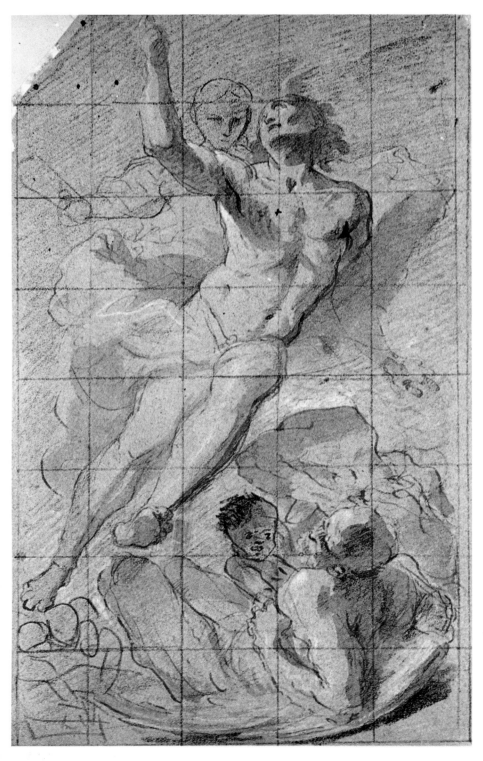

These axes, the cross and the diagonal, form the chief elements in the history of drawing. Combined, enriched, and interwoven, they can create a pyramidal structure, a square or circular layout, or a mixed, curved, or linear composition.

The diagonal composition, based on the potentiality of a movement from one corner of the paper to the opposite one, instantly suggests a dynamic situation. Functioning in terms of the direction of reading (i.e., from left to right), this situation takes on either a rising or a falling interpretation depending on whether the composition is organized on a diagonal from top left to bottom right or from bottom left to top right.

Gravelot (Hubert-François Bourguignon, 1699-1733): The Conversation. *Black pencil, white-lead highlights, 285 x 430 mm. Louvre, Cabinet des Dessins, Paris. Sometimes, as in this drawing, the diagonal composition seems naturally linked to the subject and the postures of the figures. The gentleman, stretched out at the feet of the lady, lifts his face toward her, and the rising direction is stressed by the faintly indicated group in the background.*

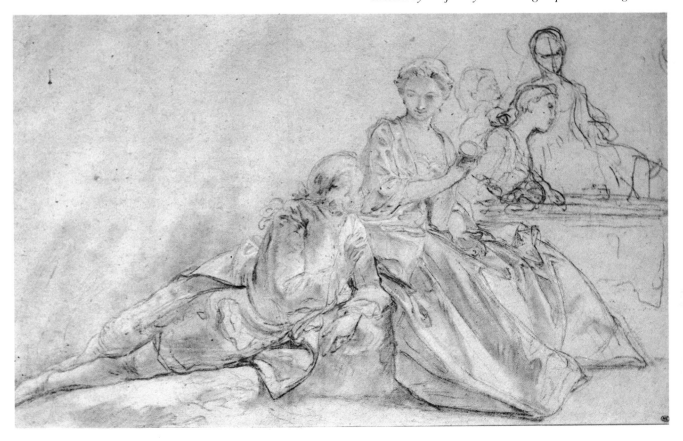

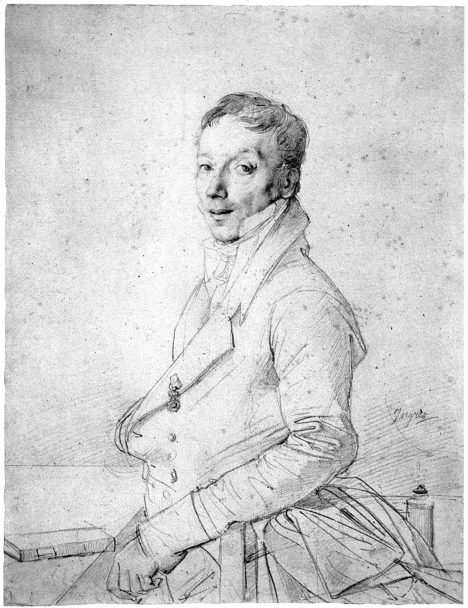

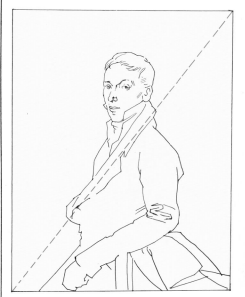

Jean-Auguste-Dominique Ingres: Portrait of a Young Man. *Pencil, 290 x 220 mm. Museum Boymans-van Bruningen, Rotterdam.*

Diagonal Composition in Portraits

The diagonal composition is typical of portraits, especially half busts or half figures. Look at Jean-August-Dominique Ingres's *Portrait of a Young Man* (reproduced above). Does the ascending diagonal have a particular significance here? It may not. In this case the diagonal may simply indicate an emphasis on the sitter's straight posture.

As in all of Ingres's portraits, the detailed face is drawn with great psychological depth and the figure is sketched with a few essential strokes. The posture is typical of a portrait with a foreshortened figure, with the face slightly turned, and the eyes gazing at the viewer (and hence at the artist).

When Ingres wanted to modify the "linearity" of the composition, he did so in a clean way, even suggesting an oval composition. In his portraits, however, the composition was still characterized by a diagonal movement that underlied the sitter's position, framing his volume in the depicted space and suggesting the rest of the figure and the continuity of the surroundings.

In *Artist's Mother Resting in an Armchair*, the Austrian painter Oskar Kokoschka lays out his drawing on the diagonal, giving the image a deep sense of repose and complete relaxation. He deliberately chose a direction from upper left to lower right rather than the more dynamic opposite motion.

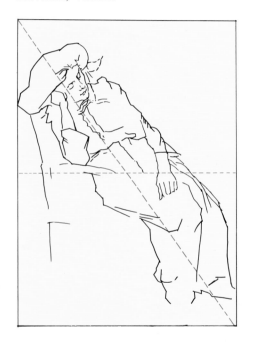

Oskar Kokoschka: The Artist's Mother Resting in an Armchair. *Black pencil, 402 x 280 mm. Graphische Sammlung Albertina, Vienna.*

Aside from the composition, we ought to stress the outline of the figure. This outline seems to block in the entire figure, with all its weight, wrapping it in the course of its line—and an affectionate line at that. The figure, leaning her right arm on the arm of the chair, is sketched with a nervously expressive line that is typical of Kokoschka. It seems to envelop the body with a special meaning, even with respect to the vague drawing of the chair.

When confronted with certain drawings, we have to ask ourselves whether the diagonal composition was planned or whether it was produced intuitively. I would say that in the drawing of a figure or in a portrait like this one—probably inspired by feeling—the posture and hence the rendering are intimately linked and emerge spontaneously. The compositional rules (indicated by criticism and brought out by instruction) confirm the correspondence of the geometrical and underlying meanings.

In any case, we must remember that after choosing a subject, we must find the best position for drawing it. Even if it is hard to define the best position for a portrait, the examples of the masters suggest that we focus on the diagonals and pay attention to a synthetic, overall vision.

Diagonal Composition in Religious Scenes

Apparition of the Virgin and the Child, a drawing by the Spanish painter Bartolomé Esteban Murillo, is interesting because of its technique and the immediacy of the brushstrokes. The artist ran a diluted ink wash over an initial pencil sketch, still visible on the figure of the Virgin. The composition here is based on a diagonal that runs from bottom left to top right. Since this compositional structure is so basic, it is therefore particularly effective in appealing to the faithful in terms of an essential "dialogue."

On one side of the drawing the monk is supported by two figures. On the other, a bit higher, the Virgin with the Child is seated on a throne of clouds. Naturally, the dramatic and miraculous effect of the scene is intensified by Murillo's skillful use of chiaroscuro. Marking the background and the Madonna's mantle, the shadow brings out the clarity of the monk's habit, while the monk himself is struck by the luminous vision.

In the highly dramatic rendering of *The Betrayal of Judas,* van Dyck omits no element, however melodramatic, in his drawing. There are two figures struggling in the lower left foreground:

Murillo: Apparition of the Virgin and Child to a Monk in Ecstasy. *Black ink, with colored pnenil on watercolor, 246 x 178 mm. Musée Condé, Chantilly.*

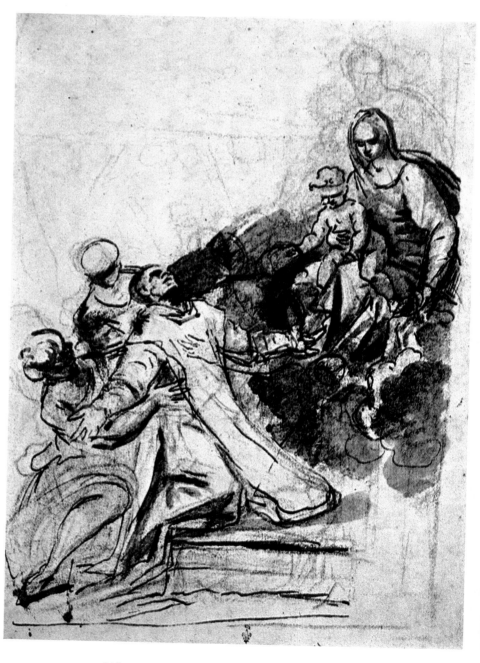

the warrior with the Renaissance curiass and helmet, and the soldier with the sling and raised hands and arms. At the right, the two protagonists, Judas and Christ, appear, wrapped in the masses of their mantles. Judas takes Christ's hand in his and places his other hand on Christ's shoulder, moving toward Christ to kiss him. Christ rises above all the others, composed and serene. At the extreme right, a soldier is about to seize the Son of God. And in the background, barely sketched, a tree extends its twisted branches toward the sky.

The study for this grand drawing, with the richness and magnificence of its gestures and figures, finds its meaning, synthesis, and drama in the composition, which is placed on a diagonal drawn from bottom left to top right. This imaginary line guides our eyes from the tumult in the foreground to the ferocious face of Judas, and then to the serene face of Christ, with both faces framed by the branches of the tree.

The dynamic thrust of the diagonal seems to stop in the meeting of the two faces, and the confusion, the movement, the drama seem to be concluded cathartically in the figures of Judas and Christ.

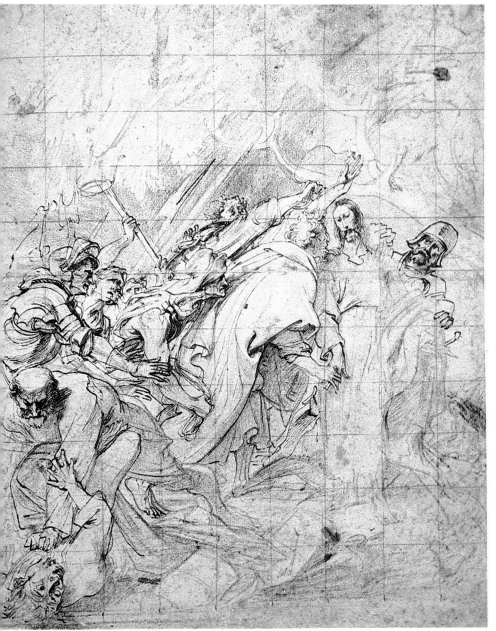

Anton van Dyck: Judas's Betrayal. *Black pencil, pen, with brown watercolor, 533 x 403 mm. Kunsthalle, Hamburg.*

Van Dyck: Contrasting Two Directions

One seldom finds two drawings of the same subject (two preliminary studies for a painting, that is) that present the same composition but in reverse. Yet here, fortunately, we can compare two sketches of a scene, *Christ Falling under the Cross,* done by van Dyck when he was very young. Their comparison allows us to understand the meaning of the same diagonal composition. One version is drawn, ideally, from the top left to the bottom right; and the other, from the lower left to the top right.

Van Dyck was only seventeen when he was invited to work with a group of already successful artists, including Rubens and Jacob Jordaens, on a series of fifteen paintings of the lives of the Madonna and Christ (*The Mysteries of the Rosary,* Church of Saint Paul, Antwerp, Belgium). Thus, we are not surprised by the ardor and passion of the young artist in this "acid test" of his merit, nor by the many preparatory sketches he did for *Christ Falling under the Cross,* the subject assigned to him.

In the first drawing, executed with swift lines and brushtrokes of sepia ink on the black pencil sketch, van Dyck shows Christ collapsing under the weight of the cross as he turns toward his weeping mother, who stands next to him but separate from the group of soldiers on the left. The composition is based on the diagonal running from top left to bottom right, emphasized by the soldier's arm and the cross, and ending in the figure of the Virgin.

Beyond the brilliant sketching of the figures and the shadows, which give body and light to the characters, we are moved by the essential diagonal character of the composition. Following the normal direction of reading, it leads our gaze and our attention to the Madonna and, more generally, toward the bottom. This downward movement may have been what impelled van Dyck to try a second sketch of the same scene, with an equivalent but reversed composition, along the diagonal from *bottom* left to *top* right.

In the second sketch, the figures, united in a single mass that includes the Madonna, seem to draw together toward Golgotha as well as toward the glory of the heavens. Thus, logically, van Dyck preferred the second solution for the final version of the painting. For this is the composition that expresses Christ's climb to Calvary, the diagonal that leads the eye and the mind in the ascent to heaven.

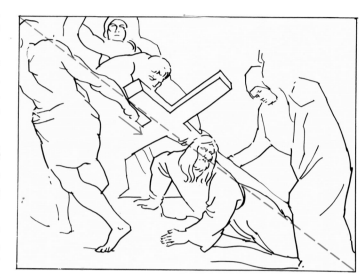

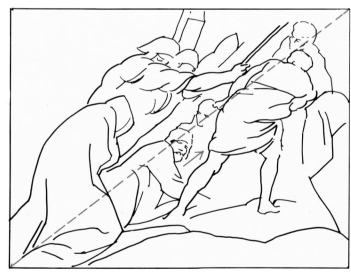

Anton van Dyck:
1. Christ Falling under the Cross. *Pen and ink, sepia watercolor over black pencil, 155 x 202 mm. Bibiloteca Reale, Turino.*
2. Christ Falling Under the Cross. *Pen and ink, and watercolor, 160 x 205 mm. Musée des Beaux-Arts, Lille.*

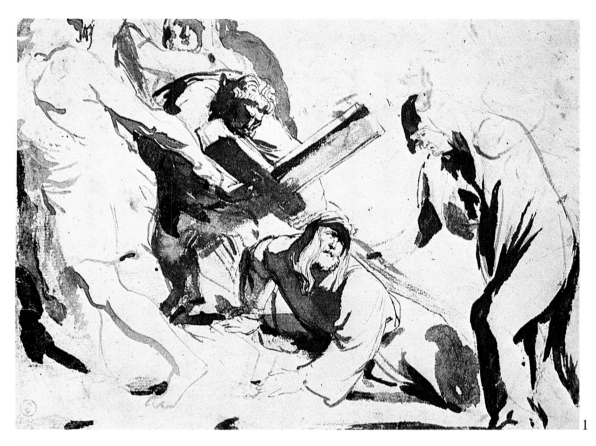

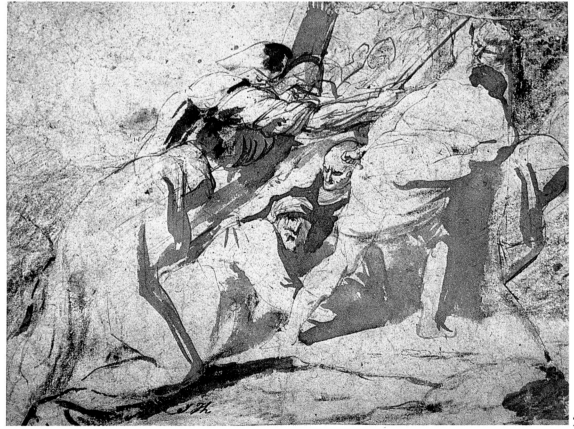

A Drawing a Day

Although obviously different in their positions and in the conception, these two female figures are lying along the same diagonal. The imaginary lines brought out by these diagrams not only help us to find the posture, proportions, and shape of the fig-

ure, but they also contribute to positioning it within the sheet of paper, suggesting, along with the model's presence, the space (the blankness on the right) in which she moves and the plane of the bed on which she lies. Thus, as usual, even in these drawings, the empty portions—the undrawn parts of the paper—are as important as those drawn.

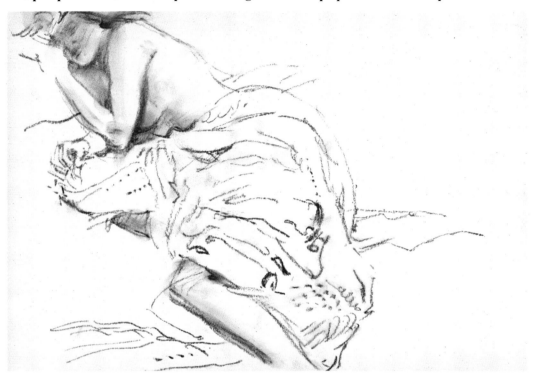

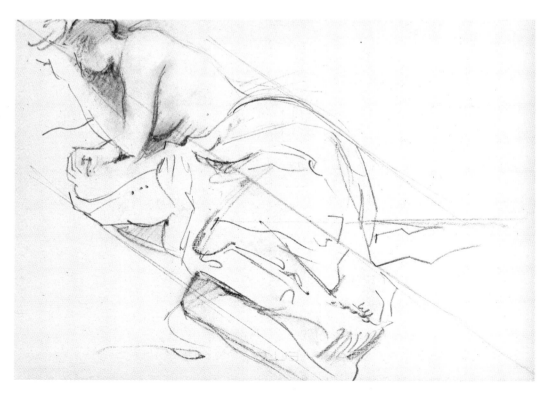

In the first drawing, the figure is cut off above and below (head and feet) by the edges of the paper while, in the second example, she can "breathe" on other side in a framework and layout that underscore her posture and position. We observe her from up close, and thus feel involved.

In the second drawing, however, the framework, with its more distant viewpoint, comprehends the entire figure in her abandoned position. Naturally the drawing is based on proportions defined by the references and relationships among the various elements.

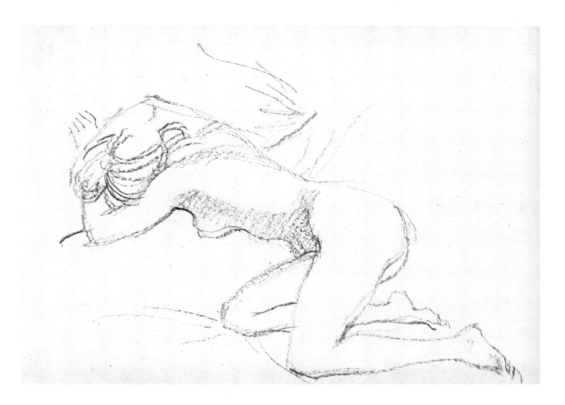

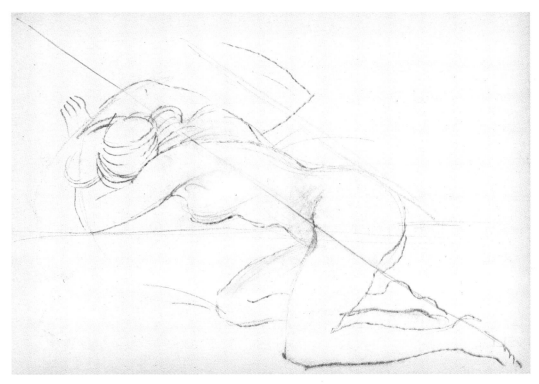

Braque's *Bird in Flight*

Sometimes a diagonal composition can be merely a direction, suggested or indicated, that gives meaning to the picture.

A characteristic example is Braque's *Bird in Flight.* During his final years, a flying bird became a symbol of freedom for Braque, embodying both lightness and a mastery of space. This example is a variation of his constant theme of birds, which appear as white silhouettes on colored backgrounds or as blue shapes flying across the white space of the paper.

It is Braque's ability to make his birds soar through the skies of our imaginations that signals a precise reference to the composition, or rather, to the diagonal direction that slices through the space of the drawing, indicating the dynamic and the direction of the flight.

The flying bird has crossed the inner space of the paper and is about to soar beyond it. All this is suggested by the position of the blue outline with the spread wings up in the top right corner, at the end of the diagonal.

To clarify Braque's problem in conveying this meaning, we have shifted the bird's silhouette within the rectangle of the paper: Solution no. 1 shows the bird at the center; solution no. 2 puts it at the lower left.

In the first variation, the bird seems static and immobile, caught in mid-flight. In the second variation, it seems to be just starting out, about to traverse the interior space of the "sky" in the already suggested direction. It is only in the original lithograph, where the outline has already reached the edges of the surface, and the space now seems inadequate, that the suggested or imagined diagonal direction manages to burst the limits of the paper and carry us off into the skies of poetry. Nothing seems to better define the art of Braque (whom France recognizes as its national painter, even placing him above Picasso) than these lines from his *Notebooks:* "Reality is not revealed if it is not illuminated by a ray of poetry. Everything around us is sublime."

Georges Braque: Bird in Flight. *Lithograph. Private collection.*

1

2

Triangular Composition

Logically, a diagonal composition leads to a composition based on a pyramidal structure. Although it had been used previously, the pyramid was favored above all by Leonardo da Vinci and then definitively confirmed by Raphael. Da Vinci's Madonnas led to Raphael's compositions. Raphael blocked in the lines of the diagonal into a defining triangle and softened the hard edges of the shadows against the soft lines of the landscape.

In the late eighteenth century, Orsini, a painter and art writer, recommended the "painterly pyramid." In his *Anthology of the Art of Painting*, Orsini stated: "There is no artist who does not know how to form a pyramid in his compositions, but the point is to do it well, to make it graceful, orderly, and magnificent, and not show any hardness in the angles."

By then, the pyramidal shape had already been used to add great variety, splendor, and perfection to a painting. "This character of 'greatness' can be expressed with the figure centered in a large circle surrounded by other objects in the composition, with the perspective plane being ample and vast. To achieve this effect," Orsini said, "we need

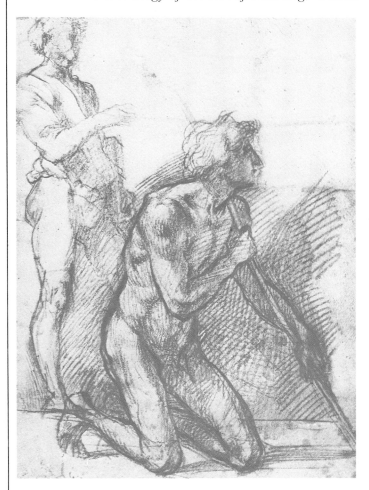

Andrea del Sarto: Life studies for St. John Gualberto and Saint Onofrio for the altar piece Madonna with Saints *(1528). British Museum, London.*

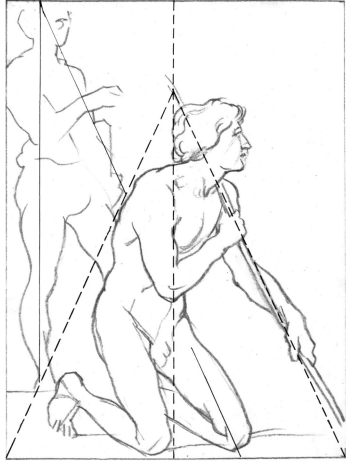

Andrea del Sarto's study is based on a triangular shape that blocks the figure, as shown by the diagram of a hypothetical intermediate phase.

"For various reasons, in all eras and especially today, there has always been a conflict between spontaneity and discipline. This means that many artists prefer relying exclusively on their natural gifts, on their intuitions and feelings, refusing to accept any rule or system beyond intuition or instinct. On the other hand, following the examples of the earlier masters, other artists decide to base their art on rules, prosody, and syntax that can sustain their art without restricting the freedom of the creative act per se. Nevertheless, the artist determined to raise the level of his art as high as possible usually tries to find a union between the two directions. However, we cannot solve this controversy here. Indeed, it doesn't exist for us, for everything that is rule, grammar, syntax, etc., does not belong to 'art.' These things actually belong to 'craft.' That is, to the highest and most noble part of craft, which in certain cases is so close to art as to merge with and incorporate itself into the creative

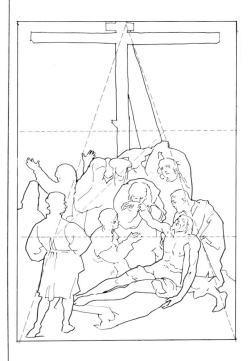

Albrecht Dürer: Lamentation for Christ. *Pen and bistre, 315 x 214 mm. Graphische Sammlung Albertina, Vienna.*

The scene is rendered in the spirit of a "sacred depiction." The protagonists are surrounded by spectators who gesticulate and despair theatrically. This work may not have the intensity of other religious scenes drawn by Dürer, but the construction of the narrative is careful and precise. Blocked in the pyramid, whose vertex lies in the intersection of the two arms of the cross, the sacred depiction unfolds as a narrative. It begins with the two figures standing at the left, moves through the praying women who kiss Christ's hand, and suddenly concentrates on the abandoned figure of Christ. Starting at the two men and ending in the group of women around Christ, there is a diagonal that runs upward within the pyramid. Behind the group we see the figures that share the grief of Mary and all humanity. The group opens with a woman who raises her hands to the heavens, and it concludes in the boy, John, who wrings his hands in despair.

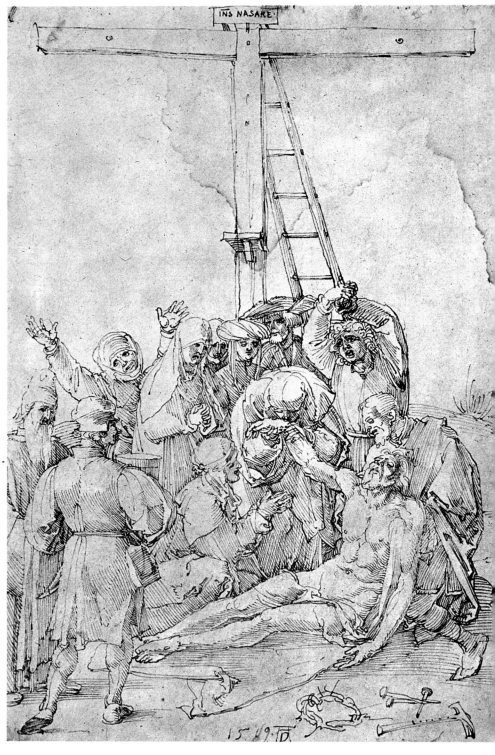

act....Still, the aesthetic laws we believe in are not based solely on metaphysics or on an exclusively idealistic or platonic position....The circle, square, triangle, and even solid geometric bodies produce a *primary*, universal, and unvarying sensation within us. That is why all great eras of art used...simple geometric shapes. For the body of the art work, its internal structure, can be based only on these eternal primary shapes that arouse relatively constant and unvarying primary sensations in all of us. The square, for example, will always transmit a sense of stability, while the circle transmits a sense of infinite continuity. A straight horizontal line gives an impression of calm and continuous motion, while a broken line leads to discontinuous movement and rhythm. To these simple shapes we must add secondary and derivative forms; and the union of these primary and secondary shapes creates an interplay of constant sensations to produce a symphony, monument, statue, or painting that is in accordance

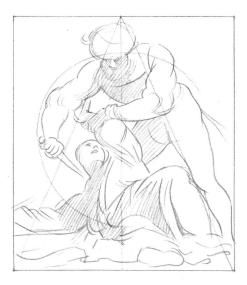

Pordenone (Giovanni Antonio de' Sacchi, 1484-1539): Martyrdom of St. Peter. *Red chalk, 239 x 202 mm. Devonshire Collection, Chatsworth.*

In this study, the composition is enclosed in a triangle or rather a pyramid. However, it is enriched by dynamic components—a series of curves that create a sense of continuous movement. Indeed, as in this case, the pyramidal shape is often used as a basic scheme to block the composition in a synthesis. This allows the observer to perceive the artist's message immediately. Once again, the hidden geometry is merely the beginning of a process that often makes it invisible.

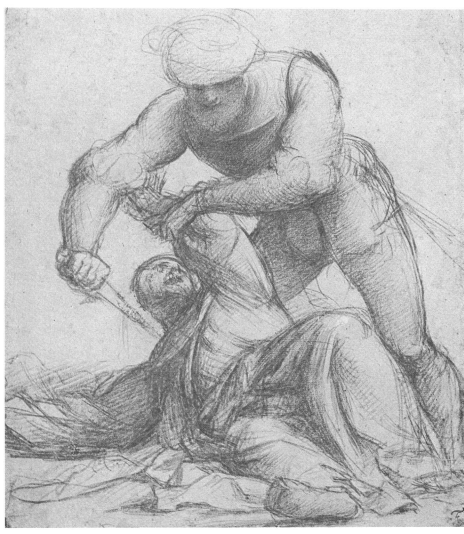

triangular shapes and serpentine pyramidal figures. However, the intervals between objects must be equal in size."

The kind of composition Orsini suggested is "pyramidal" if seen spatially (in three dimensions), and "triangular" if seen on the surface of the drawing or painting (flat). This pyramid or triangle generally defines and encloses a figure or group of figures. So, many portraits (both drafts and final versions) can be blocked into pyramids that seem to wrap them up, almost bringing out their space within the overall space of the picture.

And there are even more groups of figures, usually religious (Virgin with Child; Saint Anne, Saint Joseph, Saint John; the Three Marys at the foot of the cross), that can be unified into the simple lines of an enclosing triangle. This composition, being so elementary, becomes a factor of synthesis. Particularly expressive and meaningful, it preserves the unity and synthesis of the narrative and depiction despite a multiplicity of figures.

On the other hand, beyond the compositional demands and synthetic results, the triangular

Rembrandt: Christ Walking on Water. *Pen and brown ink, 190 x 290 mm. British Museum, London.*
In this drawing, by omitting any surrounding strokes, Rembrandt isolates the main figures of Peter and Jesus in a triangle. Behind them, beyond the triangle of light, we see the curved outline of the boat, where the apostles crowd toward the prow—a chorus commenting on the scene. For this is truly a theatrical scene in which the stupefied mariners participate: The stage is the sea, and the backdrop is the miraculous triangle of light where the gigantic figure of Christ stands and Peter moves, terrified and hopeful. However, the entire drama of fear, the serenity of the miracle, and the stupor of the apostles are rendered with great simplicity. Thanks to the composition, which is based chiefly on the triangle enclosure of the protagonists, this scene seems natural.

with the nature and character of the given shapes.

"Having thus established, albeit summarily, a solid basis for modern aesthetics, we can more easily understand that a line that is divided at one point rather than another can arouse an agreeable or disagreeable

shape has had a complex of symbolic meanings that have always made it special. In Japan, the triangle symbolizes the human individual in his threefold condition: physical, intellectual, and spiritual. It is also the ideal conjunction of the objective world (symbolized by the quadrangle composed of the four elements: earth, water, fire, and air) with the supreme reality (represented by the circle, a figure having no beginning and no end). Furthermore, in the poetics of Renaissance painters and sculptors, the triangle adds a quality of grandeur, variety, and perfection to a work of art.

feeling within us or even a notion of beauty. We can also understand why a rectangle constructed with a given ratio between the sides can be better than one constructed at random. Furthermore, it is important to repeat that a given line or rectangle is beautiful not because of a metaphysical idea of aesthetic beauty applied to them, which was the misunderstood Platonism that generated neo-Classicism, but such a figure is truly beautiful for very basic—primordial—reasons. These reasons are explained and justified by physics, physiology, and biology, by the fact that motor, muscular sensations—primary and unvarying—are aroused in us by these primary and unvarying shapes."

(Gino Severini: *From Cubism to Classicism*)

Gian B. Tiepolo: The Meeting of Anthony and Cleopatra. *Charcoal, pen, brush, and brown ink, 408 x 292 mm. The Metropolitan Museum of Art, New York.*

The triangular composition is not new for Gian Battista Tiepolo. He loved to frame his figures in bold foreshortenings seen from below, along diagonals that would frequently unite to give life to triangular shapes. The artist's style is elegant and his technique is refined. He uses pen and brush and brown ink in two tonalities, a ligther, wetter wash in the background and a drier one in the darker areas. We cannot help feel curious about the way Tiepolo dresses his figures in the style of his era—or at least, pairing the plumed helmet of the Renaissance with Anthony's Roman cuirass but without omitting Cleopatra's eighteenth-century attire. Everything is enclosed by the triangular composition that Tiepolo produces naturally—just like the silvery light, which looks colored even in brown ink. The triangular composition contains a diagonal upward movement because Anthony is lower than the queen. Her figure is given more weight, not only by her heavy train but also by the pages that hold it.

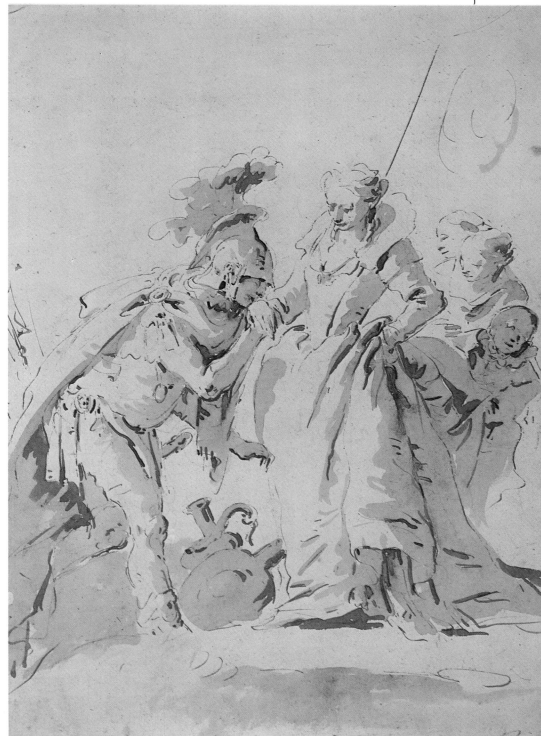

The Triangle in the Works of Raphael

If we examine Raphael's work and seek the geometric matrix that guides his composition, figure studies, drawings, and portraits, his most important canvases and frescoes show the proportions of a triangle. Indeed, this matrix is scarcely surprising in the work of this "painter of perfection," as Vasari describes him in *Lives*. "He enriched the art of painting with all the perfection of the ancient figures of Apelles and Zeuxis and even more, if possible," Vasari writes.

In Raphael, everything is so perfect that it looks natural—even too natural. In *Dialogue on Painting*, Lodovico Dolce actually states: "Those who preferred Michelangelo were mainly sculptors, who dwelt purely on the draftsmanship and awesomeness of his figures. These artists found Raphael's graceful and gentle manner too facile and, consequently, not as artistic. Yet they failed to realize that simplicity is the chief hallmark of excellence in any art and the most difficult goal to attain. Concealing art is in itself art, and the painter requires other features, all of them necessary, not just draftsmanship."

One of these necessary elements is geometry—which Raphael appears not only to have known but to have mastered. Not a single drawing or painting of his lacks a geometric construction, particularly the isosceles triangle. Often his work contains two such triangles, identical and interlacing, but with one upside down.

1. Raphael: Young Woman in Front of a Window. *Pen and brown ink, 223 x 159 mm. Louvre, Cabinet des Dessins, Paris.*

2. Raphael: Study for Moses Before the Burning Bush. *Red pencil. Gallerie dell'Accademia, Venice.*

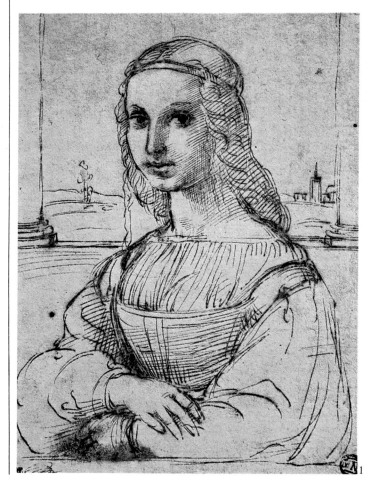

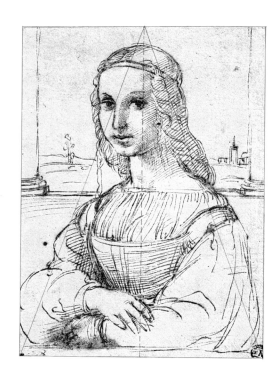

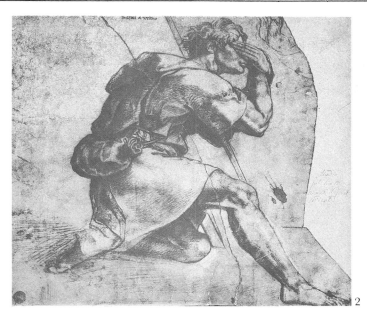

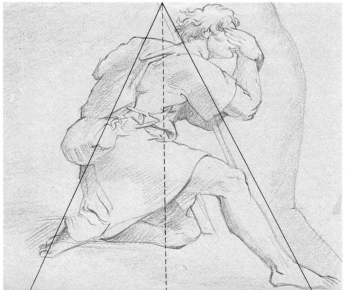

It is therefore enjoyable and stimulating to find the compositional matrices in Raphael's works. Let's begin with his drawings.

- Raphael's study for *Moses Before the Burning Bush* is constructed on a triangle that encloses the figure in its geometry. In fact, the spear he is leaning on seems to emphasize and close off the composition.

- In Raphael's portraits, the compositional matrix is the same. The sides of a triangle enclose the figure in the draft (pencil or pen and ink), and the structure becomes normal.

The perfection of the triangle and, even more, the perfection of two interlacing triangles formed the basis for a wide variety of compositions—some static, some dynamic, still others wavy or dramatic. When did Raphael first begin to see and compose in this way? Perhaps his first major work was *Marriage of the Virgin*, a painting based on Perugino's *Presentation*, which has a similar composition. But this approach is also found in Raphael's earliest works, including the paintings on the two façades of the *Standard of Charity* (painted in 1499 when the artist was only sixteen), the *Madonna of Mercy*, and *The Crucifixion*.

Thus, in Raphael's portrait of *Leo X with Two Cardinals*, the basic triangle that blocks the figure of the pope is joined by a second one, upside

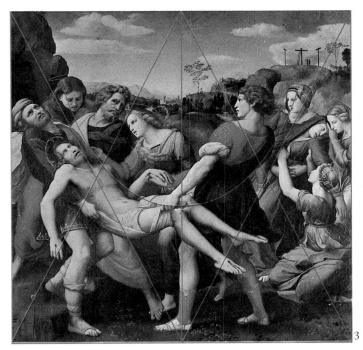

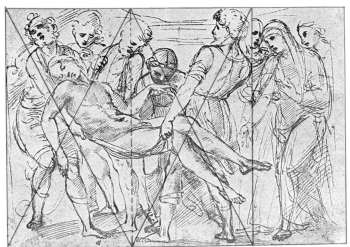

3. Raphael: Descent from the
Cross. *Painting. Galleria Borghese, Rome.*

4. Raphael: *Study for the Baglioni* Descent, *1507. Pen and ink, charcoal, 230 x 319 mm. British Museum, London.*

down, the two sides of which guide the composition of the figures of Giulio de' Medici and Luigi de' Rossi.

The triangular or bi-triangular composition becomes particularly interesting in such works as *Descent from the Cross* and the Baglioni *Descent* or in the great scenes in the Stanze of the Vatican. In the study for the Baglioni *Descent,* this geometric matrix futher emphasizes—as if this were necessary—the division of the scene into two movements: the carrying of Christ's body and the swooning of the Virgin. If we isolate the scene of the carrying, we again find the triangle that emphasizes the two carriers and the group of the Virgin and the mourners; this triangle is superimposed and upside down. However, we are dramatically impressed by the curving lines of the winding sheet and the body of Christ, who, contrasting with the network of triangles, seems to suggest a strange sense of abandonment and oscillation.

Having become secure in his compositional form, Raphael used it as the basis for other vast and grand works; for instance, *The School of Athens,* or *The Liberation of St. Peter,* at the Stanze in the Vatican.

In *The School of Athens,* the triangle is the fundamental element of the composition. An equilateral triangle guides the perspective of the cornice toward the hand of Aristotle, the central vanishing point of the entire scene. A second equilateral triangle defines the aperture circle of the vault in

Raphael: The Liberation of St. Peter *(detail), 1511-14, Fresco. Vatican Palace, Stanza di Eliodoro, Rome.*

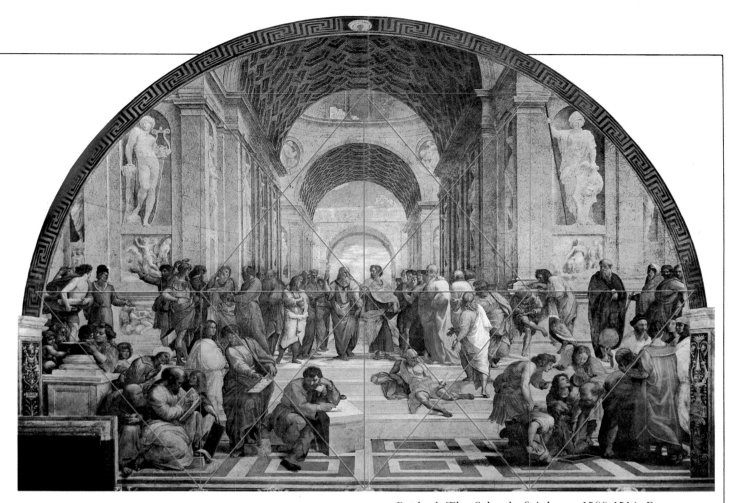

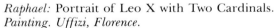

Raphael: The School of Athens, *1509-1514. Fresco. Vatican Palace, Stanza della Segnatura, Rome.*

Raphael: Portrait of Leo X with Two Cardinals. *Painting. Uffizi, Florence.*

the point where the sides intersect. A third one, with its base on the horizon line, overlaps with a fourth and a fifth one, both of them upside down. These upside-down triangles guide the complex arrangement of figures on the steps. This structure, though seemingly free and natural, conceals a very simple and erudite rule of geometry.

In *The Liberation of St. Peter,* Raphael illustrates three successive moments in the event within a more symmetrical composition. The basic ideas are freer, but the final version is stricter. As in the rest of the drawing (at the Uffizi in Florence), the triangular matrix is present in the overall pattern and especially in the central scene.

In the image of the angel who releases St. Peter from his chains, we can find (as evident as in the Baglioni *Descent*) a triangle that encompasses the angel and the saint, while a second triangle, equal in size but upside down, guides the angle of the warriors leaning against the wall. The curve of the chains oscillates (a brilliant idea!) on the crossing of the network of the sides.

Confronted with this rigor and the constant presence of hidden geometry, we cannot help but infer that Raphael had an instinctive compositional will that was reinforced and refined by training and experimentation.

A Drawing a Day

These two drawings and the diagrams illustrating an intermediary phase at the start of the development exemplify the kind of composition that is based on the triangular form. The first drawing (pen and ink) and the second (pastel) treat the same subject: a female figure resting her head on her knees, who is partly covered by a sheet.

In the pen-and-ink drawing, the diagram illustrates one of the initial phases with the line of the triangle that encloses the figure and defines the outline and the main creases of the drapery.

In the pastel diagram, the artist deals with the

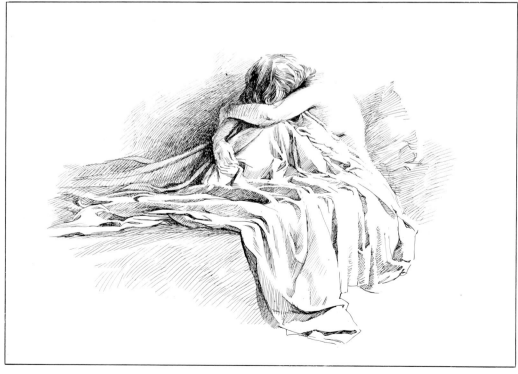

same geometry, as well as with the contrast between the white of the sheet and the hair and flesh of the figure.

As always, the definition of form is fundamental to a drawing, whether it is done in black and white with chiaroscuro or with color. Here, the model is deliberately blocked into a triangular scheme, and its outline must indicate the proportions of the various elements: head, arms, back, and the main creases in the sheet.

Equally fundamental to the drawing is defining the direction and angles of these elements, particularly those describing the space and volume of the sheet and the arms.

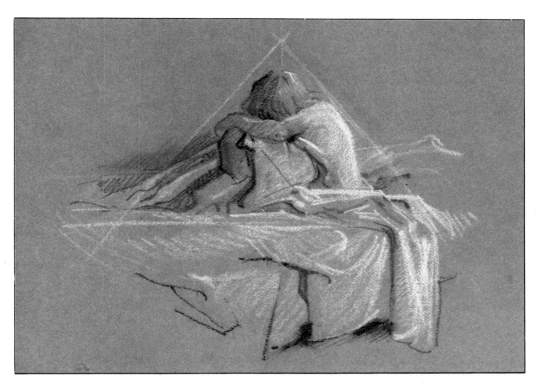

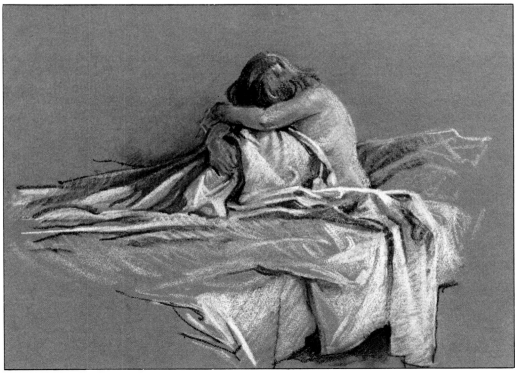

The Triangle in Architecture

An equilateral triangle symbolizes perfection, and it is therefore a shape preferred by artists, painters, sculptors, and architects who are looking for the ideal form.

If we add the symbolic meanings to the geometrical ones, we can easily see why the triangle has always been a favorite shape for architects. More than any other shape, it can symbolically express the deep, unified, and total reality of the cosmos.

We all know the ancient pyramids of Egypt, the monumental tombs of the pharaohs. These monarchs not only wanted to find a resting place for their mortal remains. They also wanted to find, through deeper meanings and symbols, constructions that were meant to integrate them magically into the universe by being modeled on its form and using its geometrical and mathematical rules of proportion. These constructions were also supposed to be a synthesis of easily recognizable cosmological elements. Thus, the four triangular sides represent the four parts of the world, the square base symbolizes the universe, the triangle symbolizes nature and perfection, etc. Made up of four triangles resting on a square base, the pyramidal structure thus reproduces the cosmos.

A further example of the symbolic significance of the triangle can be found in the ground plan of Sant'Ivo alla Sapienza, Rome, designed by Francesco Borromini, one of the masters of the Baroque.

The floor plan emerges from the triangular shape or rather from the intersection of two triangles. Indeed, the triangle already alludes to the heraldic bee of the Barberini family, for whom Borromini was working. The two intersecting triangles produce a perfectly symmetrical stellar shape. The architect used this pattern for the chapel of Sant' Ivo at the back of the court of the Sapienza, modifying the tips of the stars by inserting the chapel into the circular apse.

Pyramids of the Fourth Dynasty. At the center, the so-called "rhomboid" pyramid.

Francesco Borromini: Sant'Ivo alla Sapienza. Development of the floor plan.

The Square Composition

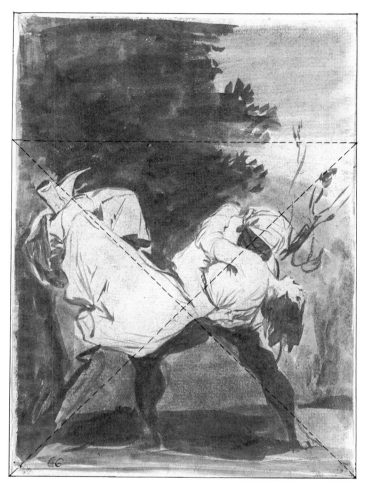

Francisco Goya: And Thus Was She Violated! *Reddish tempera and wash on yellowish paper, 203 x 135 mm. Museo del Prado, Madrid.*

This is a study for one of the Caprichos *that Goya engraved between 1794 and 1797. In its diagonals, this scene acquires the dynamics and balance of a ballet, which softens its cruelty.*

We have seen that the relationship between the square and the human figure forms the basis for all investigations into ideal proportions and acted as a "canon" to Renaissance artists. Following the advice of Vitruvius, Renaissance artists placed the human body at the center of a circle inscribed within a square, the ultimate example of which is the famous drawing by Leonardo da Vinci.

This trend continues even to our times, and we can see it in the work of the French architect Le Corbusier. He used this idea as the fundamental element in his "modulor," a unit of measure done on a human scale based on the square in which he accorded a proportional relationship to every architectural and compositional element.

Among the Japanese symbols of the universe (triangle, quadrangle, and circle), the square (which is seen as two right triangles fused at their hypotenuses) becomes the symbol of a definite aspect in the changing reality of the sensory world.

However, beyond the historical references and symbolic meanings, the square involves problems of visual perception, since it is a shape that we can easily pinpoint and discover. For example, it is the presence of the square in the "golden" rectangle that makes the latter what it is, a rectangle to be read in a certain way. And it is the shape of the square found upon a surface that allows us to proportion the surface immediately.

Finally, the square is visually important because it is a shape that can be recognized more readily

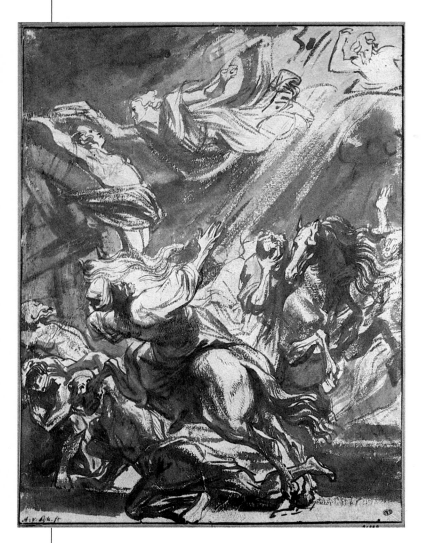

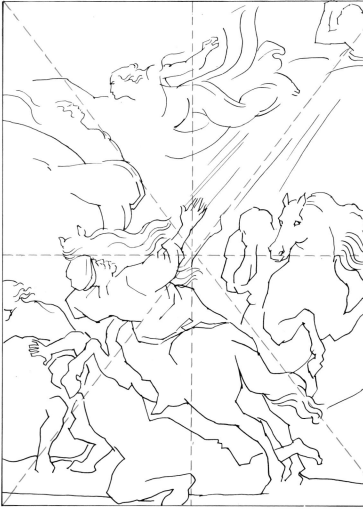

Anton van Dyck: The Martyrdom of Saint Catherine. *Brown ink, watercolor, and charcoal, 285 x 210 mm. École des Beaux-Arts, Paris.*

In this composition typical of the young van Dyck, the dynamics of his sketches and paintings turns into light and emotion. Thus, in a composition crisscrossed by the two diagonals that indicate and direct the rotating movement of the rearing of the horse and the beam of light we see the dazzled riders, the maddened horses, the saint, the angel, and the Lord. The nervous and expressive line melts into the flashes of the barely colored spots of the gouache.

than any other shape. In that connection, Rudolf Arnheim, contemporary investigator of the relationship between art and visual perception, writes: "The difference in configuration between the square and the rhombus has tangible effects. The square with its explicit verticals and horizontals is a simple, stable, resting body, while the rhombus is balanced on an angle upon a solid base.... The Stanford-Binet intelligence test reveals that a normal five-year-old child is able to copy a square, but will not be able to copy a rhombus successfully until the age of seven."

Leonardo da Vinci: *The Last Supper*

The presence and importance of the square not only as a symbolic shape, but also as a geometric compositional matrix in the philosophy and artistic poetics of the Renaissance, becomes obvious when we examine the masterpieces of this era with a new eye.

It is particularly fascinating to reconstruct the creative process of a seemingly well-known work like Leonardo da Vinci's *The Last Supper*. Despite its familiarity, we can still find something new in it, something unwonted and mysterious. (The latest analysis of this painting brings out the astrological signs of the individual apostles.) The artist used a simple arrangement, based on the relationship of the diaposon, i.e., the twofold square.

The composition is centered on the figure of Christ: a central square, between two semi-squares. Within the central square there is a second square, which pinpoints the background wall. And this square contains yet another square, a smaller one, enclosing the figure of Christ.

All the vanishing lines of all the straight lines meet in Christ's head (including the diagonals of the squares and rectangles), while the arms open along the diagonals.

The entire composition is rigorously tied to its geometric construction. Let us examine its development and focus on the individual phases:

1

2

1. Construct a square.
2. Place two half-squares next to it and trace the diagonals of the central square.
3. Divide the upper side of the central square into six parts and draw the perpendiculars down from these points, thereby obtaining the points at which they cross the diagonals of the square.
4. If you connect the pairs of these intersection points, you will have two new squares, one inside the other. At the center, the smaller square encloses the figure of Christ, limited at the sides by the windows and the edge of the table. Containing it, the intermediary square defines the background wall. The sides of the two larger squares also pinpoint the positions of the panels in the side walls. The height of these

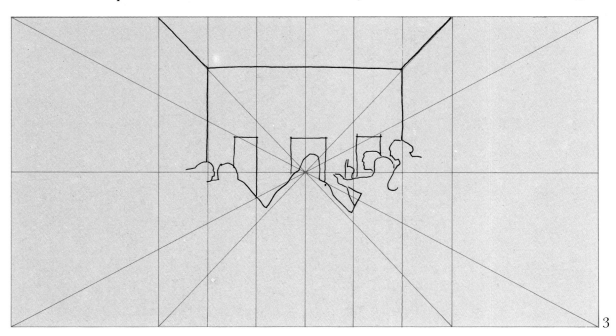

3

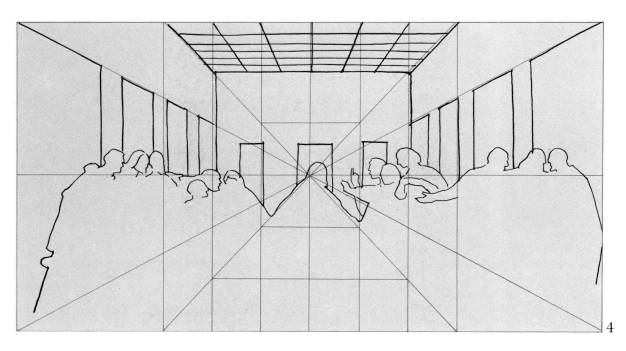

4

—168—

walls in the perspective construction is indicated by the diagonals of the inner rectangle.

5. If you divide the lower half of the shorter side of the rectangle into three equal parts and then draw two parallel lines, you will have constructed a space that corresponds to the space and volume of the table.

Finally, note the arrangement of the apostles, who are shown in groups of three. The first group is in the left-hand semi-square, the second is between the side of the larger square and the side of the smaller square, the third group is between the sides of the smaller square and the larger square, and the fourth group is in the right-hand semi-square.

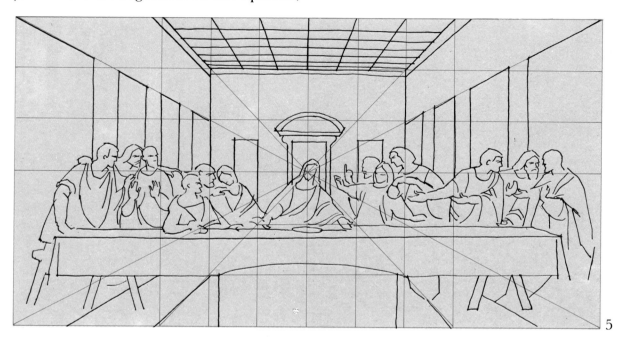

5

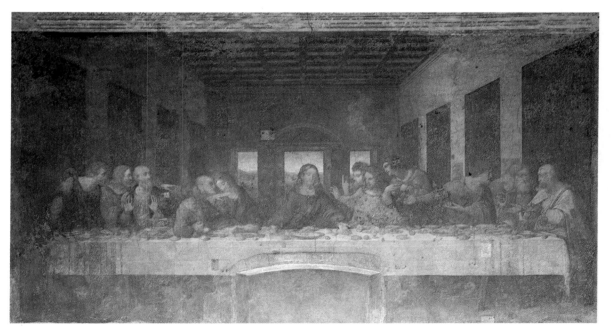

Leonardo da Vinci: The Last Supper, *1495-97. Fresco, 420 x 910 cm.*
Refectory of Santa Maris delle Grazie, Milan.

"The plastic unity that I have created is ambivalent: a blue 'background-square' organically incorporates a smaller 'square-shape,' for example, red. The research technique is based on a determined primer of fifteen 'background shapes,' mechanically cut out in the paper; of twenty vivid colors; and six gammuts of toning (red, blue, green, violet, yellow, and gray), each of which ranges from the lightest tone (no. 1), to the darkest (no. 16). These cutout elements are mobile and hence interchangeable. Fifteen 'background shapes' with ninety tones all around and as many within the unity permit a practically infinite number of combinations.

"Hence, now, the basic teaching of my method is based not on the overestimation of the number, but on the extraordinary qualitative discoveries permitted by the quantity. Without speaking of a new series of unheard-of contrasts and harmonies or of the recovery of chiaroscuro effects (light and dark) in abstract structures or

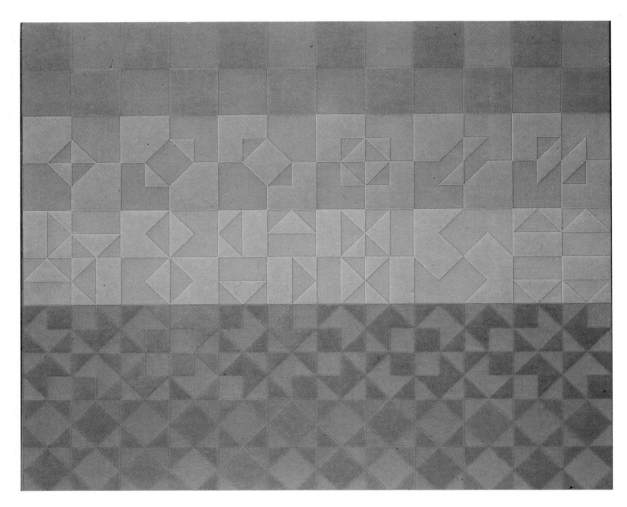

Victor Vasarely (1908): Quadrum no. 2, *1963. Galerie Denise René, Paris.*

Vasarely's "Unity"

Among recent painters, Victor Vasarely (born in 1908 in Pecs, Hungary) is the most interesting exponent of Op Art, i.e., optical art. The name "Op Art" comes from the fact that it is based on the theories and suggestions of visual perception, from ambivalent figures to optical illusions.

Vasarely's works are exercises based on the modality of perception. They are rooted in a rigorous geometric layout and pure colors, usually simply white and black. They are animated by the very ambiguity of perception, which creates motion effects and implies an interchangeability of structures.

Frequently, his works look purely decorative. But Vasarely wanted to relate his works directly to the world of technology and production. He therefore selected currently used materials (plastic, prints) or processes of industrial mass production (silk screens, lithographs). And his search for a module, an element that could be easily re-

even the reappearance of splendid monochromes.... We are all familiar with the colored checkerboards of Klee, Sophie Taeuber-Arp, Freundlich, and others. The components of their structures were multicolored—a blue square or rectangle, for instance. These artists operated as painters. With their brushes they would add monochrome touches... according to their inspirations, modifying them with some nuance. No 'combination of colors' can emerge from these works because they successfully or unsuccessfully expressed a painterly sentiment that was limited to that particular piece.

"I imagined the structures of a shape/color unity and I thought of selecting those that could appease the aspirations of my contemporaries. I therefore understood the creation of a vast totality—my work...."

(Marcel Joray: *Vasarely II,* 1971)

produced (even conceptually) and multiplied led him almost spontaneously to the square. This elementary shape, seemingly immobile and inalterable, goes through an infinite number of permutations in Vasarely's imagination, geometry, and art. (These variations are due, as we have said, chiefly to the phenomena of visual perception.)

Vasarely's investigations are based on the square, and he plays with it in many ways:

The artist brings together a certain number of squares to form a larger square. Around this larger square, he creates a series of optical effects by means of alternate colors and shadow nuances, with smaller circles or squares within the elements making up the larger square, and an alternation of forms and even a variation of colors.

The simplest example is a square made up of nine smaller squares. In these squares, the artist draws circles with diameters slightly smaller than the sides of the squares. His colors are blue and red: red for the first square and blue for the circle inside it, and then, vice versa—blue for the second square and red for the circle inside it—and so forth. He eventually concludes his composition with a glaze of gray tone, which darkens the first row of squares, is used a bit less for the second row, and with no gray for the third row. This play of nuances, of light and shading in specific areas (e.g., a rhomboidal shape within a square, darker in the center, lighter on the edges), forms the basis for many of Varsarely's "optical sensations." He also employs bright elements (light yellows) on darker elements (blue or black), made up of squares and circles, circles and rhombuses, rhombuses and squares.

From simple compositions Vasarely passes easily to more complex ones, made up of four squares arranged on the orthogonal axes. He also passes naturally from surface depiction to spatial depiction. With the same squares, whose surfaces seem to vary in their tones and shapes before our very eyes, Vasarely composes the volume of a cube. He then places this cube in an ambiguous space and joins it to others in assemblages that increase the difficulty and pleasure of reading

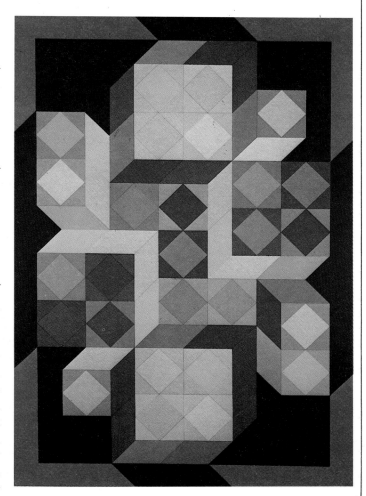

Victor Vasarely:
Tridim-B, *1968. Galerie Denise René, Paris.*

through the interplay of colors.

Finally, using a precise geometric construction, Vasarely warps his surfaces, bellying them symmetrically at their sides and centers. The effects become more and more startling and curiously up-to-date. Indeed, it is not hard to find his dynamics and his optical compositions in store windows and decorations, in advertising and fashion. Does art inspire civilization or does civilization inspire art?

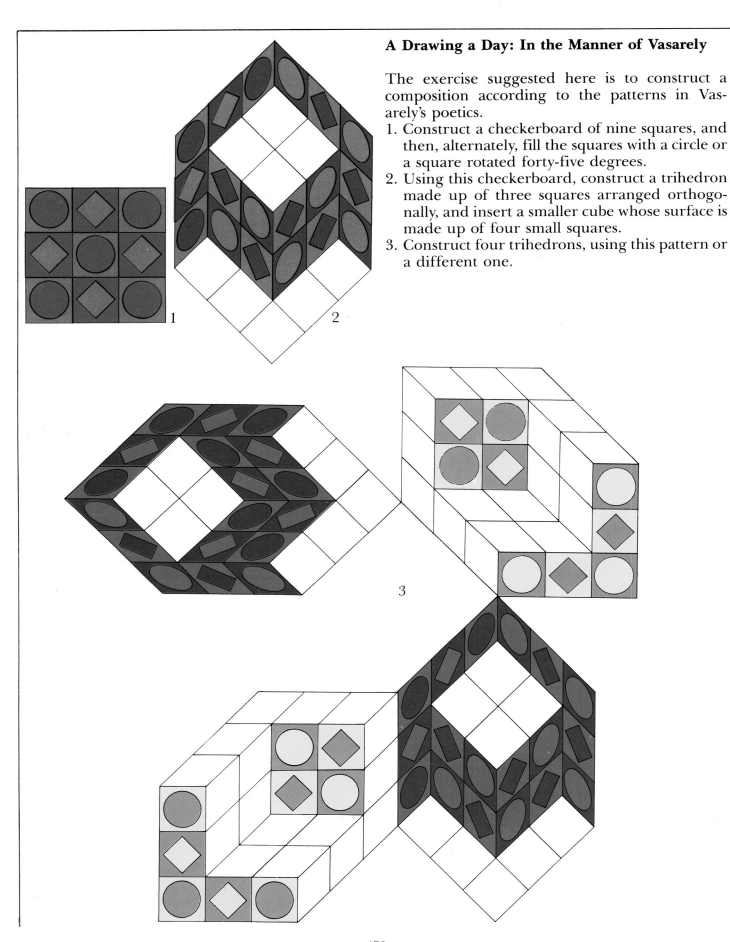

A Drawing a Day: In the Manner of Vasarely

The exercise suggested here is to construct a composition according to the patterns in Vasarely's poetics.

1. Construct a checkerboard of nine squares, and then, alternately, fill the squares with a circle or a square rotated forty-five degrees.
2. Using this checkerboard, construct a trihedron made up of three squares arranged orthogonally, and insert a smaller cube whose surface is made up of four small squares.
3. Construct four trihedrons, using this pattern or a different one.

Mondrian's Equilibrium

For Mondrian, art is not an end, but a means to construct a new reality. This new reality is regulated rationally. It is serene and perfectly balanced, and the painting that expresses it is based on an equilibrium between the vertical and the horizontal, and between the square and other squares and rectangles.

More than the relationships between pure colors (blue, red, and yellow), which are barely present in his compositions and virtually act as mosaic stones, it is a pure white that becomes the basic emblem of his work, that and the square, which is more important than any other regular element created by intersecting straight lines.

Mondrian's work might look like the death of painting, or at least of representational painting (the rendering of nature) as it was thought of until now. But actually it is not only the birth of a new way of painting, but of a "new nature," a nature created by man through the rational equilibrium that can be expressed only by the perfect shape of the square and the presence of white with black outlines of squares and rectangles, and with the mosaic stones of pure colors.

"When man transforms nature into what he is himself—a balance of nature and non-nature (i.e., reason), he will regain paradise on earth...." Mondrian wrote. "He must try to express in his art that which is essential in man and in nature, i.e., the universal." In other words, art must be "the expression of pure reality."

We have seen Mondrian achieve this pure reality by observing life and by progressively transforming and representing it on a plane in which form passes into an equilibrium of drawn and colored spaces. Do you recall the interpretation of the tree and the process of abstraction and balance that cause the sky areas between the branches to become cut-out surfaces balanced in a network of lines?

Mondrian used this same equilibrium of surfaces selected from reality and transformed into colored shapes during a series of passages. He achieved this transformation directly on the surface of the canvas, using as a basis the square, the golden mean, geometric rules, the value and weight of white and basic colors—and above all, his artistic sensibility.

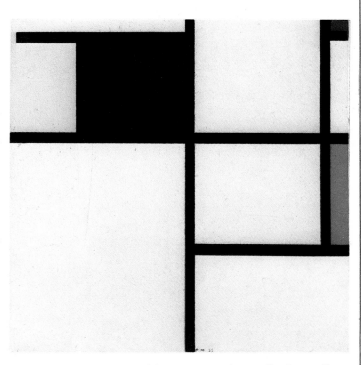

Piet Mondrian: Composition, *1923. Private collection, Milan.*

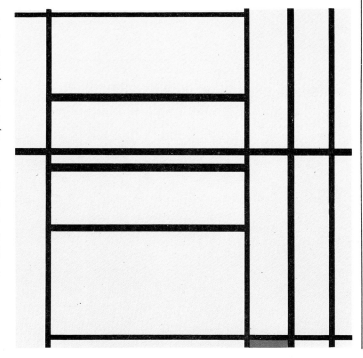

Piet Mondrian: Composition with Red, *1939. Painting. Peggy Guggenheim Foundation, Venice.*

Mondrian's Diagrams for His Compositions

1

2

1

2

1

2

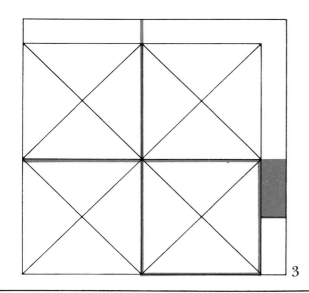

These three drawings illustrate the process—a very simple one—by which Mondrian creates his composition.

1. Mondrian divides the square into four equal squares by the two orthogonal axes.
2. He then places a streak several centimeters wide on two sides of the square.
3. Then he reinforces the two axes of the original square, running a line of the same thickness along the lower right-hand square. The ultimate balance is achieved by drawing the blue rectangle on the added face, with a side equal in length to half the side of the square.

3

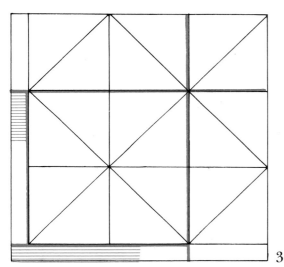

1. Mondrian traces the diagonal on the generating square. On the extension of this diagonal, he indicates a segment equal to half the diagonal, thus obtaining five more equal squares constructed on two sides of the original square.
2. Corresponding to these two sides, he adds a "ray" whose thickness is given by the ribaltamento "folding" of the semi-diagonal of one of the smaller squares.
3. He then strengthens the outline of the original square and the extensions of its two sides, and concludes with two additional elements, thereby balancing the composition.

3

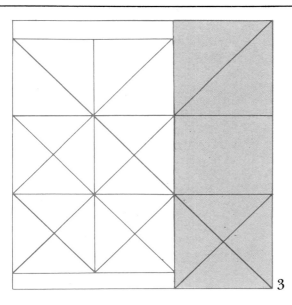

1. In the original square, Mondrian indicates the diagonals and the axes, thereby creating four smaller squares.
2. He then adds two equal squares tangential to the lower side of the original square.
3. He extends the diagonal of the fourth square upward at the lower right. On this, to the right, he constructs a wider strip, joined on the upper and the lower sides by two narrower strips.

3

A Drawing a Day: In the Manner of Mondrian

Diagrams *a* and *b* illustrate phases of the educational and compositional development of the square in Mondrian's work. Color them as we like.

Diagram *a*:

1. The drawing emerges from a square. Draw the axes and the diagonals. Within this square, insert one that is turned forty-five degrees.
2. If you pinpoint the axes and the diagonals, you will have an easier time constructing the sixteen smaller squares.
3. Join the centers of the four rotated squares.

You now have one more square, which overlaps the preceding ones in a complex way.

Diagram *b*:

1. In a "generating" square, draw a circle. Inside the circle, draw a smaller square, rotated forty-five degrees.
2. Draw a further square equal to the second one and rotated like it. Next, draw a circle inside this square.
3. Within this circle draw two more squares rotated forty-five degrees. And so on. You will thus keep drawing smaller squares and circles.

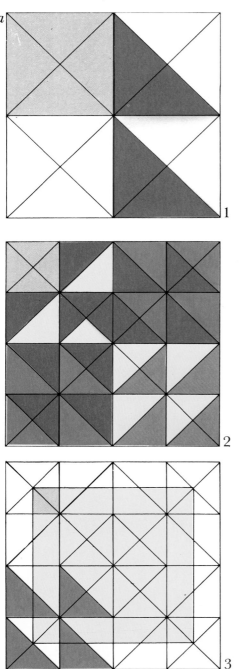

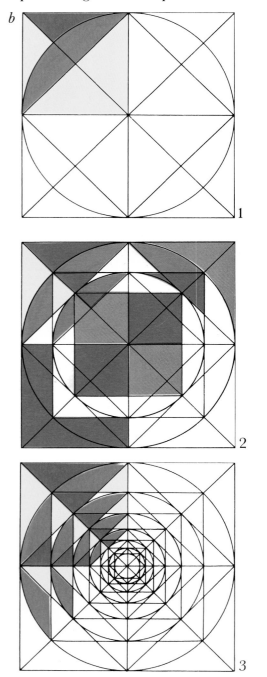

Mixed Composition

Piet Mondrian: The Sea, *1914. Charcoal and gouache, 90 x 123 cm.*
Peggy Guggenheim Foundation, Venice.

An oval and, within it, a tide of T-shaped strokes. The composition is based on a
rectangle within an oval (like the classic circle inscribed within a square). In the union
of the two forms, Mondrian seems to be expressing an organic sense of nature, from
the realism of his early studies to the complete abstraction of his final compositions.

In the late eighteenth century, the Italian art writer Francesco Milizia, a rationalist polemicist and advocate of neo-Classicism, wrote the following about composition: "Composing means to cover, discern, assemble, reunite the most interesting things purified of any defect and endowed with new graces and beauties.... The rarest gift of composition is choice...and the worthiest artist knows how to choose what is suitable for him." The artist can achieve perfection and beauty in a work through "the unity of the composition," which must be orderly. "It is not the confusion of objects tossed about every which way, but their highly orderly arrangement that produces the pleasing effect we feel in a multiplicity of things."

This relationship, which arranges and conditions the various elements, is even more important and difficult to achieve when we pass from a surface (two-dimensional) composition to a spatial (three-dimensional) one. In the latter, the objects are arranged in an order substantiated and formed by their existence in space.

In other words, this composition is not based on a geometrical shape or direction. Instead, the order emerges from a totality and interweaving of different matrixes, which, altogether, go beyond a two-dimensional structure or even a hypothetical space.

Bernard Berenson, the great American art historian and critic (1865-1959), discusses spatial composition in regard to Raphael: "It was Perugino who initiated and Raphael who perfected what I call *spatial composition,* a composition that exists not only in three dimensions, but one that suggests the amplitude and the contained freedom of cosmic dimensions."

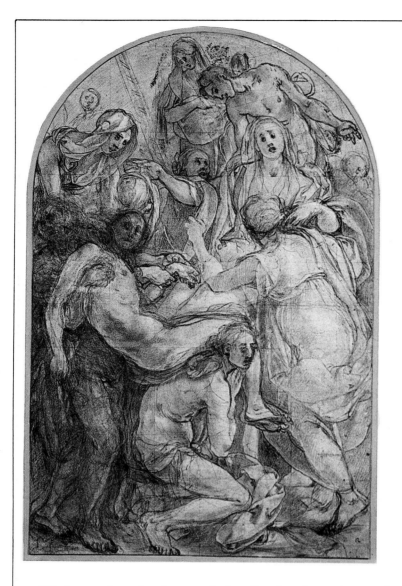

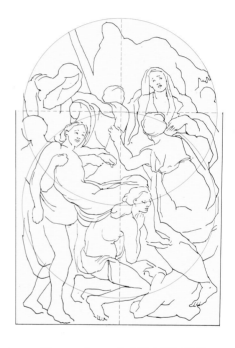

We have already observed that Raphael employs a seemingly rigid form based on the isosceles triangle. It joins with the curving of a body, a suspended chain, to suggest movement and waviness.

However, when we carefully examine the drawings and paintings of the masters, we find that their fundamental compositions are varied and different—sometimes simple, but often complex. Under the pencil lines or brushstrokes, we can unearth a hidden geometry, the plan or verification of the work. This is a compositional matrix that is made to act as a guide and basis for the composition, and can be made more precise by the drawing. Or it may be formed unconsciously and discovered only after the artist has finished the entire work; and at that point it serves to verify the structure, layout, and dynamics of the scene.

Thus, by uniting several different matrixes, the artist can obtain compositions that make his draw-

Jacopo Pontormo (Jacopo Carucci, 1494-1556/57): Deposition of Christ. *Stump, light watercolor, bistre, with highlights in white lead and ink in the upper part, 445 x 276 mm. Christ Church Library, Oxford.*

In his study for the altar of Santa Felicita, we find the typical themes and style of Pontormo, who combined the Late Gothic with Classical style. Above all, the artist fuses the religious experience with the dimension of the aesthetic component, which derives from the composition of serpentine lines emerging from the overlapping of circles. We feel echoes of the aesthetics of Gian Paolo Lomazzo (1538-1600), who, in his Treatise on the Art of Painting, *states his preference for the "most beautiful, most graceful proportion" over the natural proportion of the figure, the best posture imitating the shape of the flame. For "the shape of the flame is more capable of movement than any other shape, because it possesses the cone and the sharp point with which it seems to pierce the air and ascend to the heavenly spheres. Thus, any figure having this shape will be beautiful."*

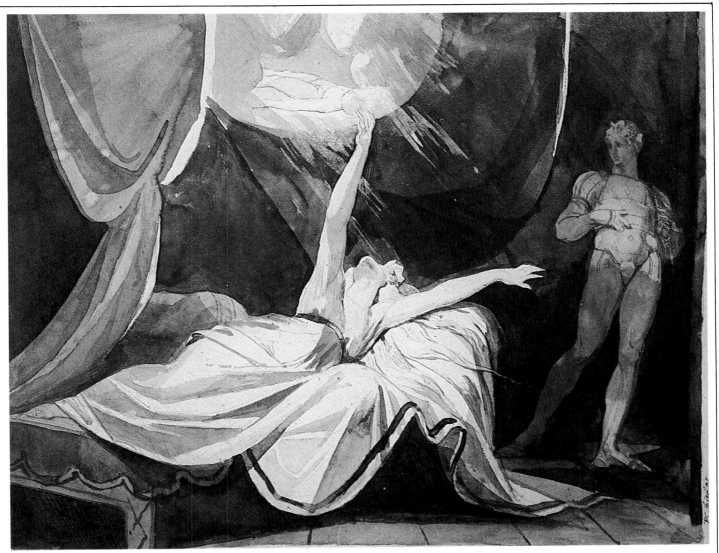

ing or painting grander, more monumental, and more complex.

A major element of such a compositional structure is the serpentine line. The British painter William Hogarth discussed this winding line in his *Analysis of Beauty*. He considered it the most suitable line for expressing not only movement and grandeur, but also, and above all, beauty.

Although Hogarth may have been its theorist, the serpentine line, or rather the serpentine shape, was first introduced by Leonardo da Vinci, who gave the following advice: "The pyramidal serpentine figure, multiplied by one, by two, by three...." This advice was then taken up by Tintoretto, whose figures all move and vibrate in a serpentine manner.

Finally, the serpentine line became a chief element in Baroque compositions, which were moved by the variations of light on a surface, agitated by the dynamics of accidental perspectives, and exalted by a deliberate attempt to astound.

Johann Heinrich Füssli (1741-1825): Kriemhild Dreams of Siegried Dead, *1805. Brush and brown wash, with highlights in watercolor and gouache, 385 x 485 mm. Kunsthaus, Zurich.*
The mixed composition is based primarily on a circular movement, concentric and radial, which transmits the sense of oscillation, the dream and the mystery, the unexpected vision. Füssli's art is visionary, and corresponds perfectly to the theatrical and dramatic quality of the scene.

"The line derives its energy from the person who draws it....Its job is to evoke those complements of which the shape is as yet devoid, but which we consider indispensable....The ornament thus conceived completes the shape; it is its extension. We recognize the meaning and justification of the ornament in its function. This function is to 'structure' the shape not to decorate it, as many artists are tempted to do. Without the support of this structure, to which the shape adjusts like a soft cloth to the loom or like flesh adhering to bones, the shape would tend to change its appearance or crumble completely. The relationship between this 'structural and dynamographic' ornament and the shape or the surfaces must be so intimate that it makes the ornament look as though it had 'determined' the final shape. We can imagine shapes that realize this equilibrium without the help of the ornament, and these shapes are the most perfect. In their simplicity, they have realized a linear schema that

Luca Signorelli: Hercules and Antaeus, *c. 1513. Black pencil, 283 x 163 mm. Royal Library, Windsor Castle.*

This drawing has a special interest and significance that go beyond the subtle demonic fascination typical of Signorelli's works on paper. This unusual quality is partly due to the instinctive but refined composition—a simple structure that finds the meaning and dynamics of the struggle here in its fundamental elements. The hands of Hercules seem to "strangle" the waist of Antaeus, an impression evoked by the sequence of hands and arms whirling around the axis of the composition. The left leg of Antaeus seems to be moving along the diagonal of the rectangle of the surface, oscillating in the air, in a space that the artist has managed to create with a few pencil strokes, but in an exemplary composition.

…constitutes a perfect eternal ornament. It may be going too far to conclude that the presence of the ornament is secondary to the beauty. The ornament is not secondary—unless it is inorganic, unconnected to the shape, and without a complementary and structural activity. The slightest emotional weakness, the slightest naturalistic association would threaten the eternal life of this ornament…. The line 'speaks' like the eyes and even more than the written word, and because of this, nothing that helped to characterize the sensibilities of the nations that have gained supremacy throughout history remains alien to us. The imperceptible impulse, the slightest reflection, the subtlest change in rhythm, the least variation in the relationship of interval or distance in accents are linked to causes that depend on the mentality and psychology of a nation."

(H. van de Velde: "La ligne est une force". in *La cité*, March 1923)

Luca Cambiaso (1527-1585): The Fall of Phaëthon. *Pen and ink, watercolor on ivory paper, 305 x 217 mm. Civica Raccolta Stampe Bertarelli, Milan.*

The theme is fascinating and the composition seems inspired by Michelangelo's treatment of two drawings on the same subject. However, Luca Cambiaso resolves the problem in his own way, by blocking in the bodies of the horses in a circle that unites them and pulls them to the ground, making Phaëthon stand out on the axis of the composition. The circle enclosing the horses seems to dash along the plane of the paper and dash to the ground. With a few pen lines and brushstrokes, and with a marvelous composition, Cambiaso manages to create a kind of vortex as well as a direction for the fall.

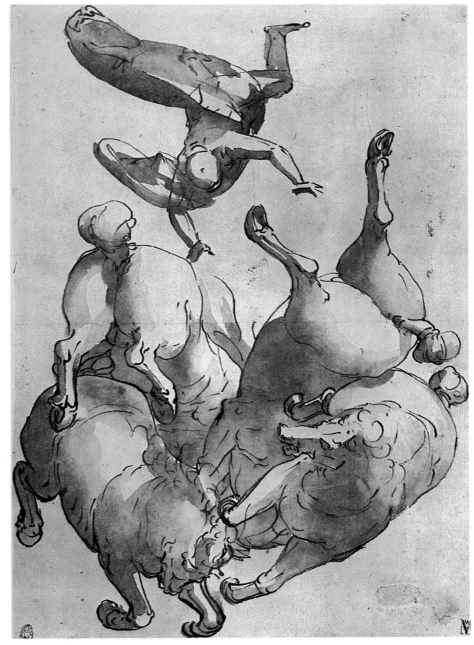

Analysis of a Composition

In this extraordinary drawing by Rembrandt, *Christ on the Cross Between the Two Thieves,* the two main directions of his composition, the linear and the diagonal, are united. This composition probably emerged instinctively, but we can nevertheless analyze it to understand how it came about. The vertical rhythm is scanned by reading from left to right. The angles are defined by the diagonals of the rectangle of the paper.

Imagine that you could follow Rembrandt's procedure and watch him working in his studio: Bent over the table, Rembrandt dips his goose quill in the ink, which he has prepared himself with nut shells. He then applies the first strokes to the paper. For the series of grand scenes illustrating the Passion, he is about to depict Christ in agony between the two thieves as a vinegar-soaked sponge at the end of a stick is held out to him.

Jesus' cross cuts off the left-hand third of the paper. Rembrandt has already tried a frontal view in drawings and engravings. Now he will frame the foreshortened figure of Christ between the thieves and place him in a well-defined space, a stage on which the drama of the Passion unfolds. The figures are arranged in a vertical rhythm scanned by the axis of the surface and then by the axes of each half, and by the axes of the figures that occupy the left part of the composition where the scene is focused. In the other part of the composition we see the indifferent soldiers on horseback.

Thus Rembrandt sketches the second and third crosses on either side of Christ—two theatrical "wings" facing each other. It takes only a few strokes, mainly for the arms of the crosses—the horizontal and parallel crosses of the thieves, staggered in the perspective, and the cross of Christ, at an angle in the foreshortening. Together, these crosses suggest a luminous space in which the figure of the Son of God looms high.

At the foot of Christ's cross, the artist places two kneeling women and a man seen from the back;

Rembrandt: Christ on the Cross Between the Two Thieves. *Pen and brown ink, brown wash with white-lead highlights, 208 x 285 mm. Louvre, Cabinet des Dessins, Paris.*

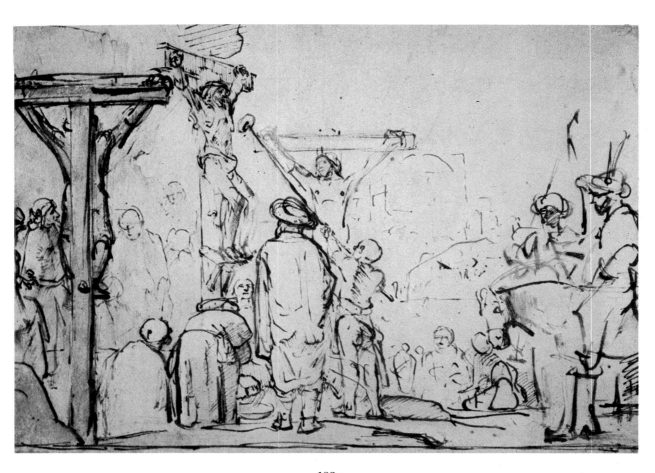

he thus leaves Christ's figure fully visible. On the right, he sketches two armed horsemen.

The theatrical space is brought out perfectly. Rembrandt adds the man with the stick, who holds out the sponge to the thirsty Christ. The dynamic diagonals are superimposed on the vertical pauses. Two movements crisscross dramatically: the diagonal line of the women and the man, rising from left to right; and the diagonal of the stick, which seems to move and open, away from the main diagonal of the rectangle.

In back, the artist sketches the mob, which moves down in the background. Finally, with a light stroke, he draws the profile of the city, with the temple of Jerusalem.

Then, with his quill, the artist goes over the drawn lines more forcefully, emphasizing the front planes—especially the cross and the left-hand thief, who is seen from the back. The artist modifies and thickens the outline of the figure with stronger and stronger strokes. He emphasizes the right-hand portion, in the shadow (the light comes from the top left) of the central figures, and he retouches the rider and his mount with a more nervous, more expressive stroke.

Using a lighter stroke, Rembrandt swiftly adds chiaroscuro with a transparent hatchwork for the figures of the thief, the women at the foot of the cross, the man with the stick, and a few places on the ground.

Before the ink even dries, Rembrandt dips his brush in the wash (a kind of sepia watercolor) and rapidly spots the left-hand cross, the terrain, and, here and there, the foreground figures, thereby heightening the light effect and the illusion of space.

It is interesting to compare Rembrandt's *Christ on the Cross Between the Two Thieves* (at the Louvre) with his *Crucifixion* (at the Städelsches Kunstinstitut in Frankfurt, West Germany). Among the many things that can be said about them, let us focus on the different layouts.

The latter drawing (1647) shows Christ frontally, unlike the other drawings and engravings, which depict him flanked. A similar frontal view will be used in the engraving *The Three Crosses*, but here there are no thieves at his sides.

The composition seems to unfold in a single

plane, on an ideal stage, underlined by the figure of a tearful John leaning on a rock, by the group surrounding the swooning Madonna, and by the spear with the vinegar-soaked sponge at the feet of the cross. The cross and the spear connect the two groups.

Rembrandt does not place Christ at the center of the composition. Instead, he shifts him slightly to the left and connects him visually to the group of horsemen and spectators, with the figure of the Magdalene at the foot of the cross—all placed in a linear rhythm.

On the right, Mary is supported by two women. Other figures loom above them, and the general motif is curvilinear. A very faint outline indicates the profile of the city in the background. The strokes are decisive. The few *pentimenti* lines strengthen or modify the figures slightly, actually superimposing them on one another.

Rembrandt uses rather intense watercolor tones with various thicknesses for his expressive strokes, thus obtaining highly imaginative painterly effects. Finally, he adds spots to the front planes and several figures with a brush dipped in bistre, thus accentuating their bodies and increasing the brightness.

As always, his scene has a powerful theatrical staging: a sacred depiction, inviting the observer to participate as a leading character, a sinner among the grieving figures at the foot of the cross. Christ's arms are not only those of a crucified man, they open wide into an embrace.

Rembrandt: Crucifixion. *Pen and ink, watercolor, with corrections in bistre and white.*
165 x 239 mm. Städelsches Kunstinstitut, Frankfurt am Main.

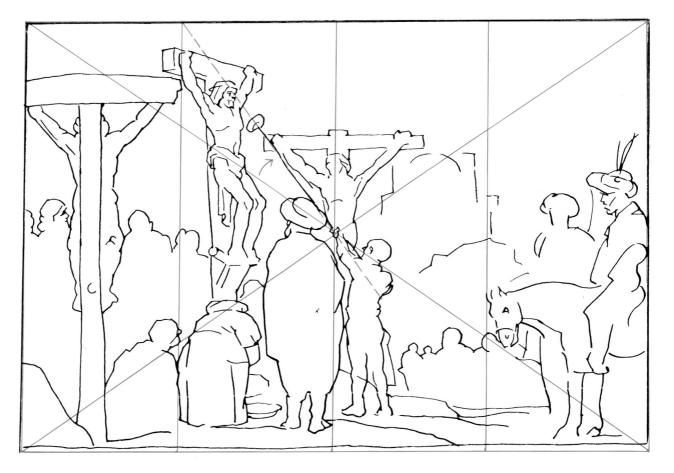

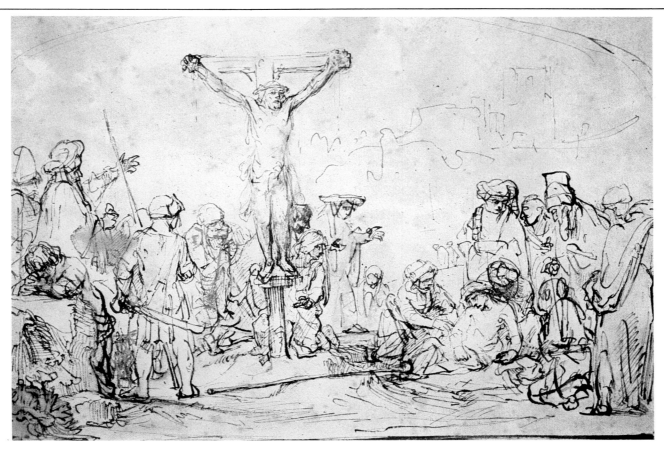

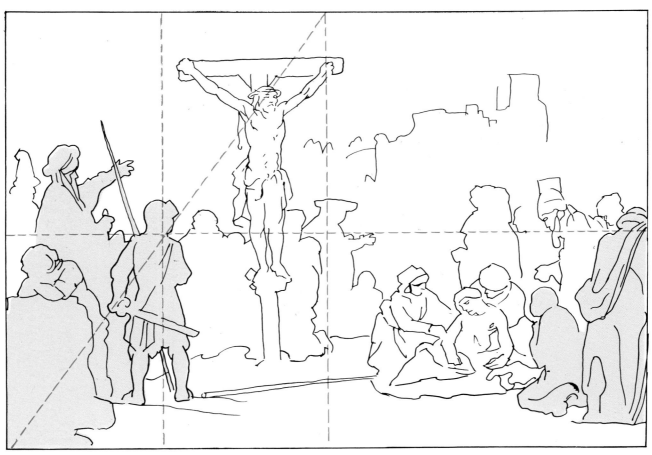

A Drawing a Day

Drawings 1 and 2 are based on a circular composition, as shown by diagram 1, which illustrates the preceding phase of the development of sketch 2. The circle enclosing the female nude accentuates the rolled-up figure. In contrast, drawings 3/4 and drawings 3/4 and 5/6, are based on the serpentine line. In these two sketches, and above all in the two diagrams illustrating the preceding phases of the development, the movement of the compositional line is obvious. Sketch 6 was done after sketch 5, constituting a further step in the search for an expressive and synthetic line.

1

2

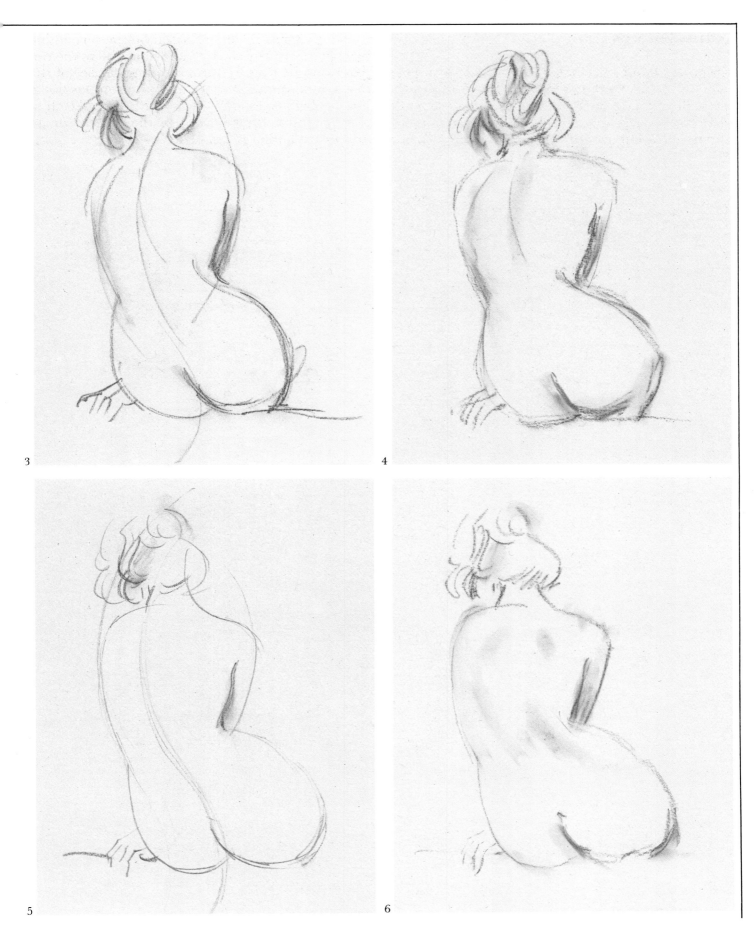

3

4

5

6

The Circular Ground Plan

The circle—a symbol of perfection and completeness—is the basic shape throughout art history for a large number of architectural designs, especially for religious buildings. The circular form was adopted by the Romans, who probably adapted it from similar Greek examples. The Romans used it especially for temples dedicated to the goddess Vesta. However, they also employed it for the Pantheon, the temple of Venus in Baalbek, the Mausoleum of Adrian, and the Castle Sant'Angelo.

In Byzantine architecture, the ground plan is frequently central, but with a polygonal shape and side chapels, as in the Temple of Minerva Medica in Rome or the church of San Vitale in Ravenna.

On the other hand, we find a circular shape in the Mausoleum of Saint Constance, where the double columns at the center, arranged radially, accentuate the centripetal character of the space.

In the Romanesque period, for example, in Pisa and Parma, the floor plans of baptistries were circular. It was during the Renaissance, however, that the circular design was truly favored and given its most complete expression.

We may note, above all, the small temple of St. Peter in Montorio, Rome. Its architect, Bramante, who was inspired by Roman architecture, achieved a complete and perfect form, a kind of ideal space. It is especially active and pulsating because the temple, presented as a tabernacle, was supposed to be the center of a circular colonnade.

1. *Section and ground plan of the Baptistry of Pisa (1153).*

2. *Section and ground plan of the Baptistry of Parma (begun in 1196) by Bernedetto Antelami.*

3. *Section and ground plan of the Tempietto di San Pietro, Montorio (1502) by Bramante.*

INDEX